For my wife,
Rebecca McKelvey whose
support has meant every-
thing; and for my children,
Max and Dana Rose

A RotoVision Book
Published and Distributed by RotoVision SA
7 Rue du Bugnon
CH-1299 Crans-Près-Céligny
Switzerland

RotoVision SA,
Sales & Production Office
Sheridan House
112/116A Western Road
Hove, East Sussex BN3 1DD
UK
Tel +44 (0)1273 72 72 68
Fax +44 (0)1273 72 72 69
E-mail: Sales@RotoVision.com

Distributed to the trade in the United States by:
Watson-Guptill Publications
1515 Broadway
New York, NY 10036
USA

10 9 8 7 6 5 4 3 2 1

ISBN 2-88046-313-0

Book design by Roy McKelvey

Production and separations in Singapore by
ProVision Pte. Ltd.
Tel +65 334 7720
Fax +65 334 7721

Hyper
Graphics

Roy McKelvey

Acknowledgments

Many people contributed to the making of this book, both directly and indirectly. I am indebted to the many designers, programmers, photographers, illustrators, writers and clients whose efforts all contributed to the excellence of the work included in this book. To all who granted me permission to show this work, I am a very grateful.

At Virginia Commonwealth University, John DeMao, chairman of the Department of Communication Arts & Design offered encouragement and support. My colleagues, Phil Meggs and Rob Carter provided invaluable guidance in the ways of making books. Their suggestions and encouragement were always of great value. David Colley's hand and eye have been invaluable in the evolution of the book design. I have relied heavily on Professor Colley's experience, good humor, and friendship throughout this project. The title page design would not have happened without his help. Jerry Bates and Joe Dimicelli have always been available with technical support. A special thanks to my colleague in interaction and interface design here at VCU, Jean Gasen. Her suggestions and unflagging encouragement are deeply appreciated.

At Rotovision I am deeply indebted to Angie Patchell for guiding me gently through the terrors of building a book up from scratch, and to Brian Morris, for showing tremendous patience with my progress. Betsy Hosegood copy edited the book, and her initial revisions were both insightful and instructive.

Finally, I could not have done the book without the generosity and loving support of my wife, Rebecca and my two children, Max and Dana. The patience and understanding they showed me during the days and months of disrupted family life has been extraordinary. I will always be in their debt.

Contents

Introduction

The Medium of the Web

In the early days of the personal computer revolution it was often claimed that a new era was emerging, the era of the "paperless office". Mail, memos, meeting agendas, minutes—informal communications of all sorts —would be exchanged electronically, and a new, green world would emerge.

The realization of this dream has been long in coming. The personal computer spawned the desktop-publishing revolution, and laserwriters around the world have been coughing out paper at a rate unimaginable in the days of the typewritten page. The electronic forms of communication uniquely afforded by the computer, e-mail, bulletin boards, mailing-lists etc., have not lessened the amount of printed material in our lives, but have actually increased the amount of information available to print.

With the advent of the world-wide web the possibility of a purely electronic form of print has arisen once again. While it is too early to know what final effect the web will have on in-house and corporate publishing, there's no doubt that material that was once routinely printed is now moving toward a purely electronic form. WIth the web, certain key potentialities of the networked personal computer have reached their first real synthesis. Rather than being simply a screen-based facsimile of a printed piece, the web document is something unique, something that cannot be realized in any other form. The medium is once again the message, and the web is a medium of interactivity. The potential for the web to replace certain aspects of print communication is based on the fact that it may be better suited to the goals of particular projects.

A web site provides a publishing and distribution system unlike any in history. Although its form is far from established—new browsers and other technologies seem to appear with the seasons— certain advantages of web-based publishing are becoming clear:

1. The web supports a form of "just-in-time" publishing. Information is distributed only when it is requested. There are no inventories to be warehoused, and no waste associated with overproduction.

2. The web provides access to a global audience. The web has no central location, and is borderless. Once a user is connected to any part of the web, he is essentially connected to all of it.

3. A web page allows users to interact with the information and the provider. Meaningful information flows both ways.

4. The web is creating "communities of interest". One of the most striking outcomes of the internet revolution has been the creation of virtual communities— people sharing a common interest or situation. These self-selecting groups are natural audiences for certain messages and services.

5. The web is a phenomenon. The size of the web audience continues to increase exponentially and the technologies that support the web are still in their infancy. Improvements in band-width, development tools and site-support software are sure to make the web an increasingly stable and integral mass medium.

On Being a Web-Page Designer

As recently as 1994, few professional designers were involved in designing for the web. The medium had not yet reached its current fever pitch, and the possibilities of attaining any level of graphic sophistication in page design were slim indeed. Although there have been significant improvements in breaking free of the constraints of early web browsers and the first dialects of HTML, the web is still a very primitive place for most designers. The web's success is related more to its pervasiveness than the quality of its content or its form.

Typographic controls are limited to setting margins, hitting carriage returns at the end of lines and choosing among a small range of pre-defined type sizes; specification of particular fonts is chancy at best; images are limited to screen resolution and are severely constrained in their palette and file size; support for structuring pages—definition of grids, columns and layers—is extremely basic and involves significant jury-rigging of HTML code to achieve desired design results.

As designers become familiar with what they can and cannot do formally in HTML, they also must redefine their design process to accommodate new issues raised by the web such as computer-programming, interaction design, and software maintenance. As page-layout programs forced designers to rethink their role with respect to typesetting and pre-press, web-page design has forced them to adapt to certain aspects of computer coding.

While many web sites are designed and programmed either in-house, or by a single consulting firm, they are rarely the work of one individual. Most web sites in this book are the product of interdisciplinary teams. A typical web-design team includes artists, animators and photographers; graphic designers; writers and other content specialists; programmers and coders; and often some form of web-site architect who is responsible for high-level coordination of the project.

About this Book

This book is intended for the graphic designer interested in understanding what goes into the visual design of compelling web pages. The book avoids a too-detailed focus on HTML, or other encoding technologies that drive the web. I have attempted to give the reader an insight into those web technologies and constructs that most immediately affect the composition of web pages and the quality of the elements they contain. These are changing fast, particularly with the onset of style sheets and recent releases of second-generation web authoring environments such as Macromedia's DreamWeaver. However, the web pages shown in this book have been built with techniques, and under constraints, that will be of continued relevance for the foreseeable future.

The attitude taken in this book is that the best way to learn about web design is by example. The principles of good visual, interaction and site design shown in *Hypergraphics* will always have relevance, and will certainly outlive the inevitable technological metamorphosis of the medium.

Guidelines for Effective Web Design

Designing an effective web site is a complex and time-consuming task. Just building the first prototype of a system can take months of effort. The site must be efficient both technically and in its navigational design, and it must work in a wide variety of computer configurations. Getting a site design right the first time is a challenge. The following guidelines will help you avoid some of the main pitfalls that plague first-time design efforts.

1. Everything starts with bandwidth

No matter how beautifully designed your web site is, or how useful the information it provides, it will get very little use if it does not download in a reasonable length of time. Nothing will drive visitors away faster than a sluggish site. Because a great many internet users connect with slow modems, it is important that every web page be kept to a minimum size. A standard rule-of-thumb for transmission speed to low-end users is about 1 kilobyte of data per second. This means that for a web page to arrive in 30 seconds—a pretty long wait—the entire page must total no more than 30K.

2. Know your users, test your designs

Web sites must be designed to be *used*, not just looked at. People usually come to a web site for a reason, and with expectations about what they will be able to accomplish. The earlier you understand users' goals, the better you will be able to accommodate them. Don't assume that your experience is typical. The only effective way to see if your design meets users' needs is to have them try it out and to watch them closely. Frequent interaction with users during the design cycle is the hallmark of good interaction design.

3. Don't jump in too soon

The web is constantly evolving, with new formatting technologies and plug-ins appearing daily. If you design for the web it's almost impossible not to be aware of ground-breaking technology, and it's only natural to want to take advantage of it. However, most users of the internet don't pay such close attention to web technology. A sizeable number only upgrade their software when they can no longer do the simple things they want to do.

4. Don't go overboard

HTML, Javascript, Shockwave, Flash, streaming video and other technologies can add tremendous appeal to your site, but they may also get in the way of the site's purpose and the user's ability to get things done. Be careful about putting flashy elements on the page just because they're available. These elements are usually quite large and should only be used to enhance the site's content, not to distract from it.

5. Design for Growth

In many ways a web site is never finished. The medium is tailor-made for evolution of content, and it is inevitable that new information will have to be plugged in regularly. Don't think of each page as a new composition. Instead, create a format that can carry across entire sections of the site. Use a grid to help define the arrangement of pages. Adding a page becomes simply a matter of applying an existing design. Also assume that the number and names of site sections will evolve. Design navigation panels so they may be easily changed to reflect new site architectures.

6. Use several computers

The single biggest mistake that first-time web designers make is to develop web sites on a single machine, using only one browser to test the results. Web pages come up in alarmingly different ways from machine to machine and from browser to browser, so it is essential to check your work on a number of machines throughout the development process.

7. Don't expect to do everything

In the early days of the web it was possible, with a little effort, to master all aspects of web technology. Those days are long gone. Designing a web site involves significant skill in graphic design, software applications, HTML, object-oriented programming, writing, editing, systems management and maintenance. The only sane way to work in this exploding medium is to team up and delegate. You'll also learn a lot more about the web by working with experts in other areas than by studying alone by yourself.

8. Design your pages to degrade

Many users either knowingly or unknowingly visit the web using older browsers. A number of other users choose to view web pages mostly in a text-only mode. It is good web design practice to build your site so that it will not be dysfunctional for those arriving without the goods to see your site in full bloom. Provide alternative views of content whenever possible. With a little programming it's possible to detect what browser a visitor is using, and whether certain plug-ins are available. Many HTML tags, such as those that create frames, offer a way to provide for unempowered users. How far you go in taking care of users with limited capacity to view your site depends on many factors, but to ignore this issue is always a mistake.

9. Take advantage of the disk cache

A well-designed site will have many pages that share common elements. Navigation panels, graphic elements and text elements may appear on virtually every page of the site. This repetition not only helps to structure site content, but also pays a huge dividend in site performance. Since a graphic element is stored locally in the user's disk cache the first time it is downloaded, it can be used over and over with no time wasted waiting for it to come across the net. Design elements so that

they can be reused, and be careful of changing things for the sake of it. Too much variety almost always means more wasted time for the user.

10. Don't overwhelm users with choice

In a hypertext environment like the web, where any word or image can be a link to a new location, it's tempting to allow users to jump immediately to any place in the site from a number of different locations. However, users are not usually looking to jump incessantly from one context to another and it is often the case that the destination of a link is not clear until it is followed. Sites that provide dozens of navigational choices per page tend to lead users in endless circles. It's better to give users a good understanding of the site's informational structure by providing links only to major site sections.

11. Provide a search function

If your site is of any significant size, consider adding a search engine early on. Most users come to a site with a particular goal in mind. Help them jump right to the information they need by key word search. This does not contradict the previous point. Information should be found as painlessly as possible. Combining a search engine with a clear hierarchical navigational structure is the best way to make this happen.

12. Understand what can't be done

Despite all attempts to make it seem so, a web page is not a printed page. Many failed web site designs have come as a result of designers trying to mimic the appearance and seemlessness of a printed piece. Usually attempts to coerce the medium into the appearance of print results in extremely slow downloading and pages which are hard to update. Designing for the web always involves a balancing act between performance and visual quality.

Site Architecture

Whether a site is a pleasure or a frustration to explore depends largely on its structure, on the clarity of its information hier-archies and the relevance and versatility of its hyperlinks. To travel successfully through a site, users must know where they are, have confidence where they are going, and be assured they can easily get back to where they have been. These issues depend on the successful organization of information, and on making that organization clear through the design of navigational controls.

& Navigation

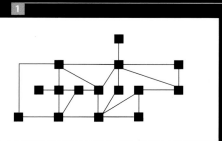

At its rawest a web site is simply a collection of pages connected by an arbitrary number of hyperlinks. Such an unstructured connected architecture is referred to as a *network*, or a *web*. Networks typically contain many cycles—pathways that allow a node (a page) to be visited repeatedly from many different directions.

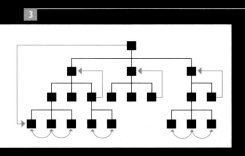

A tree structure organizes information into strict hierarchies. Each node contains a distinct set of descendants and only one parent. Striking connections between nodes in different branches violates these rules and, essentially, reverts the tree back to a network.

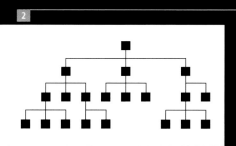

The most common site structure combines the informational hierarchy of a tree with the flexibility of a network. It allows a limited set of hyperlinks across and back through the structure. Technically a network, the success of the structure depends on limiting the additional links, and on presenting them to users in the context of the hierarchical structure.

Web or Tree?

Web sites consist of a number of pages connected by multiple hyperlinks (fig. 1). The number, direction and organization of these links determine a site's *information architecture*. Designing a site's architecture requires a careful balancing of ease of access with the need to establish information categories and subcategories for the user's benefit.

For most design situations, structuring begins with isolating the distinct categories of information to be included in the site. These categories should anticipate the kinds of access that the site's audience is expecting. They will be broken down repeatedly into successive hierarchical levels until a form of tree is established (fig. 2). Trees offer three main benefits. First, they can be extended easily. Adding a new area to a site requires only minor modifications of the highest level pages (adding an additional graphic link, for example). Second, a tree is a familiar concept to most site users—far more so than a loosely structured network—and so provides a good mental model for users of a site's layout. Finally, a tree imposes an order on navigation. To get a page down in the site hierarchy, users must pass through various intermediate levels. These intermediate pages provide a context for those that follow and also become familiar landmarks on the return trip.

While trees provide an ideal model for structuring information, they are usually far too rigid to be the sole support for site navigation. Most sites will use a structure which also contains an array of cross and back links (fig. 3). In a successful design, these links will be limited in number, lead only to key navigational pages and carefully avoid confusing the site hierarchy.

Site Maps

When users first arrive at a site they will have no clue as to its size, content or organization. Users need to have some feel for the lay of the land, to know up front what regions of the site exist and how they relate to each other. An obvious approach is to provide a map.

Site maps are particularly helpful in large sites with many topics and subtopics. A map can immediately convey the size of the site, show the subcategories under a major section header, and provide a useful way for users to jump down a large site hierarchy without losing a sense of place.

A site map can take many forms—a typographic list (fig. 4), a schematic (fig. 5), a combination of the two (fig. 6), or even an animated sequence (fig. 7).

4

The site map as an index. This site map from Adobe Systems uses a purely typographic approach to represent the site structure. The site's large number of sub-sections is presented on a single page permitting users to jump at will across the site. By using text links, it also shows the user which parts of the site have been previously visited.

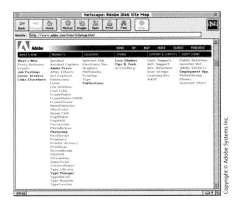

5

This site map from the Audi Germany site arrives in a floating window that can be placed off to the side of the browser for continual reference. The site's content is shown in relation to the color-coded subdivisions of the site hierarchy.

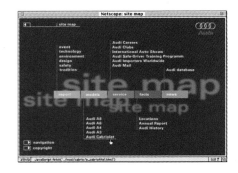

6

The site map from the Discovery Channel uses a combination of thumbnail images (reduced screen captures) and text to orient the user. It allows users to recognize parts of the site they have accessed before and select an area from a purely visual perspective. However, a significant amount of scrolling is required to see the whole map.

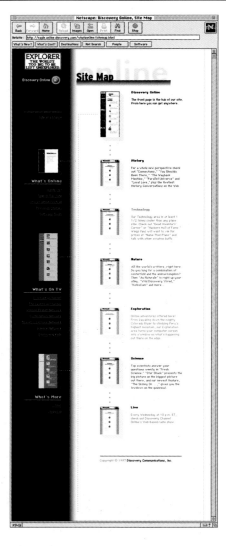

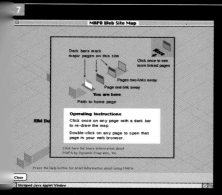

The IBM site map uses Dynamic Diagram's MAPA™ technology to lead users through a dynamically generated representation of the entire site hierarchy. It presents the user with a four-level encoding of the site tree(explained in fig. 7a) indicating pages that are available near the currently selected page (shown in white, fig 7b). The map, appearing in a separate window, is implemented as a Java applet and uses animation to reveal the site incrementally. Rollovers provide the URL of the page icons, and a click on any page expands the tree to show the site structure in that area. Figures 7c-7f show some stages of the animated reconfiguration of the tree after the user has selected a different page within the map.

a)

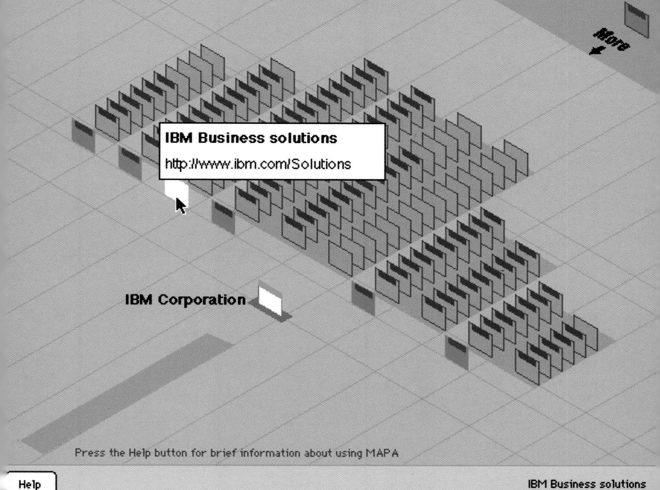

b)

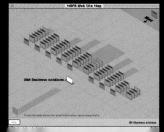
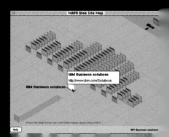

8

While the technology of a search engine often dictates the basic elements that are presented to a user, it is important that the results support the user's need to effectively choose among an often imposing number of hits. Careful writing of document descriptions and an ability to easily drill down on initial results can hav[e] a tremendous effect on user satisfaction.

Searching a Site

Many users arrive at a site with a particular topic or subject area in mind. For these users a search engine is often the best way to get directly to the required information. Search engines are not simple to construct, and many sites use third-party packages to provide this capability. Most of these provide the ability to generate hotlinked document titles, summaries and some indication of relevance for each "hit" (usually indicated as a percentage).

Search results are an important channel of communication with the user and need to be designed to speak in the user's terms. As an example, compare the screens in figure 8. Adobe lists clearly differentiated document titles. No entry is repeated, and documents with similar content are evident by their descriptions. A combination of color coding and document symbols divides the list into two visually distinct sets—pages which are above and below a given threshold of relevance.

The Netscape page, on the other hand, presents a list of documents, many with identical titles, that bear no apparent connection to the search topic. The only indication of relevance is the probability reading on the left—a very abstract confirmation indeed.

One of the exciting things about the web is the opportunity it affords for new ways of organizing information and supporting searches. Many novel approaches are being explored by web developers, including searches by affinity (looking at things that people like you enjoy—see www.firefly.com), or by criteria related to visual rather then textual properties (fig. 9).

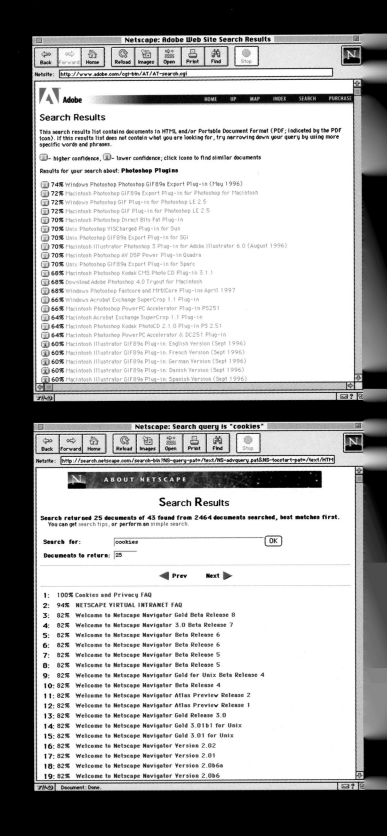

Users of the Digital Stock site can search for images by index number, key word, or visual similarity. To accomplish the latter, users first bring up a set of images by conventional keyword search. After selecting a "find visual matches" icon (the rightmost button below the image), they can then specify the kind and degree of visual similarity that meets their search criteria. Additional keywords can also be added to further narrow the search. By experimenting with different mixes of visual and keyword boundaries, the system can deliver images that evoke the composition and subject matter of the original (bottom), or those that relate in terms of mood and atmosphere (right). Shown with the images are some of the keyword indices the system used to search the image database.

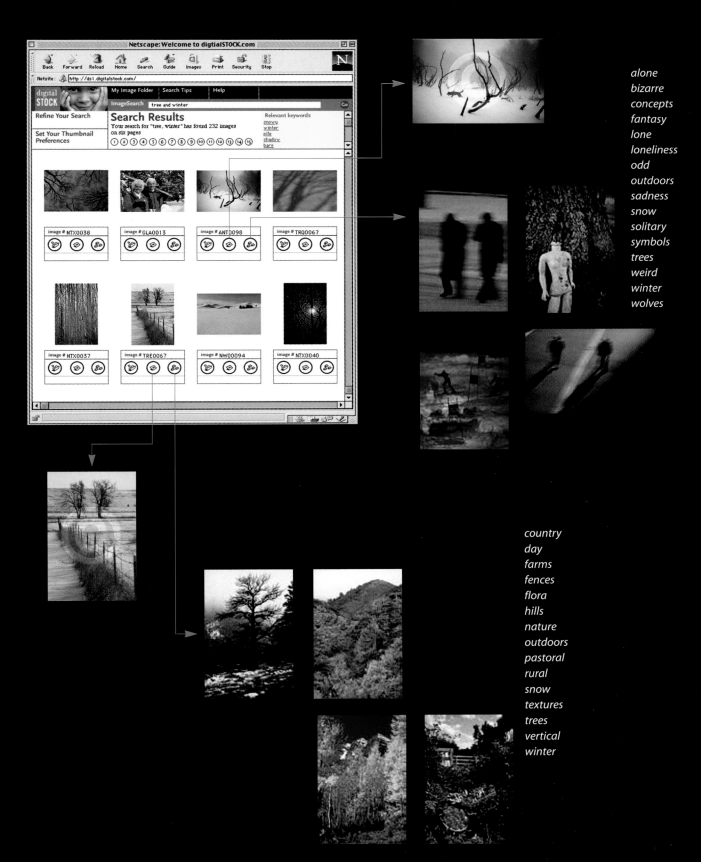

alone
bizarre
concepts
fantasy
lone
loneliness
odd
outdoors
sadness
snow
solitary
symbols
trees
weird
winter
wolves

country
day
farms
fences
flora
hills
nature
outdoors
pastoral
rural
snow
textures
trees
vertical
winter

Navigation Panels

Site maps and search engines are useful supports, but most site visitors will assume, quite rightly, that successful navigation should be possible based on the information provided on each page. It's easiest to see how this works—or doesn't—by looking at examples.

To see some of the pitfalls, look at figure 10. Devoted entirely to navigation, this page contains a dizzying number of clickable regions. With several sets of buttons arranged in different areas and orientation, the user is left to guess what relationship they may have to each other and to the overall structure of the site.

The "Did you know" graphic on the right of the page leads the user to a page of Program Schedules under the On Air section of the site, but this is on a separate branch of the hierarchy (fig. 11). On arriving, the user must navigate in this new context, unaware how it relates to where he has just been, or what paths might eventually lead him back.

Notice also that some of the navigation panels available in the first page disappear when the page is switched, while one remains. While it is useful (as shall be shown in the next example) to have some high-level navigation present on each screen, to have several panels which come and go may ask too much of the casual visitor.

The navigational ambiguity felt by users of this site was one of the main reasons for its redesign (discussed in detail later in this book).

10

This page gives the impression of a site full of interesting things, with lots of special features, but all this is counterbalanced by the feeling one has of never really mastering its content. The design makes it hard to be sure what areas may have been missed or visited before. The tight design of content, icons and labels also results in such brevity of information that the only way to determine the full meaning of a link is to follow it and see where it leads.

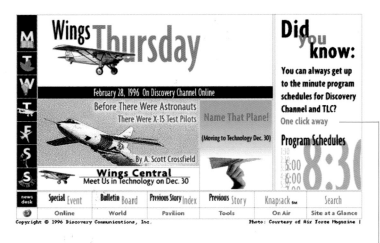

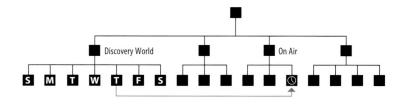

11

This diagram shows how the user would leap from the Wings Thursday to the Discovery On Air sections in the example above. While it is a great temptation, it is usually inadvisable to strike such direct connections between pages that are not strongly related in informational context. Note how nothing on this new page indicates its connection with the major site subsection On Air.

By laying out the top control panel and the content below in a common 6-column grid, the navigational controls are able to play a dual role in the information design. Notice how the sub-sections of the page serve as both links and as column-headers for the page layout below. This integration of navigation and content reinforces the user's understanding of the site organization.

Navigation as Visible Structure

A more structural approach to the design of navigational control is shown in figure 12. Starting with the identifying banner at the top, each page contains a clickable array of labeled icons which correspond to the major subdivisions of the site. Selecting one of these produces a second tier of controls.

 The user's path through the hierarchy is clearly depicted through a set of mutually reinforcing signals. The section icon is brightly colored to show its selected status. Then drop shadows are added to place the lower set of buttons on a separate surface from the rest of the controls. The users can see where they are, what sections they might visit next and, at the click of a button, what sub-sections lie beneath each area.

 One key to the success of this approach is the limited number of links outside the navigation bars. The content portions of the site generally contain links only to pages within their own context. To get to other parts of the site, users must start near the top, picking a high-level section from the menu bar and working back down. As a rule, users prefer having to navigate a few steps through a predictable structure than to have instantaneous links that, in the end, disorient them.

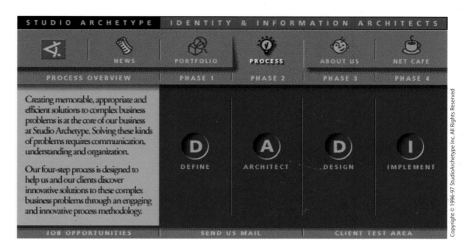

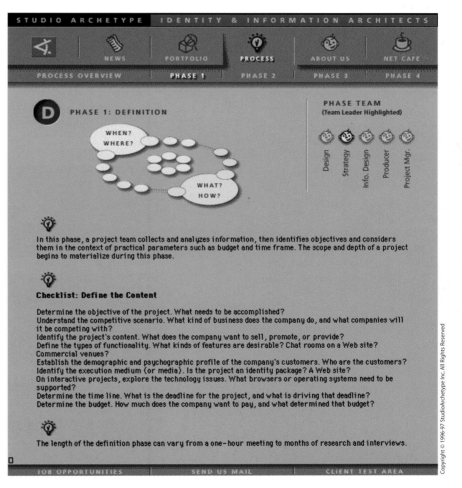

The Opening Page

The opening page can set the tone of the whole publication and introduce users to the site structure and methods of navigation. Like the cover of a book or magazine, it draws the viewer in and builds anticipation for the content to follow. Some sites include a table of contents or a limited index on the front page. Others consist of a single image or short opening animation (fig. 14).

The right choice for a site opening can depend on a number of factors: the nature of the site's information; the frequency with which visitors revisit the site; or the frequency with which the site's information changes.

The Adobe site (fig. 13) is one of the busiest on the web, visited by tens of thousands of people daily and servicing many repeat customers. Containing well over 10,000 pages, the site distributes information on a huge range of topics and is updated almost continuously. Its front page is designed to orient first-time users to the site structure (by immediately introducing the navigation bar) and to alert frequent users to recent additions. In sites as well known and frequently visited as this one, there is no room—nor necessity—for a separate cover page. Users are welcomed instead with a restrained and manageable contents page that allows them to start retrieving their information immediately.

13

The Adobe splash screen entices readers to delve further. Frequent changes keep the site fresh and provide a good reason for the site's regular visitors to check back to see what's new.

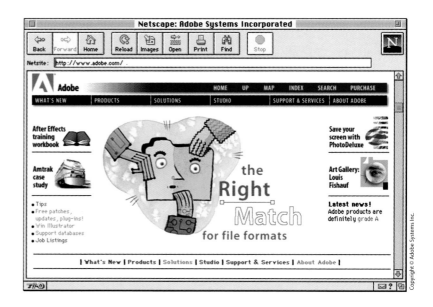

14

This is the opening to the Studio Archetype site. Taking only a few seconds to play out, this animation communicates the firm's clean graphic style with maximum efficiency.

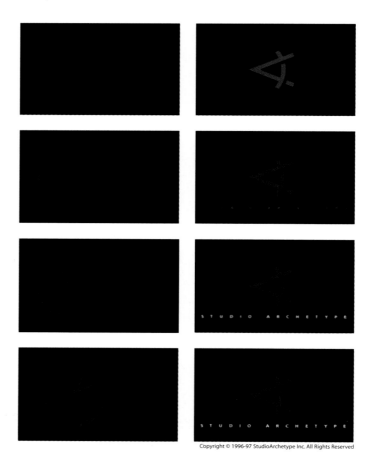

Starting with a rapid montage of colorful portraits, the opening of the HotWired site evokes the youthful exuberance and love of technology associated with Wired magazine, the site's parent publication. The use of strong, highly saturated colors, brings a strong sense of unity to the two publications.

Leveraging Existing Identity

Successful companies invest considerable time and money in developing a coherent and recognizable presence before the public. The system of communicating this presence can be thought of as a form of design language comprising certain forms, colors and image treatments. One of the challenges of web site design is to find appropriate translations of these languages into this visually restrictive medium while at the same time taking advantage of its unique possibilities.

One of the most successful site designs to address this issue is found at www. hotwired.com (fig. 15). Wired magazine has been a leader in addressing the transformation of the popular and technical culture as it enters the digital age, and its design is one of the most recognizable in the publishing industry. The site moves the visual language of its sister publication onto the web with considerable skill. The site's opening page, a series of flashing, digital portraits of the HotWired staff, communicates the youthful optimism of the corporation with a dynamism immediately recognizable as part of the Wired style.

Introducing Services

Another class of web site focuses on introducing a firm's range of professional services and business approach. Like the previous example, the focus of these sites is on establishing new clients, not providing a random-access information service. For this reason, the opening page can have a narrative structure, serving as the opening of a business pitch (fig. 16). It's presumed that visitors are generally first-time users looking for an overview of the firm, its history and structure, and most importantly its professional track record.

For this kind of opening to work screens must load very quickly and the message needs to be brief, engaging and to the point. Repeat visitors must be able to pass them over or skip the entire sequence.

The Fitch site begins with a single evocative graphic. As users move into the site, this sparseness is maintained. The result is a calm and controlled experience for the user.

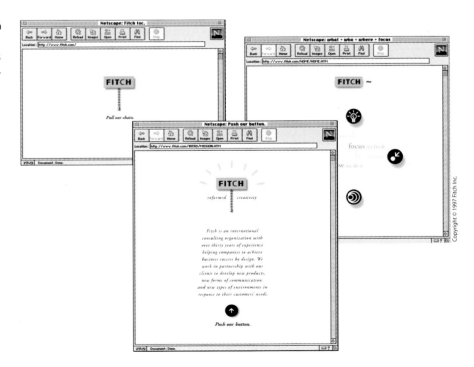

The CNet site draws upon the layout of a daily newspaper, carefully placing the most important content at the top. The upper zone's dimensions are determined by what will comfortably fit on small 640 x 480 pixel monitors. All crucial information resides here, including the CNet logo, publication date, the site's highest rent advertising space and the day's feature article. The yellow content area on the left and a sidebar of feature articles on the right are introduced here as well, inducing visitors to scroll down to locate pertinent content. This design is a thoughtful response to the problem of varying monitor sizes and screen resolutions. The top zone accommodates the most limited display, yet expands gracefully to virtually any vertical dimension.

Providing the Latest Information

What if the role of the site is to deliver frequently updated information? CNet is a computer technology daily that is a regular stop on the net for many of its users (fig. 17). The site thrives on the topicality of its content, which is updated several times a day. Visitors to this site are looking for the latest news, which CNet delivers on a wide range of topics.

The design of CNet's front page is reminiscent of a daily newspaper, with masthead, sidebars, a table of contents divided by section and an array of featured headlines. It is designed for rapid scanning (albeit requiring a fair amount of scrolling) and access to a regular set of site sections (listed on the left sidebar).

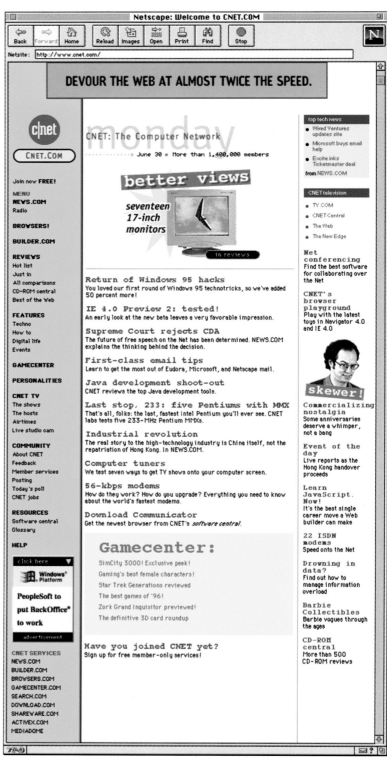

18

When pages contain a compLete text, as in this article from the MSNBC site, it is beneficial to the reader to move links out of the main body. By placing these interactive elements off to the side, their supplementary nature is clearly communicated.

Cross Referencing

There are two basic approaches to cross referencing. One is to separate off all references to other articles or sites and the other is to embed them in the text.

Figure 18 shows one approach, separating all links and supplementary interactivity to the left margin. A yellow box holds links to related pages within the site. An interactive poll questions the readers on their views of a controversial issue raised by the main text. Chat rooms, bulletin boards and external site links are also provided. By keeping links outside the article, readers are encouraged to stay with the text and pursue connected information separately.

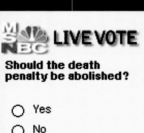

Screen shots of MSNBC used by permission from MSNBC

■ Rare glimpse of
a grim underworld

■ Texas: A precedent
for executions?

■ Photo documentary:
'Texas Death Row'

LIVE VOTE

**Should the death
penalty be abolished?**

○ Yes

○ No

○ Undecided

VOTE

Chat Rooms

■ Chat with photojournalist Ken
Light about 'Texas Death Row'

Bulletin Boards

■ Bulletin Board: What's your
take on death row and
rehabilitation?

Internet Sites

MSNBC not responsible for content

■ Ken Light's 'Texas
Death Row' page

■ Links toward abolition

■ Death penalty
information center

■ Demographics
of the death penalty

19

This cover page to a lead story from ZDNet is an explosion of navigational possibilities. With unvisited and visited links displayed in red and blue respectively, the text is a patchwork of typographic clusters. While the readability of the page suffers, its primary function as a high-level access mechanism to a large collection of related articles is well supported. To add another dimension to the reporting, links are also provided to a number of audio clips.

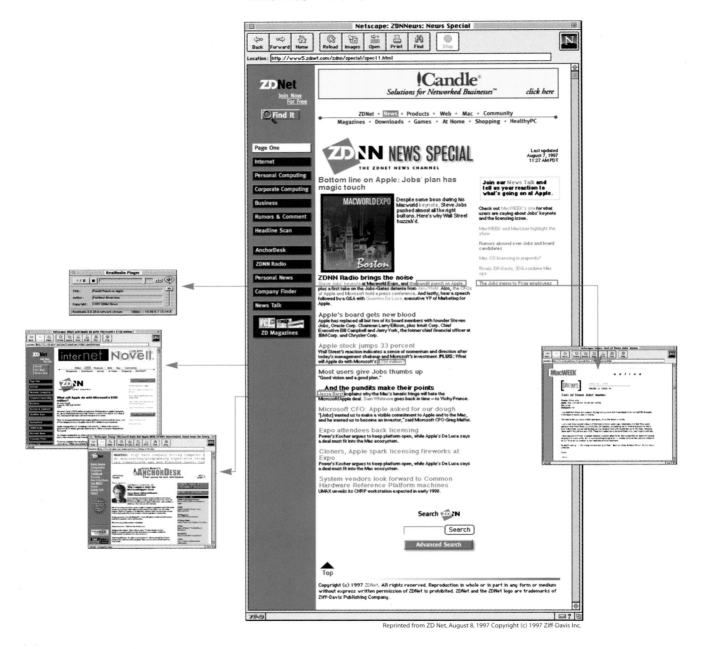

Figure 19 shows how links can be embedded in the text. Readers may scan just one or two lines from the middle of the page and decide to follow a link to another document. Later, they might choose to return and complete the original text, or return and quickly branch off again. While this approach encourages readers to shift contexts frequently and only rarely read articles to completion, it also allows for sifting quickly through a large sample of viewpoints on a breaking story.

The story's opening page is essentially a clickable text map to the expanded reportage available elsewhere in the site. From a number of capsule summaries describing the main aspects of the story, the reader can select from several links to articles provided by this large family of computer-oriented magazines. The high saturation of links is not repeated in these specific articles, so the potential for users getting lost is minimized. As a result, the story's cover page serves as a navigational hub via which the reader can locate those parts of the story of particular interest.

One drawback of the embedded link approach is that due to the use of color to indicate links, the page takes on a mottled appearance. Attempts at 'normal' reading of the page are hampered by the continually shifting typographic treatment and the appearance of unintended color patterns within the text.

To most web users color is a strong indicator of hyper-linked text. In this page from the Virgin Records site however, color serves double duty—as a navigational signal and to differentiate levels of the text. The problem for the user is knowing which of these signals is in force. As shown by the arrows, colored labels within the body of the page are actually targets for the links in the button mosaic at the top of the page. The colored text elements at the top and bottom of the page however serve as links to other main sections of the site.

Color Coding Links

Color is one of the most common and effective signals for denoting clickable text links. In the early days of the web, the color of text links was determined exclusively by a browser setting (typically blue) and was out of the web page designer's control. This constraint is no longer with us, but the notion that colored text implies a hyperlink is deeply ingrained in most users.

While some people still advocate a standard, unchanging color for text links—Jakob Nielsen of Sun Microsystems for example lists using any color other than blue for links as one of his well-circulated Top Ten Mistakes in Web Design—applying color to text is one of the few typographic variables graphic designers have to breath life into a page. However, whether a link is rendered in blue or red is less important than ensuring it stands out from the remaining text.

Color as a Compound Signal

On the right are two examples where color serves a dual role, leading to some confusion for the user. In figure 20 color is used to distinguish the main text from the remaining typographic elements. In use, however, visitors discover that only a select number of the colored labels function as links—the others are subheadings.

HotWired prides itself on utilizing the latest web technologies. The page shown in figure 21 is intended to show some of the new capabilities for positioning and rendering independent text boxes now possible with dynamic HTML and cascading style sheets. The hyperkinetic nature of the design (another Wired trademark), however, makes finding the page's links a bit of a challenge. Due to the effects of simultaneous contrast, the red and blue text in the text blocks seem more like four or five colors. Ironically, the use of blue for links as advocated by Nielsen does little here to resolve the ambiguity as to which text is to be clicked.

In this page from the HotWired site users are confronted with such an explosion of color that they must use trial and error to determine which color signifies a link. Most of the page's links are set in a consistent blue color, but competition from the many other colored elements on the page render them indistinct.

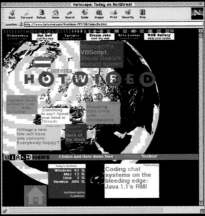

Page Structure

That the web would become a world-wide commercial communica-

tion medium, integrating the worlds of desktop publishing, e-mail,

digital video and interactive database technologies could not have

been predicted by its founders. Originally conceived as a means

for scientists and researchers to share technical information, the web

and its page description language, HTML, were designed to move

content in a readable form rather than to support the delivery of

elaborate page designs. Good web page design still happens largely

in spite of the medium, and like the early days of desktop publishing,

the promise of the medium far surpasses its actual performance.

Things, however, are improving quickly.

& Typography

When HTML first appeared it was assumed that the border of the web page was the browser window itself. The final appearance of the page could change dramatically as a window was resized.

HTML tables provide page structure by defining fixed areas of the window into which text and graphics can be placed. The dimensions of a table can be made stable and therefore unaffected by the window resizing. Tables remain the dominant tool for controlling a page's positive and negative space.

HTML Frames allow a browser window to be divided into independently behaving regions. One frame, for example, can be set to scroll while another remains fixed. Frames also allow hyperlinks to modify only one part of the page. Frames are the favorite tool for separating navigational control panels from page content.

Cascading Style Sheets and the proprietary Netscape Layer tag allow page elements to be placed into separate overlays. These overlays can be manipulated in response to certain user actions, and make possible the inclusion of many familiar interface components, such as pull-down and pop-up menus.

From one point of view the possibilities for designing web pages have come a very long way since the introduction of the first Mosaic browser in 1993. Any comparison of a web page from those early days with the professional-level graphic design exhibited in many sites today would make the point with ease. Despite these gains however, we are still witnessing the infancy of the web medium. As the case studies in this book make clear, achieving graphic quality and consistency on the web requires a frustrat-ingly complex manipulation of HTML. The tools available for laying out pages in HTML are improving, yet translating a design concept into reality is a time-inten-sive and often difficult process. While we wait for a truly versatile interactive web-page authoring program to appear, it remains necessary to grapple with the details of direct HTML formatting.

The HTML language contains dozens of formatting tags, however many of these are used rarely by professional designers. Most, if not all, sites shown in this book, are built in a very similar fashion, relying on a small number of versatile for-matting tags to control page composition. In this section, these formats and the tech-niques used to make them work to a designer's advantage are discussed.

Starting with an overview of basic HTML formats (fig. 1), the three primary tools of web page design are reviewed: the table (fig. 2), the frame (fig. 3), and cascad-ing style sheets (fig. 4).

Raw HTML Formatting

The fundamental starting point of a web page is the browser window itself. HTML-formatted content arrives in a linear stream, and each web page is essentially poured into the browser window line-by-line and from top-to-bottom. It is this streaming quality of web page transmission that most strongly flavors the design of the HTML language.

HTML is a form of mark-up language, an approach to describing page layout by embedding formatting codes directly within the page content. Each formatting code in HTML is essentially a mode which begins, affects the appearance of a certain amount of content, and then ends. A very simple example is the bold tag, **this text is bold**.

As information arrives at the browser, it is placed sequentially across and down the page, element-by-element, until either the page border, or an explicit line-break code is met. As a result, the layout of a web page, as described in HTML, must be articulated in strict sequence.

Some simple examples of the linear nature of HTML and how it responds to the shape of the browser window are shown on the right. Figure 5 shows a simple composition of images and text. The page starts with two line breaks to create a top margin. The images come next, on what is essentially the third line of the page. A paragraph follows below with line breaks triggered automatically by the window border. When the page is expanded, the text stretches out to the new window/page size (fig. 6). When it is reduced, both the text and the images are subjected to line-breaks and the page falls apart (fig. 7).

5

With the browser set to a relatively "normal" width, the relationship of the number images and the text are seen as intended.

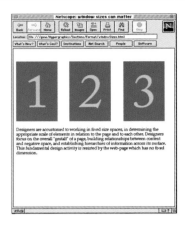

6

When the window is expanded, the paragraph stretches out to fill the available space. The resulting lines are much too long for comfortable reading, and the spaces of the page become awkward. With the unpredictability of page proportions, and basic HTML's tendency to fill out all available space, typographic fine points like adjusting the rag become moot.

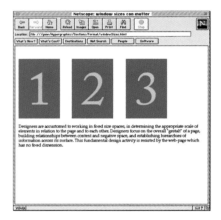

7

Things get worse when the browser window is reduced. The images, occupying the same lines of the page as the text, are subjected to a line break just like the text below. The structure of the page is now completely lost.

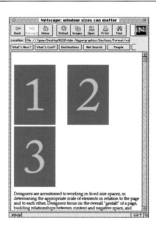

Alignment

HTML supports a number of alignment tags allowing a certain amount of structure to be applied to text. Alignment controls associated with paragraphs, for example, allow text to be set flush left or flush right within the window frame (fig. 8). Other alignment controls associated with images result in text wrap-around. While text wrapping provides some interesting options for manipulating page margins, the problem of overall paragraph shape remains. A common use of alignment to an image is in the creation of drop caps to start a paragraph (as in figure 9).

Structured Layout Tags

Beyond these basics of pouring text, HTML includes a number of "canned" formats derived mostly from the typographic conventions of academic journals. These include the block quote, the numbered list and the bulleted list (fig. 9). Designed to provide simple automatic formatting, these settings apply standard margins and indents which, until very recently, could not be changed by the designer. (The new technology of cascading style sheets, described later does allow for their modification.)

While standardized formats make certain formatting tasks very simple, they are often overstructured from the professional designer's perspective. For this reason they are rarely used outside of the most elemental text settings.

8

Text can be set to run around images on either side by the use of an alignment setting in the image tag. Just where the wrap around will begin and end is dependent on both the window dimensions and the user's choice of typeface. In this example the first paragraph is set to the default of align = left. The second to align = right.

9

HTML offers many pre-defined formats. Shown here are the ordered list, the block quote and the unordered list. Like templates that come with a page layout program, these formats can bring instant order to a page. The result, however, is almost always mundane.

Structuring with Tables

If one element can be said to have revolutionized the design of web pages, it would have to be the table. First introduced in 1995, tables provided a way to break the browser window into a number of fixed-size blocks which remain unaffected by the shape of the browser window (fig.10). With tables, designers found themselves on more familiar ground. Finally, some semblance of a grid could be created to allow determined designers to exhibit a degree of graphic sophistication on the web that was unthinkable before.

HTML tables were never intended to act as general-purpose layout tools. They were, true to their name, designed to display simple tabular data, such as statistics, and financial figures. Most, if not all, of the table's properties are based on supporting this type of use. Two properties of tables led to their transformation into page layout tools. First, the cells of the table could be stretched out to any size—tables could therefore occupy an entire page. Second, the borders of a table could be made invisible, making them behave, in some ways, like a traditional layout grid.

Properties of Tables

Tables consist of rows and columns separated by borders. The dimensions of a table are normally derived from the size of its elements (fig. 11). However, more control over the size and shape of a table can be attained by specifying a fixed size for the whole table (fig. 12), or by fixing the size of individual cells (fig. 13).

10

For many the Discovery Channel site marked the beginning of table-based web design. One of the first large-scale sites to use the technique, its pages presented a treasure trove of examples of how to organize the space of a web page.

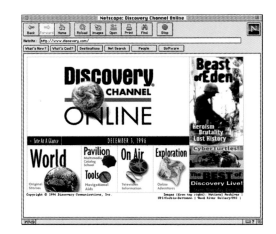

11

At its most basic, the size and shape of a table depends on its elements. In this example, each column of the table stretches out to encompass the longest word. The overall table width is determined by the combined widths of its three longest words: "mangoes," "pomegranates" and "pears".

mangoes	peaches	pears
apples	pomegranates	figs

```
<table border=1>
<tr>
   <td>mangoes</td>
   <td>peaches</td>
   <td>pears</td>
</tr>
<tr>
   <td>apples</td>
   <td>pomegranates</td>
   <td>figs</td>
</tr>
</table>
```

12

When an overall pixel width is given for the table, in this case 200, the cells stretch out to meet that length. The relative proportions of the columns are a function of the word lengths.

mangoes	peaches	pears
apples	pomegranates	figs

```
<table border=1 width=200>
<tr>
   <td>mangoes</td>
   <td>peaches</td>
   <td>pears</td>
</tr>
<tr>
   <td>apples</td>
   <td>pomegranates</td>
   <td>figs</td>
</tr>
</table>
```

13

Table widths can also depend on the widths of individual cells. In this case, the content of the cell has no direct affect on cell size. This property is most useful in using tables for layout. Note in the example that when a column width is specified in the first row, it need not be repeated below.

mangoes	peaches	pears
apples	pomegranates	figs

```
<table border=1>
<tr>
   <td width=80>mangoes</td>
   <td width=80>peaches</td>
   <td width=80>pears</td>
</tr>
<tr>
   <td>apples</td>
   <td>pomegranates</td>
   <td>figs</td>
</tr>
</table>
```

Aligning Data Within a Table

As the size of a table grows, alignment of the content within the table cells starts to become an issue. Elements can be aligned vertically to the top, middle or bottom, and horizontally to left, center or right. Alignments settings occur in the table data tag (<td>). Figure 14 shows a simple example.

Cellspacing and Cellpadding

When an element is placed within a table cell, it is useful to be able to control the space between it and the cell border, and to be able to adjust the size of the border itself. The *cellpadding* and *cellspacing* properties provide this control. *Cellpadding* amounts to a kind of in-cell margin, adding space at the border of the cell (fig. 15). Unfortunately, this space is applied to all sides of the cell. Rather than adding a little horizontal space, moving table content a little away from the border, it pushes the table out in all directions.

The *cellspacing* property controls the distance between tables cells by affecting the thickness of the inter-cell borders (fig. 16). Like *cellpadding*, *cellspacing* affects the overall size of the table and the spacing of its elements in both the horizontal and vertical dimensions.

Empty Table Cells

Table cells may also be left empty, creating separation between particular table elements. By giving empty cells explicit dimensions, they function as spacers between other table elements. With the table borders set to zero (which makes them invisible), the empty space of the cell becomes a definable negative space (fig. 17). Empty table cells are a staple of web page composition—they will be encountered frequently in many of the case studies at the back of the book—and are the preferred way to establish page margins and gutters between columns of text, and to add space between images.

14

Elements within a table cell can be aligned vertically to either the top, bottom or center by setting the *valign* property of in the table data tag. Horizontal alignment is set with the *align* property, and places the element to the left, right, or center of the cell.

mangoes	peaches	pears
apples	pomegranates	figs

```
<table border=1>
<tr>
   <td width=80 height=40 align=center
   valign=top>mangoes</td>
   <td width=80 height=40 align=center
   valign=top>peaches</td>
   <td width=80 height=40 align=center
   valign=top>pears</td>
</tr>
<tr>
   <td width=80 height=40 align=center
   valign=top>apples</td>
   <td width=80 height=40 align=center
   valign=top>pomegranates</td>
   <td width=80 height=40 align=center
   valign=top>figs</td>
</tr>
</table>
```

15

Cellpadding sets the space between an element and the table border. Adding cellpadding increases the overall size of the cell, while setting it to zero pushes the table element to the extreme edge of the cell. The default setting for cellpadding is 1.

mangoes	peaches	pears
apples	pomegranates	figs

```
<table border=1 cellpadding = 4>
```

16

Cellspacing controls the width of the table border. As the border increases in size its beveled edges become more pronounced. A cellspacing of zero removes the border entirely. If table borders are to be exposed, cellspacing should be kept to a minimum to avoid competing with the table content.

mangoes	peaches	pears
apples	pomegranates	figs

```
<table border=1 cellspacing = 4>
```

17

Empty table cells can be used to block out space. Here, the same table shown in figure 13 is modified by removing the content of the middle two cells. Setting the table border to zero removes the table borders, and only the ample white space is left.

mangoes		pears
apples		figs

```
<table border=0>
<tr>
   <td width=80>mangoes</td>
   <td width=80></td>
   <td width=80>pears</td>
</tr>
<tr>
   <td>apples</td>
   <td></td>
   <td>figs</td>
</tr>
</table>
```

Using Tables as Layout Grids

In traditional graphic design, grids are an invaluable tool for giving structure to a page and for providing continuity to a publication (fig. 18). HTML tables are as close as the web gets to the layout grid, but their use is not nearly so flexible. Tables, unlike layout grids, literally hold their content. Where an illustration can freely cross any number of grid cells in the traditional situation, a large graphic placed in an HTML table will literally push the cell borders out until they are large enough to hold it. As a result, the neighboring table cells will get pushed and resized as well (fig. 19). For this reason the design of HTML tables used for layout tends to be quite ad-hoc, with grid cells fashioned explicitly to accommodate page content.

Defining Irregular Tables

The tendency of tables to grow and shrink in relationship to the size of their content makes them difficult to define. Only by knowing in advance the size and arrangement of the elements that will go into a table can its overall shape be determined. For this reason, the table can be seen to be almost the exact opposite of a traditional grid. Where a grid is defined in advance of the sizing and positioning of content, the table can only be defined after the dimensions of the page are finalized. Where a grid is regular and modular, most tables are irregular and idiosyncratic in form.

Defining regular tables like those shown in figures 11-17 is not too difficult. Arriving at a table like the one in figure 19 is another matter. When tables do not contain an even number of rows and columns they must be tailor made by using two peculiar table cell properties—rowspans and colspans.

18

A layout grid in traditional design work serves as a visual guide for the placement of page elements. Text can flow into several columns, while other elements, (such as the blue bar at the top of the page below) can cross any number of grid lines. Often a certain element will be deliberately offset from the grid to provide visual tension.

19

Tables are the web's answer to the layout grid. Their form, however, is rarely regular. This example, taken from the Discovery Channel page, shown with its elements loaded in figure 10, is typical. The size and shape of the table cells are derived directly from the page elements they hold.

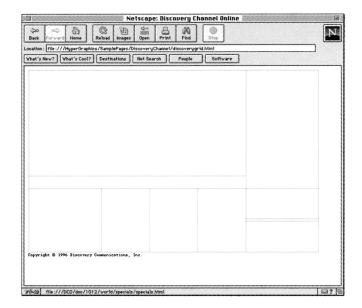

Colspans and Rowspans

The first task in understanding the structure of a table is to count its rows and columns. The first table (fig. 20) has two rows and three columns. The first row consists of the orange *1* and the blue *m*. However, the *1* occupies the second row as well. When this happens it must be given a *rowspan* setting equal to the number of elements it *spans* vertically—in this case, 2.

With the orange *1* already accounted for in the previous row, row two begins with the purple *o* and ends with the orange *x*. Because the blue *m* in row one spans both of these elements horizontally, it is given a *colspan* setting of 2.

In figure 21 four gray cells have been added in a column on the right side. The table now has four rows and four columns. The first row is the *1*, the *m* and the top gray rectangle on the right. Row two, surprisingly, consists of just one element—the second gray rectangle. This is because, on this level, all other elements are spanning down from row one. Row three is the *o*, the *x* and the third gray rectangle, while the fourth and final row is again a single gray rectangle.

The addition of the four shapes requires a number of adjustments to the *rowspan* settings of the table elements. The *1* now spans four rows, and the three middle elements each span two.

Because the structure of an irregular table depends so crucially on the elements it contains and their spanning relationships, it is almost always necessary to have a complete sketch of its layout in hand before any coding begins. Further, for a tightly integrated table like the one shown here, all elements must be sized in advance if they are to meet up in perfect alignment.

20

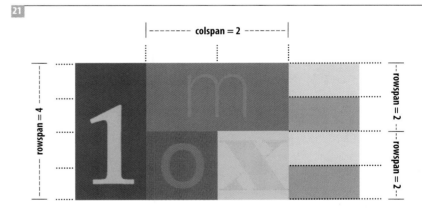

```
<table border=0 cellpadding=0 cellspacing=0>
<!--ROW 1-->
<tr>
    <td rowspan=2 width=50 height=100>
    <img src="1.gif"></td>
    <td colspan=2 width=100 height=50>
    <img src="m.gif"></td>
</tr>
<!--ROW 2-->
<tr>
    <td width=50 height=50><img src="o.gif"></td>
    <td width=50 height=50><img src="x.gif"></td>
</tr>
</table>
```

21

```
<table border=0 cellpadding=0 cellspacing=0>
<!--ROW 1-->
<tr>
    <td rowspan=4><img src="1.gif"></td>
    <td rowspan=2 colspan=2>
    <img src="m.gif"></td>
    <td><img src="gray.gif"></td>
</tr>
<!--ROW 2-->
<tr>
    <td><img src="grayer.gif"></td>
</tr>
<!--ROW 3-->
<tr>
    <td rowspan=2><img src="o.gif"></td>
    <td rowspan=2><img src="x.gif"></td>
    <td><img src="gray.gif"></td>
</tr>
<!--ROW 4-->
<tr>
    <td><img src="grayer.gif"></td>
</tr>
</table>
```

Tables in Use

To get a sense how tables are used to format a complex set of elements, consider this example from the Carnegie Hall web site (fig. 22). The search form elements—the buttons, pop-up menus and text fields—and an explanatory text are placed on the page with the use of an invisible table (shown on the right for comparison). The table exhibits both regularity and a somewhat haphazard organization. This is typical. The table creates regions of precise size and alignment, while being less exact in areas where it has no effect on the page.

The table begins with a large empty table cell in the upper left corner. This cell carves out a distinct negative space, establishing the margin for the white text. Note how this margin becomes a key alignment axis for many of the cells that come below.

Starting in the next row, a small cell is created for the first radio button, followed by a long cell to hold its label. The next three rows begin with an empty table cell creating an indent, and are then subdi-

vided into 3 additional cells to hold a button, a label, and the pop-up menus. Each search section is separated vertically by a long table cell that spans all rows. Finally, the Search and Reset buttons are placed in a lower-right alignment within another table-wide cell at the bottom.

This level of complexity is daunting, but it is, unfortunately, about the only way to achieve this degree of precision and stability in web page layout.

22

Tables used for layout are normally invisible to site visitors, but to a trained eye, their presence is unmistakable. Tables are usually built in an ad-hoc basis and require a great deal of pre-planning and measurement to get right. For precise alignment and pixel-accurate control over the definition of negative space, however, they are a very necessary tool.

© CHC 1998

Single-Pixel GIFs

Next to the table, the most indispensable element used by page designers to manipulate space is the single-pixel GIF. This takes advantage of the GIF file's support for transparency (see page 54) and the ability of browsers to resize images after they have come across the net.

The single-pixel GIF (or spacer-GIF) is a 1-pixel by 1-pixel graphic set to be transparent or the same color as the page background. This can be placed anywhere on the page and stretched out to occupy any amount of vertical or horizontal space.

Single-pixel GIFs are used for many purposes as the example in figure 23 shows (the single-pixel GIF is highlighted in yellow).

The page begins with a single-pixel GIF set to a height of 50 pixels and a width of 1 to create a vertical space. Another is stretched into a rectangle to add vertical space and to move the line over for the placement of a caption. A third single-pixel GIF, stretched vertically to 15 pixels, adds space before the bottom paragraph. Finally, a single-pixel GIF is used to lead the last paragraph to a line height of 18 pixels.

23

Single pixel GIF files provide an easy way to push elements across and down the page. When saved as a transparent color, they become invisible. Because images, once downloaded, are saved in a cache on the local hard disk, only one copy of this little file needs to be downloaded. Afterward it can be used as often as needed with no additional cost in download time.

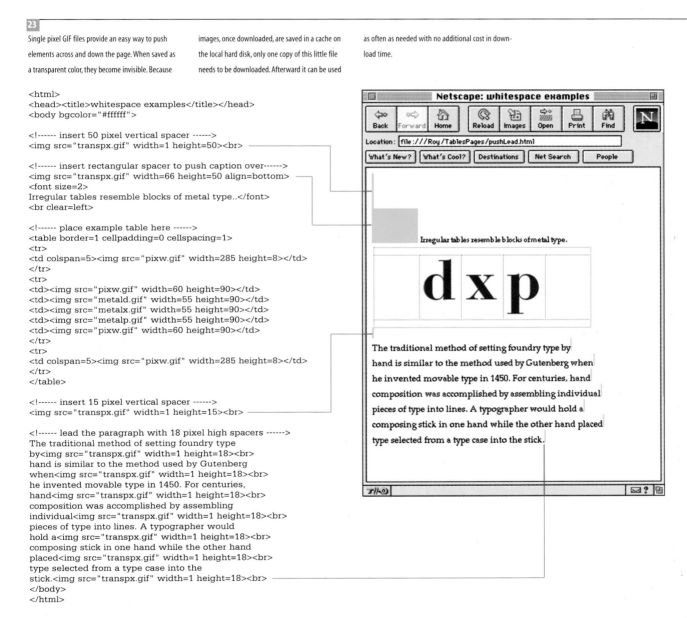

```
<html>
<head><title>whitespace examples</title></head>
<body bgcolor="#ffffff">

<!------ insert 50 pixel vertical spacer ------>
<img src="transpx.gif" width=1 height=50><br>

<!------ insert rectangular spacer to push caption over------>
<img src="transpx.gif" width=66 height=50 align=bottom>
<font size=2>
Irregular tables resemble blocks of metal type..</font>
<br clear=left>

<!------ place example table here ------>
<table border=1 cellpadding=0 cellspacing=1>
<tr>
<td colspan=5><img src="pixw.gif" width=285 height=8></td>
</tr>
<tr>
<td><img src="pixw.gif" width=60 height=90></td>
<td><img src="metald.gif" width=55 height=90></td>
<td><img src="metalx.gif" width=55 height=90></td>
<td><img src="metalp.gif" width=55 height=90></td>
<td><img src="pixw.gif" width=60 height=90></td>
</tr>
<tr>
<td colspan=5><img src="pixw.gif" width=285 height=8></td>
</tr>
</table>

<!------ insert 15 pixel vertical spacer ------>
<img src="transpx.gif" width=1 height=15><br>

<!------ lead the paragraph with 18 pixel high spacers ------>
The traditional method of setting foundry type
by<img src="transpx.gif" width=1 height=18><br>
hand is similar to the method used by Gutenberg
when<img src="transpx.gif" width=1 height=18><br>
he invented movable type in 1450. For centuries,
hand<img src="transpx.gif" width=1 height=18><br>
composition was accomplished by assembling
individual<img src="transpx.gif" width=1 height=18><br>
pieces of type into lines. A typographer would
hold a<img src="transpx.gif" width=1 height=18><br>
composing stick in one hand while the other hand
placed<img src="transpx.gif" width=1 height=18><br>
type selected from a type case into the
stick.<img src="transpx.gif" width=1 height=18><br>
</body>
</html>
```

Partitioning with Frames

An alternative to subdividing a web page with tables is to use frames. A frame acts much like a separate browser window within the page. It can be scrolled independently, and it maintains its own navigational context, allowing hyperlinks to be travelled within it while not affecting the rest of the page. Interactions within one frame can be made to affect other frames, and it is this feature that makes it an attractive addition to web page design.

With frames it is possible to separate a navigation panel from the content it controls (see fig. 27). This separation pays several dividends in usability and performance. First, isolating the controls allows them to remain fixed while the remainder of the window scrolls or moves through a series of links. Second, by remaining in place, the elements used in the navigation panel need only be downloaded once, saving significant time for users with slow connections.

Properties of Frames

Frames divide the browser window into separate rectangular regions. Unlike tables, the borders of frames extend completely across the window and grow and shrink as the browser window is resized. (An exception to this is Internet Explorer's "floating frames", a feature not supported by Netscape, so rarely used.) The dimensions of a frame can be set to a specific number of pixels or a percentage of the browser window or be told to occupy all remaining space (figs. 24-26).

Like tables, frames have several settings that control the appearance of their borders and the placement of elements within. The border of a frame, for example, may be turned off or on (the *frameborder* property)—or set to a certain width and color (the *border* and *bordercolor* properties). The margin of a frame can be set via the *marginwidth* and *marginheight* tags. Other frame properties control the presence of scroll bars and the user's ability to resize the frame in the browser window.

24 Shown here are two frames dividing the screen much in the same way as used by the Audi site shown opposite. The left frame is fixed at 180 pixels, while the right frame is set to occupy the remainder of the screen (i.e. it will grow and shrink as the window is resized). The asterisk symbol is used in a frame definition to indicate a dimension of "all the rest".

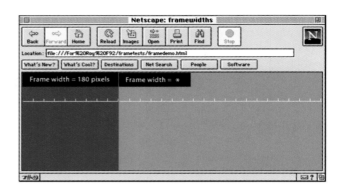

25 When the dimension of a frame is defined as a percentage, it maintains a fixed ratio of the window regardless of size. The white tick marks in these examples are set at 20 pixel intervals. As a comparison with the above example shows, the left frame is now about 200 pixels wide.

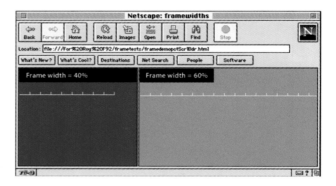

26 Frames can be set to scroll, or to remain fixed in location. If scrolling is desired, the scroll bars can be set to appear regardless of the size of the frame content, or to only show up when the content expands beyond the current window size. In each frame on this page the *marginwidth* and *marginheight* properties are set to 1.

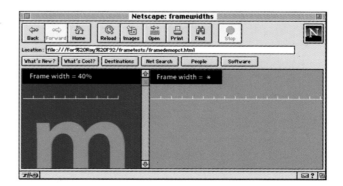

The Audi site (discussed in greater detail later in this book) uses frames to separate high-level navigation controls from the content of the site. The left panel serves as a kind of hyperlinked contents page where the entire structure of the report can be seen while its pages are being visited. The blue arrows show a sequence of interactions with the panel. Selecting a link labeled *Water* (27a) loads an article in the right frame about water conservation (27b). Selecting the link labeled The Confrontation loads an article about the history of the company while also changing the left panel to show more detail about other historical articles. Selecting the white triangle at the top of the left panel returns both frames to their original state (see 27c).

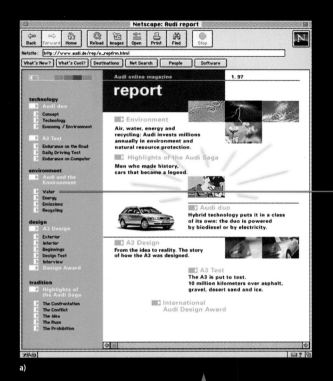

a)

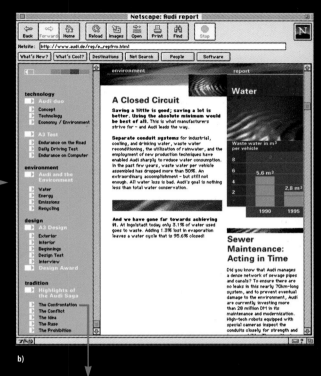

b)

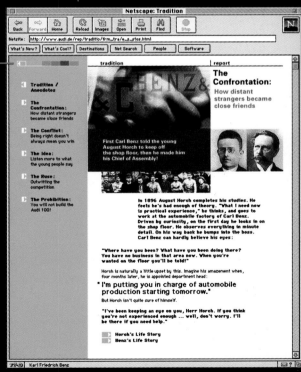

c)

Associating targets with hyperlinks allows linked files to be directed to particular frames or windows. Targets are useful for controlling the results of links selected from side menus (as shown in this example), and for directing the user to particular information without losing navigational context.

Targeting Hyperlinks

The ability to direct content into particular frames is made possible by the use of *targets*. These allow the downloading of URLs to be directed to particular frames or even to new windows. Targets are associated directly with hyperlinks, controlling where in the frame structure the incoming file will be displayed.

There are five different target types. Four, sometimes known as *magic* targets, load the new URL into a location defined in relation to the frame in which the hyperlink is clicked. The fifth directs the new URL to a frame or window that has been assigned a particular name at the time it was created.

Figure 28 demonstrates each of these options. The *left* and *right* areas (fig. 28a) show the division of the browser window into two separate frames. The *new* graphic represents a URL being linked to by each menu item in the left frame.

Selecting the first link type, *target= _blank*, produces the situation in Figure 28b. The *new* file is loaded into a separate browser window. The *_blank* target is frequently used to direct users to external web pages without having them leave the current site altogether.

Figure 28c shows the results of using *target=_self*. This target directs the incoming URL to the frame where the link holding the target was clicked. This replaces the left frame completely with the new URL.

The *_parent* and *_top* targets result in the removal of frames. The *_top* target wipes out all frames in the window, replacing them with the new URL (fig. 28d). The *_parent* target is designed for the rare situation when an existing frame has been divided into smaller frames during use. Using *target=_parent* removes only these most recently created frames.

Figure 28e shows targeting to a named frame. Here the *new* URL is directed to the frame named *right*.

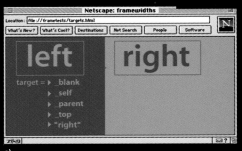

a)

b)

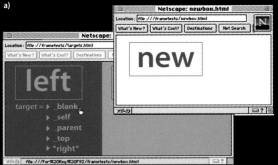

c)

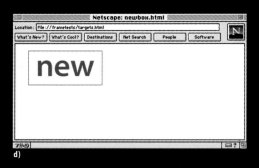

d)

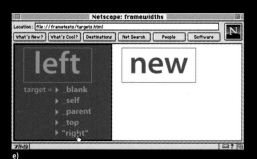

e)

Style Sheets

Cascading style sheets represent a technology designed specifically to address the issue of flexible page composition and precise control over every page element. They are similar to the style sheets used in word processors, enabling web designers to redefine the particular behavior of any existing HTML structure, or create any number of variations on them by applying what are known as *classes* to them on an as-needed basis.

Style sheets can be defined within a single HTML file, or they can be stored externally, and used by any number of pages in a site. This latter option promises great efficiency in the design and production of large web sites, where a house style can be defined once, and then be applied to hundreds of web pages in an instant.

With style sheets, designers are finally given the kind of control they have come to expect from other page design software. Style sheets can be used to control fonts—their size, weight and style—and to control key typographic variables such as letter, word and line spacing (fig. 29).

Style sheets also provide the means to position elements on the page in a way that circumvents the line-by-line model of basic HTML. Elements can be placed instead with respect to given offsets, measured either in pixels or percentages, from the window border, or be placed in invisible rectangles which behave much like the picture and text boxes of QuarkXPress or PageMaker (fig. 30).

Finally, the specification also allows elements to be composed in any number of layers, providing, for the first time, the means to stack page elements directly on top of one another without constraint.

29

In this example two different styles are applied to a piece of children's verse. The first style, applied to the odd lines of the poem, uses 24 pixel Palatino on a line spacing of 30 pixels. The second, applied to the even lines, changes the size of the type to 22 pixels, the type style to italic and moves the margin in by 30 pixels. The colors, also included in the style definitions, are chosen from the browser-safe palette.

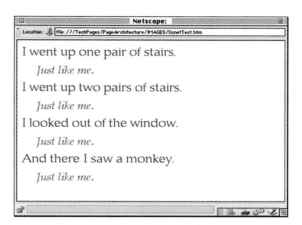

```
.oddline
    {#color: #003399;
    font-size: 24px;
    line-height: 30px;
    font-family: Palatino}
.evenline
    {color: #0066ff;
    font-size: 22px;
    line-height: 30px;
    font-family: Palatino;
    font-style: italic;
    margin-left: 30px}
```

30

In this example styles are defined to position graphic elements on the page. Each style defines a box into which the image is placed. Locations are defined with respect to either the browser window, or image, that was last put down. In the case of the *.backgray* style, the location is 40 pixels down and 20 pixels over from the window origin (the upper left of the browser window). The remaining styles are defined to be used within the coordinate system of the gray rectangle. The blue "1" shape, for example, is defined to be 15 pixels over and 15 pixels down from the its upper left corner. The magenta "m" shape is defined to be 65 pixels over and 15 pixels down (accounting for the 50 pixel width of the "1" shape).

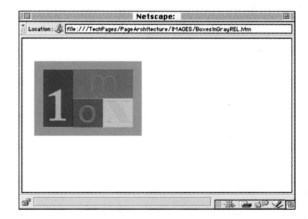

```
.backgray
    {position: absolute;
    left: 20px;
    top: 40px;
    width: 180px;
    height: 130px
    z-index: 1}
.onebox
    {position: absolute;
    left: 15px;
    top: 15px;
    width: 50px;
    height: 100px
    z-index: 2}
.mbox
    {position: absolute;
    left: 65px;
    top: 15px;
    width: 100px;
    height: 50px
    z-index: 2}
.obox
    {position: absolute;
    left: 65px;
    top: 65px;
    width: 50px;
    height: 50px
    z-index: 2}
.xbox
    {position: absolute;
    left: 115px;
    top: 65px;
    width: 50px;
    height: 50px
    z-index: 2}
```

Modifying Existing Tags

The simplest use of style definitions is to modify the behavior of existing HTML tags. For example, it might be desirable to have all subheadings in a page set in italic type. To accomplish this the style, *h3 {font-style: italic}* need only be defined. For the sub-headings to be set in dark blue, simply add *color: #000033* to the above style definition.

Classes

Sometimes it is necessary to modify a tag in several different ways. Suppose we wanted to add several additional color variations to the H3 subheading modified in the example above. To do this, each color definition can be defined using *classes*. Classes can be applied to a given tag one at a time, affecting only particular applications on the page. For example to have both dark blue and dark red H3 subheadings, the classes *.dred {color: #660000}* and *.dblue{color: #000066}* would be defined. These could then be applied as needed to the <h3> tag like this: *<h3 class="dred">* Red Title</h3>.

Placement

As we saw in the example on the previous page, style sheets can be used to determine locations on the page as well as the appearance of individual elements. The example on the right shows the use of style sheets to create a simple typographic composition. Each layer of the composition is defined as a separate region and then loaded with the appropriate content. For example the style used to create the region in figure 31b is: *p1 {left: 185px; top: 40px; width: 500px; height: 700px}.* The style for figure 31c is *p2 {left: 112px; top: 18px; width: 500px; height: 700px}.*

The revolutionary aspect of style sheets is now brought into play. Each region is simply placed in its position on the page, without any need to consider the usual top-to-bottom, linear behavior of HTML. This freedom is an extraordinary advance in web technology.

31

With style sheets control over typography and page composition is greatly improved. Invisible blocks, much like those used in QuarkXPress, can be defined anywhere on the page and can overlap in any number of layers. These blocks can then contain elements formatted with respect to other style definitions. In this example, three such blocks coexist on the page. The differences in typeface and size in the two text blocks are the result of applying different class definitions to the standard paragraph tag.

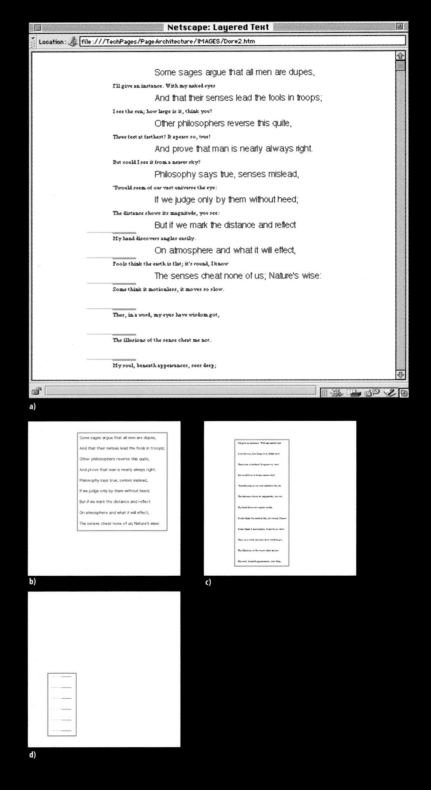

a)

b)

c)

d)

In this example from HotWired's webmonkey page, style sheets are used to create a sliding control panel. The ability to place web content and navigational elements on separate layers opens up many new options for web page interfaces.

Layers as Interface Elements

The ability to use layers opens up a wide range of new possibilities for web page design. A particularly elegant example is the sliding toolbar featured in WebMonkey, HotWired's storehouse of information on web technology (fig. 32).

Given the low resolution and limited size of most computer monitors, a key problem for web designers has been finding room for navigational controls. The designers at HotWired solve this problem by using style sheets to create a separate layer for the placement of links to other parts of the site. The layer is defined as a rectangular region, much like those used on the opposite page. The location of the region is set to a negative number so that all but 12 pixels of the box remain off-screen (to the left). The 12-pixel on-screen area of the box is loaded with the stripe graphics and arrow buttons; the off-screen area is loaded with the colored text and text links that appear when the panel slides out. To activate the panel, users click on one of the black arrows. A Javascript routine then moves the panel out in a smooth animated motion.

Limitations of Style Sheets

Despite their many advantages, it will take some time before style sheets completely replace other formatting approaches. Only the latest releases of Netscape and Internet Explorer support the technology—and not always consistently. While we wait for a final standard to emerge from the World-Wide-Web Consortium, style sheets will have to be used with caution and a lot of careful testing. As with any new web technology, style sheets will fail for those users who have not updated their browsers, or who, for good reason, use alternative methods to access the web.

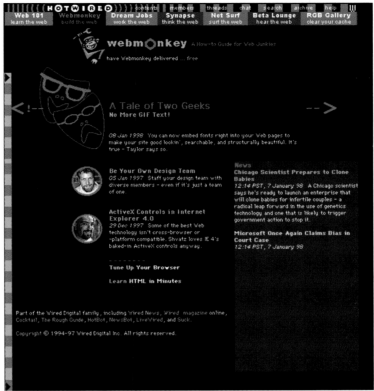

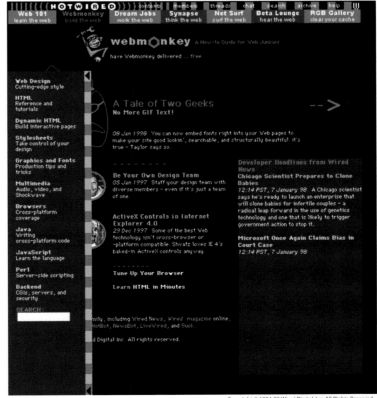

Web Color

The web is a unique medium, in that the technology used to create the communication, the personal computer, is the very same that will be used by the reader to view it. However, with the many subtle differences that exist between computer brands and configurations, web designers face difficulty in anticipating how their work will appear when reconstituted on various users' machines. A key area of concern is color. While there is little standardization between computers on this issue, certain techniques and technologies are available which make cross platform color a possibility.

& Image Formats

Designers working in the world of print have learned through painful experience that the colors they see on the computer screen will be quite different from the ones that eventually come off the printing press. To overcome this, they have learned to anticipate how certain colors will look when converted to ink. They've also learned the value of choosing colors from a predefined color system such as the Pantone or Trumatch systems which are designed to take advantage of the technologies of final production.

Ironically, web designers have had to face similar problems even though the raw material of a web page is both made and displayed in what would seem to be the same medium, the computer screen. The reason is that competing computing systems have developed different color display models, models that reflect certain differences in their hardware, and in their evolution over time.

The art of designing a web page is to create an experience that is uniform for the entire audience. A page should look the same whether it is brought up on Windows, Unix or the Mac, or, whether it is viewed in 24 or 8-bit color displays.

This chapter reviews some of the basic issues that effect consistent cross-platform color and the role that standard graphic formats play in standardizing the representation of images and other graphic elements.

Managing Web Color

Understanding the role of color in designing a web page is crucial, not only because of its importance to image quality, but also because color is a key factor in determining an image's file size, and thus the speed with which it will move across the web.

Managing color requires a fundamental understanding of how bit-mapped graphics are represented by the computer. This means understanding the relationship of the image's *color depth* to the number of colors available to render it, and the role that palettes play in mapping color from one machine to the next.

Color Depth

Color images on a computer come in two standard sizes: 24-bit or "full color," and 8-bit or "indexed color". Full color images contain pixels that are described directly as intensities of the additive primaries: red, green and blue. These color descriptions are exactly those used by a computer monitor so a 24-bit image can be rendered with complete accuracy. The result is an almost photographic level of quality. Indexed color images on the other hand have their colors described in reference to a fixed and often quite limited palette. Storing colors separately from the image results in significant reductions in the amount of memory required to store the image (see fig. 1).

Computers also come in the 8 and 24 bit varieties, but in this case these terms refer to the *computer's* capacity to show color. A computer with 24 bits of color will be able to show any graphic of 24 bits or less at full color resolution. An 8-bit machine however will have difficulty in accurately displaying images with a larger amount of color information. A full color image brought up in this environment for example will have to have its color scaled down in order to be seen. This process is explained in figures 2 and 3.

1

The number of colors available to render an image grows dramatically as the number of bits per pixel is increased. A simple way to remember the relationship between an image's color depth and its palette size is to think in terms of powers of 2. Graphics represented by 8 bits or less of color will require a palette to store color definitions.

Color Depth	Powers of Two	Available Colors
1	2^1	2
2	2^2	4
3	2^3	8
4	2^4	16
5	2^5	32
6	2^6	64
7	2^7	128
8	2^8	256
16	2^{16}	65,536
24	2^{24}	16.7 million

2

When full color images are displayed on an 8-bit monitor they must be mapped to a common 256-color *system* palette (see fig. 4). This mapping can happen in two ways. Consider the example below. When the colors of the original image (2a) are not found in the palette, they can either be shifted to the closest colors (as in 2b), or simulated by a halftoning technique called *dithering* (2c). The number of colors required for dithering may range from 2 to as many as 18 (2d).

a) b) c) d)

3

The effects of color mapping are somewhat different when applied to photographic imagery (3a). Shifting colors to their nearest equivalents in this case results in pronounced posterization of the image (3b).

When dithered the image still displays some banding in the shadows and transitional areas (3c, 3d), but a fairly natural, albeit textured appearance is achieved.

a) b) c) d)

The Browser Safe Palette

When a page containing images is down-loaded from the web onto a machine with only 8-bits of color, it must be displayed by using the computer's *system palette* (fig. 4). Unfortunately, the system palettes of the world's two most popular computing environments are not the same, so the appearance of a graphic element seen in one environment may not be the same when viewed in the other. The light blue "m" in figure 2 for example could conceivably exist in one palette but not in the other. If this were the case, the letterform would appear clean and undithered in one case while having a highly textured appearance in the other.

In response to this situation, web designers have come to rely on a palette that uses only those colors common to both the Mac and Windows system palettes. Known as the "Netscape Color Cube" or the "6x6x6 palette", this set of 216 colors has become the color standard for the web (fig. 5). Images mapped to this palette (done automatically by leading web browsers) will be identical regardless of the platform.

The Non-Dithering Colors

Most web pages contain large areas of solid color—in page backgrounds, banners, illustrations and display type. The presence of unsightly dithering patterns in these elements is something that experienced web designers carefully avoid. To do this designers treat the color cube as a kind of swatch book for the web, with spot color chosen only from its set of 216 colors (fig. 6). These colors, whether viewed in 24 or 8 bits, on a Macintosh or Windows machine, will be sure to remain clean and consistent.

4

Below are the system palettes for Windows (left) and the Macintosh (right). System palettes contain colors optimized to represent the full color spectrum (alone and when combined with dithering patterns). They also contain a number of reserved colors which are used by the operating system to display the various components of a desktop interface (such as menus, dialogue boxes and icons).

5

The color cube consists of 216 colors representing 20% divisions of the spectrum. The cube is arranged with the three additive primaries—red, green and blue—placed in one set of opposite corners, and the secondaries—cyan, yellow and magenta in the others.

White and black occupy the remaining corners. Accessing the colors of the cube involves choosing any color whose red, green and blue component is some multiple of 20% (see the next page).

6

Here are two versions of the same graphic shown after being mapped to the color cube palette. The first (6a) contains colors chosen directly from the color cube: [80%, 60%, 80%] for the background, and [20% , 60%, 80%] for the type. The second image (6b), uses slightly altered colors: [78%,59%, 78%] and [22%,59%,78%]. While the difference is barely perceptible when viewed in full color mode, the conversion to the color cube results in an unsightly dithering of the colors when the image is viewed in 8 bits.

a)

b)

Inside the Color Cube

The 216 colors of the web-safe palette are presented in three color charts spreading over the next six pages (figs. 7-9). Each chart is identical save for the units of color mixture used to identify the colors. The graphic elements included on web pages come from a number of different sources such as scanners, digital video capture, paint and drawing systems and image processing software. These devices and software packages can often define color in different units, so it is convenient to be able to think about web safe colors in several formats. The chart below shows the red, green and blue components of the

7

100% 100% 100%	100% 80% 100%	100% 60% 100%	100% 40% 100%	100% 20% 100%	100% 0% 100%	80% 100% 100%	80% 80% 100%	80% 60% 100%
100% 100% 80%	100% 80% 80%	100% 60% 80%	100% 40% 80%	100% 20% 80%	100% 0% 80%	80% 100% 80%	80% 80% 80%	80% 60% 80%
100% 100% 60%	100% 80% 60%	100% 60% 60%	100% 40% 60%	100% 20% 60%	100% 0% 60%	80% 100% 60%	80% 80% 60%	80% 60% 60%
100% 100% 40%	100% 80% 40%	100% 60% 40%	100% 40% 40%	100% 20% 40%	100% 0% 40%	80% 100% 40%	80% 80% 40%	80% 60% 40%
100% 100% 20%	100% 80% 20%	100% 60% 20%	100% 40% 20%	100% 20% 20%	100% 0% 20%	80% 100% 20%	80% 80% 20%	80% 60% 20%
100% 100% 0%	100% 80% 0%	100% 60% 0%	100% 40% 0%	100% 20% 0%	100% 0% 0%	80% 100% 0%	80% 80% 0%	80% 60% 0%
40% 100% 100%	40% 80% 100%	40% 60% 100%	40% 40% 100%	40% 20% 100%	40% 0% 100%	20% 100% 100%	20% 80% 100%	20% 60% 100%
40% 100% 80%	40% 80% 80%	40% 60% 80%	40% 40% 80%	40% 20% 80%	40% 0% 80%	20% 100% 80%	20% 80% 80%	20% 60% 80%
40% 100% 60%	40% 80% 60%	40% 60% 60%	40% 40% 60%	40% 20% 60%	40% 0% 60%	20% 100% 60%	20% 80% 60%	20% 60% 60%
40% 100% 40%	40% 80% 40%	40% 60% 40%	40% 40% 40%	40% 20% 40%	40% 0% 40%	20% 100% 40%	20% 80% 40%	20% 60% 40%
40% 100% 20%	40% 80% 20%	40% 60% 20%	40% 40% 20%	40% 20% 20%	40% 0% 20%	20% 100% 20%	20% 80% 20%	20% 60% 20%
40% 100% 0%	40% 80% 0%	40% 60% 0%	40% 40% 0%	40% 20% 0%	40% 0% 0%	20% 100% 0%	20% 80% 0%	20% 60% 0%

browser-safe colors in multiples of 20%. It is important to note that the colors of the web palette are made up of the brightest and most saturated colors available on a computer monitor. These colors, mixtures of colored light, are largely impossible to render accurately in printing inks. These color charts (and indeed every illustration in this book) are only approximations of the actual colors experienced by users of the web. Readers are strongly encouraged to visit all of the sites shown in this book to see the work as it was intended to be seen. Pointers to on-line resources to web color can also be found at the back of the book.

80% 40% 100%	80% 20% 100%	80% 0% 100%	60% 100% 100%	60% 80% 100%	60% 60% 100%	60% 40% 100%	60% 20% 100%	60% 0% 100%
80% 40% 80%	80% 20% 80%	80% 0% 80%	60% 100% 80%	60% 80% 80%	60% 60% 80%	60% 40% 80%	60% 20% 80%	60% 0% 80%
80% 40% 60%	80% 20% 60%	80% 0% 60%	60% 100% 60%	60% 80% 60%	60% 60% 60%	60% 40% 60%	60% 20% 60%	60% 0% 60%
80% 40% 40%	80% 20% 40%	80% 0% 40%	60% 100% 40%	60% 80% 40%	60% 60% 40%	60% 40% 40%	60% 20% 40%	60% 0% 40%
80% 40% 20%	80% 20% 20%	80% 0% 20%	60% 100% 20%	60% 80% 20%	60% 60% 20%	60% 40% 20%	60% 20% 20%	60% 0% 20%
80% 40% 0%	80% 20% 0%	80% 0% 0%	60% 100% 0%	60% 80% 0%	60% 60% 0%	60% 40% 0%	60% 20% 0%	60% 0% 0%
20% 40% 100%	20% 20% 100%	20% 0% 100%	0% 100% 100%	0% 80% 100%	0% 60% 100%	0% 40% 100%	0% 20% 100%	0% 0% 100%
20% 40% 80%	20% 20% 80%	20% 0% 80%	0% 100% 80%	0% 80% 80%	0% 60% 80%	0% 40% 80%	0% 20% 80%	0% 0% 80%
20% 40% 60%	20% 20% 60%	20% 0% 60%	0% 100% 60%	0% 80% 60%	0% 60% 60%	0% 40% 60%	0% 20% 60%	0% 0% 60%
20% 40% 40%	20% 20% 40%	20% 0% 40%	0% 100% 40%	0% 80% 40%	0% 60% 40%	0% 40% 40%	0% 20% 40%	0% 0% 40%
20% 40% 20%	20% 20% 20%	20% 0% 20%	0% 100% 20%	0% 80% 20%	0% 60% 20%	0% 40% 20%	0% 20% 20%	0% 0% 20%
20% 0% 0%	20% 20% 0%	20% 0% 0%	0% 100% 0%	0% 80% 0%	0% 60% 0%	0% 40% 0%	0% 20% 0%	0% 0% 0%

The 8-bit Color Scale

Many graphics applications define color as RGB values specified in a range of 0-255, with 0 representing the absence of color and 255 full intensity. This scale is based on the way computers and computer hardware represent color intensities: as one byte (or 8-bits) of information. An RGB, or 24-bit color will have 1 byte per color component available to describe its mixture. The 20% divisions of the spectrum expressed in this scale result in a rather awkward set of numbers (fig. 8). With 20% of 255 being 51, the resulting even divisions of the spectrum in the 0-255 scale is: [0, 51, 102, 153, 204, 255]. Because of its direct mapping with the computer this scale is the most precise way to think about web color.

8

255 255 255	255 204 255	255 153 255	255 102 255	255 51 255	255 0 255	204 255 255	204 204 255	204 153 255
255 255 204	255 204 204	255 153 204	255 102 204	255 51 204	255 0 204	204 255 204	204 204 204	204 153 204
255 255 153	255 204 153	255 153 153	255 102 153	255 51 153	255 0 153	204 255 153	204 204 153	204 153 153
255 255 102	255 204 102	255 153 102	255 102 102	255 51 102	255 0 102	204 255 102	204 204 102	204 153 102
255 255 51	255 204 51	255 153 51	255 102 51	255 51 51	255 0 51	204 255 51	204 204 51	204 153 51
255 255 0	255 204 0	255 153 0	255 102 0	255 51 0	255 0 0	204 255 0	204 204 0	204 153 0
102 255 255	102 204 255	102 153 255	102 102 255	102 51 255	102 0 25	51 255 255	51 204 255	51 153 255
102 255 204	102 204 204	102 153 204	102 102 204	102 51 204	102 0 204	51 255 204	51 204 204	51 153 204
102 255 153	102 204 153	102 153 153	102 102 153	102 51 153	102 0 153	51 255 153	51 204 153	51 153 153
102 255 102	102 204 102	102 153 102	102 102 102	102 51 102	102 0 102	51 255 102	51 204 102	51 153 102
102 255 51	102 204 51	102 153 51	102 102 51	102 51 51	102 0 51	51 255 51	51 204 51	51 153 51
102 255 0	102 204 0	102 153 0	102 102 0	102 51 0	102 0 0	51 255 0	51 204 0	51 153 0

204 102 255	204 51 255	204 0 255	153 255 255	153 204 255	153 153 255	153 102 255	153 51 255	153 0 255
204 102 204	204 51 204	204 0 204	153 255 204	153 204 204	153 153 204	153 102 204	153 51 204	153 0 204
204 102 153	204 51 153	204 0 153	153 255 153	153 204 153	153 153 153	153 102 153	153 51 153	153 0 153
204 102 102	204 51 102	204 0 102	153 255 102	153 204 102	153 153 102	153 102 102	153 51 102	153 0 102
204 102 51	204 51 51	204 0 51	153 255 51	153 204 51	153 153 51	153 102 51	153 51 51	153 0 51
204 102 0	204 51 0	204 0 0	153 255 0	153 204 0	153 153 0	153 102 0	153 51 0	153 0 0
51 102 255	51 51 255	51 0 255	0 255 255	0 204 255	0 153 255	0 102 255	0 51 255	0 0 255
51 102 204	51 51 204	51 0 204	0 255 204	0 204 204	0 153 204	0 102 204	0 51 204	0 0 204
51 102 153	51 51 153	51 0 153	0 255 153	0 204 153	0 153 153	0 102 153	0 51 153	0 0 153
51 102 102	51 51 102	51 0 102	0 255 102	0 204 102	0 153 102	0 102 102	0 51 102	0 0 102
51 102 51	51 51 51	51 0 51	0 255 51	0 204 51	0 153 51	0 102 51	0 51 51	0 0 51
51 102 0	51 51 0	51 0 0	0 255 0	0 204 0	0 153 0	0 102 0	0 51 0	0 0 0

The Hexadecimal Scale

When specifying color in the language of the web, HTML, an even more machine-like set of numbers are required (fig. 9). Based on the number 16, the hexadecimal number system forms the basis for specifying the color of web type, background colors and certain features of web formatting structures such as tables and frames. While interactive web-page design programs can insulate users from dealing with this format, most web designers will want to be able to get into the raw HTML code and edit color directly. Hexadecimal numbers are nothing more than a way of representing numbers in base 16 rather than our more familiar base 10. Instead of the 10 symbols used in our counting system [0,1,2,3,4,5,6,7,8,9], hexadecimal uses 16

FF FF FF	FF CC FF	FF 99 FF	FF 66 FF	FF 33 FF	FF 00 FF	CC FF FF	CC CC FF	CC 99 FF
FF FF CC	FF CC CC	FF 99 CC	FF 66 CC	FF 33 CC	FF 00 CC	CC FF CC	CC CC CC	CC 99 CC
FF FF 99	FF CC 99	FF 99 99	FF 66 99	FF 33 99	FF 00 99	CC FF 99	CC CC 99	CC 99 99
FF FF 66	FF CC 66	FF 99 66	FF 66 66	FF 33 66	FF 00 66	CC FF 66	CC CC 66	CC 99 66
FF FF 33	FF CC 33	FF 99 33	FF 66 33	FF 33 33	FF 00 33	CC FF 33	CC CC 33	CC 99 33
FF FF 00	FF CC 00	FF 99 00	FF 66 00	FF 33 00	FF 00 00	CC FF 00	CC CC 00	CC 99 00
66 FF FF	66 CC FF	66 99 FF	66 66 FF	66 33 FF	66 00 FF	33 FF FF	33 CC FF	33 99 FF
66 FF CC	66 CC CC	66 99 CC	66 66 CC	66 33 CC	66 00 CC	33 FF CC	33 CC CC	33 99 CC
66 FF 99	66 CC 99	66 99 99	66 66 99	66 33 99	66 00 99	33 FF 99	33 CC 99	33 99 99
66 FF 66	66 CC 66	66 99 66	66 66 66	66 33 66	66 00 66	33 FF 66	33 CC 66	33 99 66
66 FF 33	66 CC 33	66 99 33	66 66 33	66 33 33	66 00 33	33 FF 33	33 CC 33	33 99 33
66 FF 00	66 CC 00	66 99 00	66 66 00	66 33 00	66 00 00	33 FF 00	33 CC 00	33 99 00

symbols [0,1,2,3,4,5,6,7,8, 9, A,B,C,D,E,F]. The rules for representing quantities is the same in both systems: use up all the symbols, then add a new place (the 'tens' column in base 10, the 'sixteens' column in base 16) and start moving through the symbols again. To give one example, the number 31 in base 10 would be 1F in hexadecimal (one 16 and fifteen , or 'F' numbers remaining). Fortunately, there are many base 10 to hexadecimal conversion tools available on the web, so mastering the art of hexadecimal counting is not a necessity. For our purposes, it is only important to commit to memory the 20% divisions of the 0-255 scale in hexadecimal. The hexadecimal equivalents of the 8-bit scale [0, 51, 102, 204, 255] are [00, 33, 66, 99, CC, FF].

CC 66 FF	CC 33 FF	CC 00 FF	99 FF FF	99 CC FF	99 99 FF	99 66 FF	99 33 FF	99 00 FF
CC 66 CC	CC 33 CC	CC 00 CC	99 FF CC	99 CC CC	99 99 CC	99 66 CC	99 33 CC	99 00 CC
CC 66 99	CC 33 99	CC 00 99	99 FF 99	99 CC 99	99 99 99	99 66 99	99 33 99	99 00 99
CC 66 66	CC 33 66	CC 00 66	99 FF 66	99 CC 66	99 99 66	99 66 66	99 33 66	99 00 66
CC 66 33	CC 33 33	CC 00 33	99 FF 33	99 CC 33	99 99 33	99 66 33	99 33 33	99 00 33
CC 66 00	CC 33 00	CC 00 00	99 FF 00	99 CC 00	99 99 00	99 66 00	99 33 00	99 00 00
33 66 FF	33 33 FF	33 00 FF	00 FF FF	00 CC FF	00 99 FF	00 66 FF	00 33 FF	00 00 FF
33 66 CC	33 33 CC	33 00 CC	00 FF CC	00 CC CC	00 99 CC	00 66 CC	00 33 CC	00 00 CC
33 66 99	33 33 99	33 00 99	00 FF 99	00 CC 99	00 99 99	00 66 99	00 33 99	00 00 99
33 66 66	33 33 66	33 00 66	00 FF 66	00 CC 66	00 99 66	00 66 66	00 33 66	00 00 66
33 66 33	33 33 33	33 00 33	00 FF 33	00 CC 33	00 99 33	00 66 33	00 33 33	00 00 33
33 66 00	33 33 00	33 00 00	00 FF 00	00 CC 00	00 99 00	00 66 00	00 33 00	00 00 00

Using Limited Color

While the color cube presents severe restrictions on color selection, it does provide a good distribution of hues and values with which to work. The best designs on the web tend to make the best of the situation, using simple yet memorable color combinations to create a strong sense of identity. In the examples shown on the right hot, highly saturated colors provide memorable opening statements to their respective sites. In both cases color creates a dramatic backdrop for a simple typographic message. Like a well-designed book cover, these pages invite the viewer in, balancing tasteful typography with a strong visual dynamic. The understated tone of these designs stands in stark contrast to the overdesigned and noisy pages commonly found on the web.

The limited palettes used in these sites pays another important dividend. The small number of colors allows the pages to be reduced to a remarkably small file size. The large areas of solid color are perfectly suited to the image-compression technologies used by the web's foremost graphic file type, the GIF file (the details of which will be discussed later in this section).

10

The MetaDesign site uses a classic red, white and black palette for an elegant yet visually powerful statement. The three-color scheme results in pages that are of a remarkably modest size, and therefore quite quick to download. A subtle technical detail relating to these color choices can be seen in the rendering of the anti-aliased type. Since red and white are found at adjacent corners of the color-cube, a smooth range of 6 color gradations is available for blending the type into the background. The result is an unusually clean rendering of the page's letterforms.

	R	G	B
	255	0	0
	0	0	0
	255	255	255

11

The posterized halftone used in the background image of the Nissan splash screen uses two analogous colors from the color cube. The bright orange and yellow provide an appealing contrast with the black type of the page's welcoming message and the blue sky of the inset animation. The anti-aliasing of the type here is less smooth than in the example above. With orange being an intermediate color between yellow and red, there are fewer shades available between the two colors.

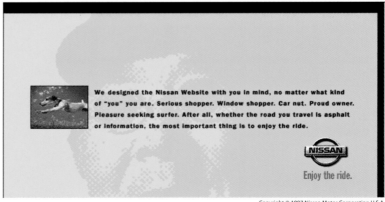

	R	G	B
	255	255	0
	255	204	0
	255	0	0
	0	0	0

Using colors outside of the color cube can lead to unpredictable results. The web page shown here uses several such colors in the rendering of the main graphic and in the yellow of the type. In 24-bit color the page looks as intended(12a). Visitors to this site with 8-bit monitors get quite a different picture (12 b). The colors of the image are shifted to colors within the color cube palette. If the same graphic is placed in the foreground layer of the page instead, it is dithered, using 64 different colors (12 c).

Choosing Other Colors

While sticking with the color cube palette provides certainty about color fidelity, there are times when other colors can be used effectively. Color difference is much less noticeable at the lower ends of the spectrum than in brighter colors so a dithering pattern consisting of dark pixels will often go unnoticed. Dithering is also relatively hidden when it is applied to small graphic elements such as type. For type that is less than 30 or so points, there is insufficient surface area within the letter-forms to make color patterns evident.

In some cases it may be decided that a color is important enough to a design that users with 8-bit machines will have to accept a dithered version. In this case the design should be previewed in different browsers and computing platforms to ensure that the final results are acceptable.

As an example of the kind of thing that can go wrong, consider the example on the right (fig. 12). The spiralling forms and small blocks of type are placed on the top layer of the page, while the machine image serves as the page background. The machine part is rendered in three gray-greens none of which is found in the color cube palette.

While the image appears as intended when viewed in full color (fig. 12a), the colors shift remarkably in the 8-bit version. It turns out that the Netscape browser treats the mapping of color differently depending on whether the image is in the background or foreground layer of the page. When placed in the foreground, the image is dithered (fig. 12c), when placed in the back colors are shifted to their nearest match in the color cube palette (fig. 12b).

Surprises such as this are commonplace in web design. Only by frequently checking a design on different system configurations will these anomalies be discovered.

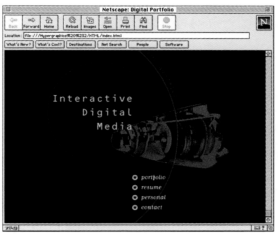

a)

R	G	B
90	74	24
41	33	0
90	82	74
247	214	0

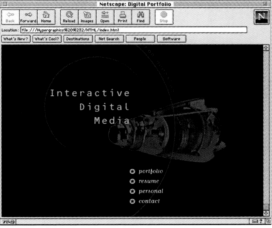

b)

R	G	B
102	51	0
51	51	0
85	85	85

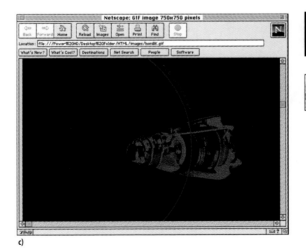

c)

Graphic Formats

In designing for the web, the first priority is keeping download time to a minimum. In determining an acceptable size for a web page, designers pay attention to the least privileged members of their target audience—users with slow (14.4 Kbps) modems. They will receive a page at about 1K per second. Because of this, most designers work very hard to keep pages under 40K —that's 40K for all text, graphics and HTML formatting codes!

What makes this seemingly absurd constraint possible is image compression. Compression technology allows images to be squeezed down considerably before transmission, and to be restored again within the user's browser. To design a web page, it is mandatory to understand the two basic approaches to compression supported by the web and the file types that use them.

GIF Files

GIF files are ideally suited for graphics that are flat, geometric and uniform in color. They are used exclusively for solid background areas, banners and display type. GIF files are limited to 8-bits of color and use a process known as "run-length encoding" to compress an image. Run-length encoding compresses an image by converting it to a series of horizontal line segments of continuous color (fig. 13). By not representing each pixel individually, this approach results in savings of up to 10:1.

The amount of savings in a GIF file is a direct function of its distribution of color. Horizontal forms compress better than those that are predominantly vertical, and vertical forms do better than those at an angle. Continuous tone imagery, such as gradients, having few horizontal runs, compress poorly and must be avoided. (fig. 14).

13

GIF files compress files by storing the image as a set of horizontal line segments rather than directly as pixels. Further savings are achieved by pattern matching. For example row 1 below is saved not as 25 pixels, but as a line starting at pixel 1 and ending at 25. Row 6 is represented as three segments, two blue, length = 7, and one yellow, length = 11. Rows which are identical to previously stored rows are simply noted as copies and not explicitly stored at all. For example, rows 8 and 18 will be stored as clones of row 6.

row 1

row 6

row 8

row 18

14

The effectiveness of run-length encoding is highly dependent on the kind of image that is being compressed. Most compressible are areas of pure solid color. Next best are images with horizontally oriented elements (14a and b). Images with vertical elements (14e and f) fare less well, but nonetheless compress to acceptable levels due to the pattern repetition among the various horizontal "runs". Angled graphics such as 14d perform equally as well as those with a vertical orientation due to the sophistication of pattern matching. Blended colors (14c, g, h) are so little effected by the compression that they are avoided altogether by web designers.

a) 691 bytes b) 980 bytes c) 25,558 bytes d) 3,499 bytes

e) 3,307 bytes f) 4,872 bytes g) 23,747 bytes h) 41,673 bytes

JPEG files

JPEG compression (named for the Joint Photographic Experts Group that developed the standard) is intended for images that contain large areas of continuous tone color. This makes JPEG compression the natural choice for photographic images. Unlike GIF files which work only with color images of 8-bits or less, JPEG files assume an image of 24-bits or "millions" of colors. Depending on the choice of a quality setting—Photoshop for example offers four: low, medium, high and maximum—image size can be reduced anywhere from 10:1 to 100:1. Along with the fact that screen images are a mere 72 dots per inch, this degree of reduction allows even full screen images to come in at less than 50 kilobytes.

JPEG compression is based on certain properties of the human eye. In particular the fact that human vision is more sensitive to gradual changes in brightness and color than it is to abrupt changes over a short distance. JPEG compression divides an image into certain zones and selectively discards color information that exists in areas too subtle to be perceived by the human eye. In doing this, JPEG compression permanently alters the image. When the image is rebuilt after being opened in a browser or other image program, it will, upon close inspection, be quite different from its original state. Compression schemes that have this property have been given the rather awkwardly labeled "lossy". By contrast compression techniques which restore an image intact (like run-length encoding) are referred to as being "lossless". It is important to keep this distinction in mind when using JPEG compression. It is essential that it only be applied once per image, after all editing and modification is complete.

Examples of JPEG compression are shown on the right. The images in figure 15 demonstrate that even with significant levels of reduction, the effects on image detail are barely noticeable. JPEG files are a poor choice for solid graphic elements or display type. Note the smudgy, "halo" effects that JPEG compression imparts in transitional areas of the image (fig. 16). A GIF file is the only choice for this type of image.

15

Below are several images and image details that demonstrate the effectiveness of JPEG compression. Each was compressed with a medium-quality setting. The grayscale photograph is 288 by 381 pixels (about 4 by 7 inches) and occupies only 24K. The three-colored chair images are of a similar dimension (288 by 355 pixels) but only occupy about 17K a piece. As can be seen in the enlargements, the simplification of image detail is barely perceptible even at a 4:1 magnification.

16

Graphic Effects

While file size and image integrity are the most important aspects in choosing a proper image format, there are other considerations that sometimes favor one format over another. The GIF file in particular has evolved to support several options beyond the mere placement of an image on the page. These include interlacing, background transparency and animation.

Interlacing

For users that access the web through slow connections, the download time for large graphic elements can be frustrating. This is especially true when the page being accessed is only an intermediary step on route to the ultimate destination. One way to accommodate this situation is to save images as *interlaced* GIF files (fig. 17). Interlaced files appear incrementally, with each pass adding more information to the image. This approach to rendering allows a user, especially one who is familiar with the site, to recognize enough of the page to know where they are, and in the case of clickable image maps, where to click the mouse in order to proceed.

Transparency

For many site designers a primary tool for achieving visual complexity while keeping file sizes within limits is the transparent GIF file. Web pages—until very recently—have supported the use of only two layers of information. The foreground layer, which holds the bulk of the page's content, and the background layer, limited to a single color or a single graphic image. The GIF89a file type (discussed opposite) allows for the creation of bitmapped graphics that have a particular color set to be transparent. These elements, when placed over the background, allow the underlying color or image to show through (fig. 18). As a result, complex relationships between text and image (or between image and image) can be created without having to treat the entire page as one immense graphic. Once the background of a page has been downloaded, smaller transparent GIFs can follow.

17

Interlaced GIFs are transmitted in several passes. Instead of coming line by line, top to bottom, the image arrives in a series of evenly spaced 1-pixel stripes. The first pass contains every fourth line of the image: lines 1, 5, 9, and so on. The second pass contains every fourth line again, but shifted down one pixel— lines 2, 6, 10, etc.. By duplicating rows of the pattern as it comes in, an intelligible, low-resolution image can be seen by the user almost immediately.

Copyright © 1997 Nissan Motor Corporation U.S.A.

18

This example shows the placement of a bitmapped title over a dark background image. In order for the photograph to show through the counters of the letterforms, the black background of the original type image must be set to transparent. Shown below are:

a) the finished web page with background transparent type; **b)** the original type image from Photoshop (set on black to ensure that the letterforms will be anti-aliased to dark tones); and **c)** the dialogue box used to specify the GIF file's transparent colors.

a)

b)

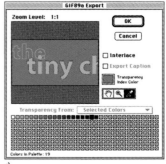

c)

GIF Animation

As the bandwidth of the web opens up, the possibilities for real-time animation of web pages are improving. However, for many applications a remarkably simple and effective alternative is the animated GIF file.

Starting with Netscape 2.0, browsers have begun to treat multi-image GIF files as animated sequences. When a multi-image GIF file arrives at the user's browser its first "frame" is immediately loaded. The file's second frame then replaces the first. Each subsequent frame is loaded in turn until the file's contents are exhausted (fig. 19). In addition to the animation frames the file may contain information on how many times the animation should repeat, whether it should loop indefinitely, or how much time should elapse between each frame.

The effects of GIF animation are rarely refined, and the performance of the animation will depend on the speed of the user's machine and network connection. If used carefully, however, GIF animation can be quite effective with only a small file size. An additional benefit is that unlike some other animation formats, GIF animations require no special plug-ins.

Evolution of File Formats

The GIF and JPEG file formats have been in existence for a number of years and they continue to evolve. GIF files for example come in two flavors: the nearly obsolete GIF87a format and the more versatile GIF89a format. A fairly recent addition to the JPEG family is the Progressive JPEG file. This format is basically a conventional JPEG file, but with support for interlacing added on. Support for this format is rapidly gaining acceptance in most major browsers.

A promising extension to the GIF file, though not yet supported by current browsers, is the PNG file. This format promises a significant improvement on the GIF file, offering more efficient run-length encoding, 24-bits of color instead of just 8, and gamma correction to improve cross-platform color. A brief comparison of these formats is shown in fig.20.

19 GIF animation can be used to add simple transitions to small images or display type. A common effect is the application of increasing levels of blur. When the page shown here is loaded the title eases in from soft to sharp focus. In this case the frames of the animation play through only once. Be careful of overdoing animation. Too many flashing and repeating elements on a page can disrupt the user's engagement with important page content.

20 An essential skill in designing for the web is knowing which graphic file format to choose for a given situation. The three main factors in making this choice are: the number of colors required to render the image, the image's relationship to other page elements in terms of layering and the need for certain special effects such as interlacing or animation. PNG files currently require a special plug-in to be seen.

	GIF87a	GIF89a	PNG	JPEG	P-JPEG
compression	lossless	lossless	lossless	lossy	lossy
number of colors	256	256	millions	millions	millions
background transparency	no	yes	yes	no	no
interlacing	yes	yes	yes	no	yes
animation	no	yes	no	no	no

Analyzing a Web Page

There are many ways to learn about the web—bookstores are bursting at the seams with texts on HTML, Java, Javascript, Cascading Style Sheets, Web Graphics and dozens of other "how-to" topics. Many of these books are extremely useful and worthy of study. But it also is true that the web itself can be an invaluable resource for understanding how web sites and web pages are designed and built. While careful study of books can lead to an encyclopedic knowledge of the medium, there is much to be said for just "following your nose" and trusting in the dynamic information space of the web to provide you with what you need.

On-line information

Because of the relative simplicity of the HTML language, the web is truly a "do-it-yourself" medium. For this reason, there has always been a vast storehouse of information available on-line describing every aspect of building pages and web sites. The web abounds with tutorials, impassioned discussions of the trade-offs between competing web technologies, and hotlist sites that point users to the best and most innovative and envelope-pushing web sites. No matter what your level of experience, or what questions you have about the web, it is almost sure that the answer can be found with only a little poking around.

HTML Files are Recipes

One unique aspect of the web medium is the fact that with the delivery of a page's content comes a complete blueprint for how it was assembled. Further, the components of the page arrive in parts, and are reassembled on the spot. It's really very much like the idea of pre-fab housing. Images and text are pre-cut into modular units and the browser, with the HTML file in hand, has a the task of building the page back up. These building blocks of a web page are also available to the site visitor. The source code for the page can be viewed by anyone, and the individual elements of the page can be copied for detailed inspection.

This access to the structure of web pages is one of the single most valuable learning tools that the web has to offer. Each reader of a page is given his own copy, a copy which can be opened up and inspected, or even altered and loaded back into the browser to see the results. This "under-the-hood" interaction with a web page can provide valuable insight into the way favorite or innovative web sites do the things they do.

An Homogeneous Environment

The web is a medium in which the machine used to create content is identical to that which is used to view it. This unprecedented feature is a large part of what makes the medium so dynamic and fluid. Content can be created, edited, added to or reassembled into new configurations by its users. In most cases, the tools that were used to create the web site, exist, at least in some analogous form, on many of the audience's machines. Few web elements are in a form that cannot be loaded into everyday text and graphic editors. This allows a tremendous amount of re-purposing and plagiarizing of page content. On the more positive side, however, it also allows users interested in understanding the web to look over each page element in great detail.

In this section, we will look at a number of simple techniques for analyzing a web page from the outside in. We'll see that armed with only rudimentary understanding of HTML and its basic structural features, a lot can be learned from the page sitting right in front of you.

Probing with the Mouse

Now that the convention of underlining links has largely been abandoned, it is often unclear which text elements represent links and which do not. Does a blue subheading of a paragraph lead somewhere, or is it just being offset visually as part of the overall page design? Graphic elements are even more ambiguous, where any image on the page may be a link, or even a clickable map providing several navigational options. Only by inspecting these elements with mouse can users understand what navigational possibilities the page contains (fig. 1).

If your task is to figure out how a page is put together, these feedback mechanisms are equally valuable. By using a few simple techniques, a fair amount of a page's structure can be discerned.

Selecting Text

Web pages often contain a mix of HTML and bitmapped text. While it is often simple to see the differences between the two representations, a simple click-and-drag of the mouse confirms the situation unequivocally (fig. 2). More information is gained when larger areas of text are highlighted. With HTML text can be laid down in a number of different structured formats, or even be divided among several areas of the page (e.g. with tables). As a cursor is dragged across the page, however, these divisions are ignored by the text-selection function of the browser. As figure 3 shows, this ability to have text selection jump across the page gives immediate visual feedback as to the divisions of text and graphic regions of the page.

1
The cursor provides the initial clues as to the breakdown of a page. In this graphic from the Informatics-Studio site (full page is shown opposite), the clickable map at the top of the page has four links—the colored text set in all caps. The smaller *Informatics Studio, Inc.* area, however, is not a link—a fact communicated to the user only when the cursor remains unchanged as it passes across it.

2
All HTML-set text is selectable by the mouse. While this feature is used by most to cut and paste content to other files, the visual feedback provided by the selection box gives a good picture of the size and extent of table cells being used to shape the page.

3
Sweeping the text cursor over larger extents of the page reveals more of the page architecture. Here it can be seen that the page consists of two separated HTML text regions separated by a row of graphic dots. Further, it is revealed by the reversing out of the address, that the dashed yellow lines are not graphics, but a series of dashes set with the font colour turned to yellow

Probing Images

Once the size and shape of the text regions have been investigated, similar techniques that can be applied to images. These vary slightly from platform to platform. If you're running Netscape on a Mac for example, you can see the size and shape of any graphic by holding the mouse down on an image and temporarily dragging away from it. A dotted rectangle appears and moves with the mouse (fig. 4). This visual feedback, like the reversed text region in the previous example, gives a good indication of table boundaries being used to structure the page. In Internet Explorer this dragging technique does not work. However, clicking the right mouse button on a graphic brings up a pop-up window of options with the graphic boundaries temporarily highlighted (see figure 5 on the next page).

4

The Macintosh version of Netscape allows users to directly manipulate page graphics with the mouse. A quick and easy way to visualize the decomposition of a page is to drag an image slightly out of registration. A bounding box attaches itself to the cursor revealing the graphic's size and shape. If the box is dragged to a disk icon, the image can be copied for later inspection. These two actions are shown below. The top navigation bar is pulled slightly over and its size and placement is readily apparent. At the bottom of the page, the e-mail icon is shown being copied to disk.

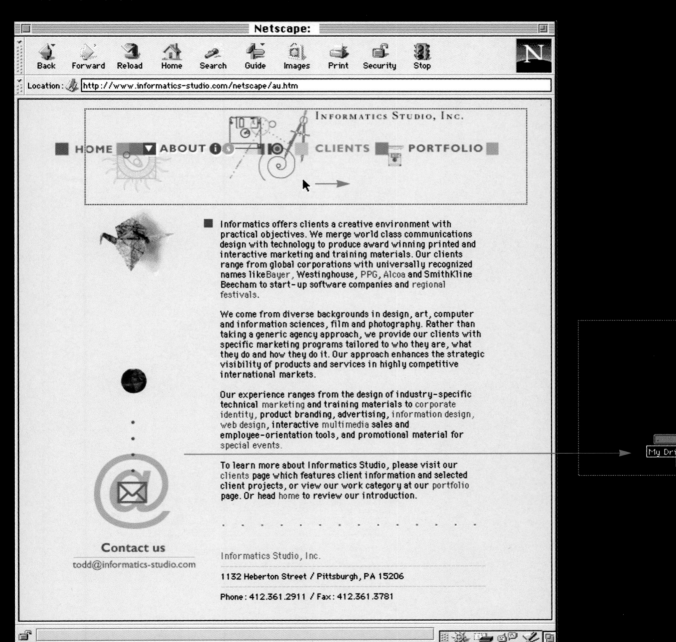

Analyzing Elements

The techniques mentioned so far give a good clue as to the number and location of a page's parts, but the analysis can go a lot further once elements are copied to disk. Copying images from a web page is remarkably easy. A simple mouse action—a right-button click in a Windows environment, or a simple mouse-down on the Mac—brings up a pop-up window with a save image option (figs 5a and 5b). Once the image is saved, it can be looked over in greater detail with an image editing program like Adobe Photoshop. In these environments you have a number of tools for probing into the image. Just the ability to zoom in, for example, can give you a sense of the amount of JPEG compression an image has undergone. (After doing this a few times, it becomes clear how effective low-quality settings can be.) Colors can also be analyzed for their compatibility with the browser-safe palette, and particularly effective color schemes can be noted.

An even easier check on an image is to load it right back into the browser window. Web browsers accept not only HTML files, but also images, sound and other standard web object types (known as MIMEs). As figure 6 shows, loading an image back into the browser gives immediate feedback on the its overall size and shape as well as its background transparency setting.

Inspecting Animations

Animated GIF files can be copied to disk in exactly the same manner as regular GIF files. Frames of an animated GIF are stored in a GIF file just like a single image, so a simple copy command grabs all of the frames. If you've got a simple GIF animation tool such as GIFbuilder (available in many places on the web), you can open the saved file and see the number of frames that it uses while checking on a number of other variables such as frame duration and transparency (fig. 7).

5

Any image of a web page can be copied to disk by the use of a simple pop-up menu. Once there, the file can be loaded into virtually any graphic editing program for further inspection. The example on the left (fig. 5a) is taken from Netscape Communicator. On the right (fig. 5b) is a similar menu used by Internet Explorer 4.0.

a)

b)

6

Once captured a JPEG, GIF or animated GIF file can be loaded into the browser window directly. This is a quick way to check on the image's details and to see whether the background is transparent or opaque. In this example, the background has been knocked out.

7

If the captured image is a an animated GIF, it's useful to bring it up in a simple GIF animation utility like GIFbuilder. The *Frames* window in this program allows frame-by-frame inspection, and provides statistics on image size, transparency and timing.

4 frames	Length: 1.20 s	Size: 106×102		Loop: forever	
Name	Size	Position	Disp.	Delay	Transp.
Frame 1	106×102	(0; 0)	B	30	1
Frame 2	88×90	(14; 4)	B	30	1
Frame 3	98×81	(4; 11)	B	30	1
Frame 4	98×81	(4; 11)	B	30	1

Getting a Comprehensive View

The makers of web browsers are aware of the keen interest that many users have in how web pages are built, so they have included a number of interesting tools to help figure things out.

Netscape offers a *Page Info* window that summarizes each element that has gone into the current page (fig. 8). The window is divided into two frames. The top frame lists the full path name of each element in hyperlinked form. Clicking on one of these path names brings up a wealth of useful information about the element in the bottom panel, including the element type, its file size (before and after compression) and its physical dimensions in pixels. The window also displays a thumbnail view of the image showing how it appears in isolation from the rest of the page.

Estimating Page Performance

The speed with which a web page travels the net is influenced mostly by its total data size (the total amount of bytes used by its individual elements in compressed form). The *Page Info* window (or the similar *Properties* window in Internet Explorer) shows the contribution of each element to this total in the *Content Length* field. By looking at this size for each page element, a total page size can be determined. For example, the *Contact Us* graphic shown in figure 8 has a length of 2524 bytes, or about 2.5K. When this is added to the file size of the other page elements, a total for the whole page is reached (fig. 9). In this example, the total is about 47K—a reasonably sized page that will download in acceptable time for most users.

Another important aspect of file size is revealed by the *Page Info* window—the size of a page element *after* it has been decoded by the browser. This is its size after its compression has been undone. The uncompressed file size has no effect on transmission speed, but can cause other problems for the site visitor. A JPEG file, for example, can often go from 20K up to 2 megabytes after being decoded. These huge files can cause sluggishness and even system crashes on machines with minimum amounts of free memory. For further examples see page 84.

8

Netscape provides a *Document Info* window for every page. From this display users can see the name and location of each page element and examine a number of useful statistics about them such as file size, number of colors, transparency settings and date of creation.

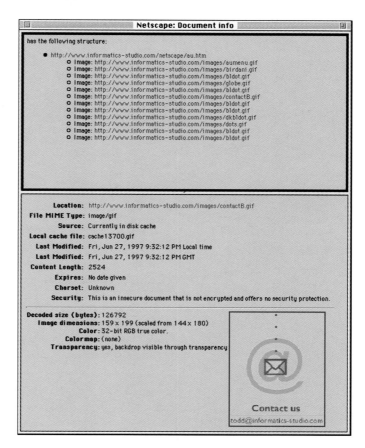

9

Looking at each element in the Page Info window (Netscape Navigator) or the Properties window (Internet Explorer) allows the total data size of a web page to be calculated. This table below shows the file sizes of the all the page elements that make up the *About Informatics-Studio* page shown in figure 4.

Page Element	Bytes	Description
au.htm	4,742	HTML file
aumenu.gif	14,612	2-frame GIF animation (navigation panel)
birdani.gif	14,539	4 frame GIF animation (oragami bird)
bldot.gif	41	1-pixel GIF file (spacer)
globe.gif	5098	6 frame GIF animation (spinning earth)
contactB.gif	2524	GIF file (e-mail icon and address)
dkbldot.gif	41	1-pixel GIF file (enlarged for blue bullet)
dots.gif	5125	GIF file (dotted line)
Total Size	46,721	

Exposing the Page

To delve deeper into the structure of a web page it is necessary to begin reading the page's HTML code, and if at all possible to play around with it as well. HTML is not a very difficult language to learn. Its basic building blocks all take on a similar form—a begin tag (e.g. <BODY>) and a corresponding end tag (e.g. </BODY>). These tags may span a relatively small distance in the file (as in the italic tag: <I>Aldus</I>), or a much larger region containing other HTML tags (e.g. the <MAP>, </MAP> tags in figure 10). Reading HTML code is never easy—its format is horribly unstructured and frustrates even experts—but, if you know what you're looking for, and use a search function in a text editor, you can quickly make headway.

The examples on this page demonstrate a very easy technique to bring a site's page structure into the light. They require a local copy of the page—copying all of the page's GIF and JPEG files, as well as the HTML source to your disk. Once there, a few simple edits of the HTML file make it possible to load locally.

The only change required is to make the specification of image files in the code consistent with their new location. To do this, strip away all path information from the IMG tags, leaving only the file name itself. For example, the image tag would be changed to . If this change is made to every image tag, and the downloaded files are stored in a single folder, the page will come right up.

Perhaps the simplest way to understand a page's layout is to expose the borders of its tables. Each starting table tag in the page will have a BORDER setting of 0 (assuming that they are not visible at the outset). Changing this value to 1 and reloading the page gives a result like that shown in figure 12. In more complex pages, with multiple tables, it may make sense to expose the borders one at a time, particularly when the tables are nested inside of one another.

10

One of the simplest and most revealing changes that can be made to a page is to make its borders visible. Simply search for the <TABLE> tags and change the BORDER size from 0 to 1. Don't choose a higher number. Thicker borders will distort the relative spacing of the table elements.

```
                        au.htm
<HTML>

<BODY BGCOLOR=#C5DEE6 LINK=#000099 VLINK=#000099>

<MAP NAME="auhead">
<AREA SHAPE="RECT" COORDS="0,40,85,60" HREF="home.htm" TARGET="_parent"
onMouseOver="window.self.status='INFORMATICS HOME PAGE';return true">
<AREA SHAPE="RECT" COORDS="100,40,205,60" NO REF TARGET="_parent">
<AREA SHAPE="RECT" COORDS="270,40,380,60" HREF="cliframe.htm"
TARGET="_parent" onMouseOver="window.self.status='CURRENT CLIENTS AND
SELECTED PROJECTS';return true">
<AREA SHAPE="RECT" COORDS="385,40,510,60" HREF="foliofrm.htm"
TARGET="_parent" onMouseOver="window.self.status='PORTFOLIO OF SELECTED
WORK';return true">
</MAP>

<CENTER>
<IMG SRC="../images/aumenu.gif" USEMAP="#auhead" BORDER=0>
</CENTER>

<CENTER>

<TABLE BORDER=1 WIDTH=475>
<TR>
<TD ALIGN=CENTER VALIGN=TOP ROWSPAN=3><IMG
SRC="../images/birdani.gif"><BR><IMG SRC="../images/bldot.gif" HEIGHT=100
```

11

Single-pixel GIF files are a common device for controlling the negative space of a page. By creating an alternative version of the file, coloring it with a bright complementary hue and altering the HTML file to refer to it instead of the original, the page can be brought up with the spacing elements exposed. In the HTML code shown below three instances of a single-pixel GIF are shown after such a change.

bldot.gif orangedot.gif

```
                    auColorDot.htm
<TABLE BORDER=1 WIDTH=475>
<TR>
<TD ALIGN=CENTER VALIGN=TOP ROWSPAN=3><IMG SRC="../images/birdani.gif"><BR>
<IMG SRC="../images/orangedot.gif" HEIGHT=100 WIDTH=1><BR><IMG
SRC="../images/globe.gif"><BR><IMG SRC="../images/orangedot.gif" HEIGHT=30
WIDTH=1><BR><A HREF="mailto:todd@informatics-studio.com"><IMG
SRC="../images/contactB.gif" BORDER=0></A>
</TD>
<TD WIDTH=20 VALIGN=TOP ALIGN=CENTER><IMG SRC="../images/orangedot.gif" HEIGHT=1
WIDTH=20><IMG SRC="../images/orangedot.gif" HEIGHT=23 WIDTH=1><BR><IMG
SRC="../images/dkbldot.gif" HEIGHT=10 WIDTH=10></TD>
<TD ALIGN=LEFT VALIGN=TOP WIDTH=300><BR><BR>
Informatics offers clients a creative environment with practical objectives. We merge
world class communications design with technology to produce award winning printed and
interactive marketing and training materials. Our clients range from global corporations
with universally recognized names like<A HREF="clifrbc.htm"
onMouseOver="window.self.status='SEE OUR WORK FOR BAYER';return true">Bayer,</A>
```

12

Exposing the borders of a table shows a lot about how a page has been put together. For example, we can see here that the navigation bar at the top of the page is not positioned within a table. Looking closely at the Source file reveals that it is held in place by a <CENTER> tag. Also it becomes clear that the three GIF files on the left are not spaced out with table cells, but by some other - at this point invisible - technique.

Exposing Single-Pixel Spacers

Many page layouts that use tables also use some form of single-pixel GIF files to manage the precise alignment of elements within the table cells. These GIF files are, by definition, invisible, either by being set to a transparent color, or by being set to the same color as the page background. Most single-pixel GIF files will have some name like "cleardot.gif", or "redpixel. gif" and can be easily spotted in the HTML code. A utility like the Netscape *Page Info* window discussed previously allows these images to be seen directly.

It is simple to expose these spacer GIFs by replacing them with a single-pixel file of another color (fig. 11). In the page shown on the right, a light blue single-pixel spacer (called "bldot.gif") is used in several places to position images and to space out the middle of the table. By replacing the "bldot.gif" references in the HTML code with "orangedot.gif", (and creating single-pixel GIF file colored a bright orange) the page comes up with the spacer tags perfectly visible (compare figs 12 and 13).

Don't be Afraid to Play Around

While it does take some knowledge of HTML code structures to make the changes shown in these examples, it is also true that reading and playing with HTML code is an excellent way to familiarize yourself with how professional web designers and programmers craft their pages. Also, *seeing* the structure of a page makes the relationship of HTML to various page structures a whole lot more understandable. With a local copy of a web page, you can muck around all you want, with no fear of ruining the real thing. Go ahead and break it—then figure out how to put it back.

Another benefit to reading other's HTML code is that it exposes you to formatting tags and coding structures that may be completely new to you. Using terms from these structures in web search engines can often lead you to on-line tutorials and discussions that make the use of these unfamiliar tags and technologies understandable.

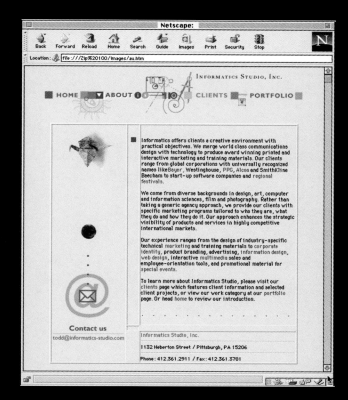

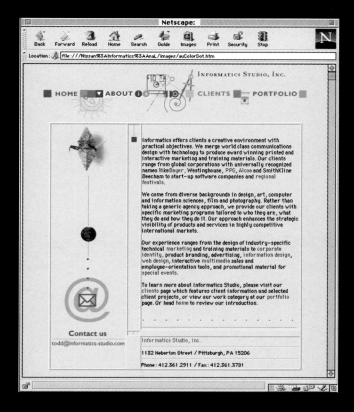

13

Changing the color of spacer GIFs shows their use in pushing graphic elements into place and in establishing the heights and widths of the page's gutters and vertical spacing. The method for positioning the three graphics in the left table cell is now clear.

Looking at Web Sites

We all have favorite web sites, and each can delight us in different

ways. Some impress us with their quality of information or with the

services they provide. Some fascinate us with their novelty, using

techniques or technologies that open up further the possibilities of

web-based communication. Others simply shine from the sheer

quality of their design and information architecture. When a site

catches your attention, it is well worth the time to stop and reflect on

how it is put together and why is seems to be such a pleasure to use.

A Difficult Medium

Building a good web site is no small challenge. The successful site design must account for a number of complex issues, ranging from the difficulties of mastering ever-changing web technology, to how to address audiences which are, at the outset, unknown in size and temperament. Building a web site opens up new challenges for the organization and presentation of information. New communication variables, such as motion, sound and interactivity, must be orchestrated with the design of text. A web site opens up the possibility of immediate feedback from the audience, and this two-way communication can greatly affect both the form and content of a site, which may have to evolve in response to comments or other interactions with users.

Technically, a web site must function within extraordinary constraints. Pages must be small enough to transmit in reasonable time. Color selection is severely limited due to the variability of computing platforms used to access the site. Typographic design has to anticipate the possibility of missing fonts and the inconsistent rendering of letterforms on various operating systems. New technologies that might make a site more efficient and useable, may not work for all users, many of which have not, or may never upgrade to the latest versions of web browsers or plug-in technologies.

Well-designed Sites

Well-designed web sites have several things in common. First, they have a clear understanding of their audience. They are designed to provide specific information to users in an efficient and appropriate manner. Second, they focus on using web technologies not for their own sake, but for their power to improve the site's message and services. Well-designed sites are simple in conception and consistent in their organization and interaction. Third, they are designed to accommodate change and growth. Web sites are, almost by definition, evolutionary documents.

Learning by Example

The 11 case studies on the following pages demonstrate these principles of good web design. They each exhibit a simultaneous regard for the needs of users and a realistic assessment of how to leverage web technology to improve their experience.

Structurally the sites demonstrate a thoughtful balancing of site architecture, navigation design, and the layout of particular pages, while aesthetically they manage a degree of visual sophistication that belies their attention to web constraints.

Each case study examines these features explicitly. A diagram accompanies each site, showing the overall site structure. The navigation design is laid out for view with special emphasis given to the relationship of its design to the site structure. Page structures are exposed (as discussed in chapter 4) to reveal the details of implementation and to show how consistency is brought to the design of the numerous pages that most of the sites offer. Finally, the studies show how information of various kinds and serving different functions are presented to users in both an effective and engaging manner.

Audi Germany

MetaDesign, Berlin

The Audi web site is an excellent example of extending an existing corporate identity onto the web. In its design of corporate publications and advertising, Metadesign developed an approach based on what they call a "multipicture look". This approach, using small cropped images arranged in tight orthographic relationships, would seem ready-made to move onto the web. In contrast to the visual elegance of its photographic mosaics and layering, realizing these compositions required a complex orchestration of tables and image splicing.

The site employs an elegant navigational scheme based on a coordinated set of color-coded symbols. Using a simple language of triangles and rectangular boxes, the design shuns the common practice of embedding links in the text of articles or within the site's numerous images. The economic typography and precise design of the site is in perfect keeping with Audi's reputation for fine engineering and lack of pretension. With its many images, some of the Audi pages push the the viewer's time limit on downloading. The inconvenience is more than compensated for, however, by efficient information design and an excellent and always fresh presentation of interesting and informative content about the Audi company, design philosophy and beautiful automobiles.

1

The entrance to the Audi site is refreshingly understated, avoiding the typical clutter of many web site front pages. To start, users choose a preferred language, and on occasion find a small image or message like the Christmas greeting (left). The site's home page is essentially a table of contents, introducing the color coding of sections and calling special attention to newly published articles or other additions to the site.

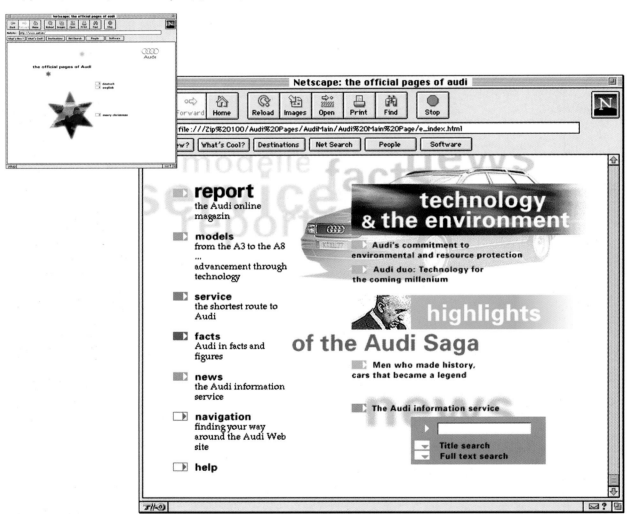

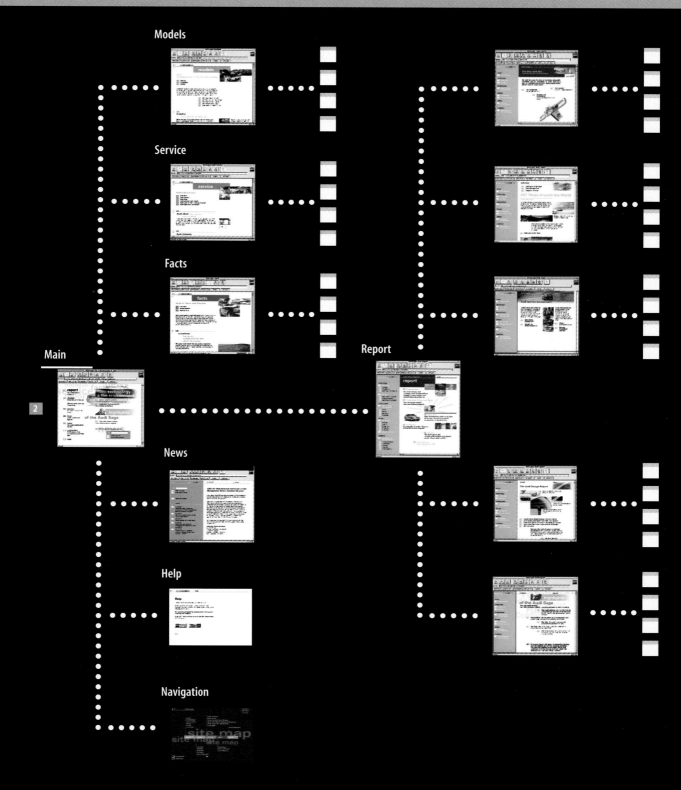

Models

Service

Facts

Main

2

Report

News

Help

Navigation

Site Structure

The Audi site, like most web sites, is arranged as a simple tree (fig. 2). From the first page the visitor moves on to one of five subsections. The *Models* section describes Audi's current line of cars. The *Service* section acts as an information service, providing dealer locations, dates of auto shows and announcements of other special programs. The *Facts* section focuses on investor-oriented information about the company and its performance, while the *News* section provides access to recent and archival press releases. Finally, the visitor can decide to move on to the *Audi Report*, the site's on-line magazine. The *Report* can almost be thought of as a site within the site having its own cover page and navigational structure (housed in an orange frame on its left side) and only occasional links back to the other sections of the site. Articles in the *Report* focus on feature stories such as company history, environmental philosophy and road tests of new models.

The navigational approach in the Audi site is simple and functional. Using a limited set of five arrow symbols—explained in the navigation help window shown in figure 3—users can move up or down within a given page, back and forth through a sequence of pages, or jump back to the current area's home page.

The arrow system is remarkably easy to pick up, and for first-time users the navigation help window is brought up in a separate floating window. The arrows are always set in a particular field of color indicating the area of the site that contains the linked information. Although the color-coding is essentially arbitrary—green

having nothing intrinsically to do with the concept of *service* for example—the colors begin to sink in after a little use.

One navigational device that does rely purely on the color codes is the "color bar" found in the upper left corner of most pages (fig. 4). This device provides "quick jumps" to the front page of any of the site's main sections. It seems doubtful that color alone would be enough of a signal to most casual visitors of the site, but the unobtrusiveness of the device argues for its inclusion. While it is never a bad idea to err on the side of obviousness in designing navigational controls, there may be a severe cost in terms of screen clutter.

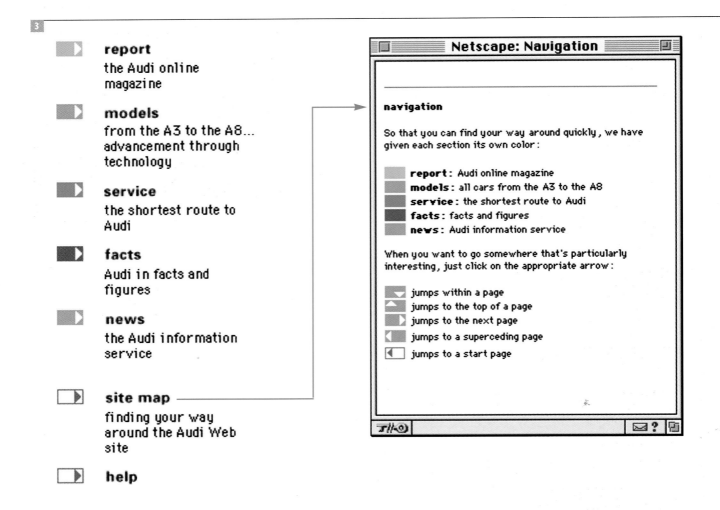

3

report
the Audi online magazine

models
from the A3 to the A8... advancement through technology

service
the shortest route to Audi

facts
Audi in facts and figures

news
the Audi information service

site map
finding your way around the Audi Web site

help

Netscape: Navigation

navigation

So that you can find your way around quickly, we have given each section its own color:

report: Audi online magazine
models: all cars from the A3 to the A8
service: the shortest route to Audi
facts: facts and figures
news: Audi information service

When you want to go somewhere that's particularly interesting, just click on the appropriate arrow:

jumps within a page
jumps to the top of a page
jumps to the next page
jumps to a superceding page
jumps to a start page

4

The title areas of each of the site's pages contain a small array of colored squares arranged on a 1-pixel rule. The colored boxes provide instant access to the other main areas of the site. To see the device in context, look at the top of the Models page shown opposite.

models

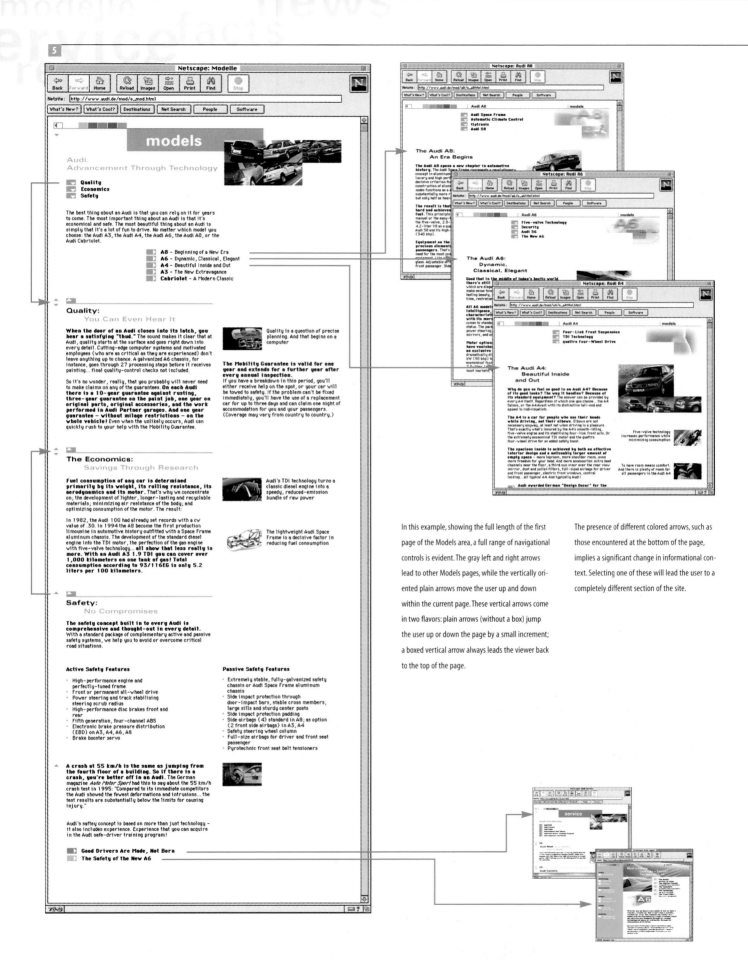

In this example, showing the full length of the first page of the Models area, a full range of navigational controls is evident. The gray left and right arrows lead to other Models pages, while the vertically oriented plain arrows move the user up and down within the current page. These vertical arrows come in two flavors: plain arrows (without a box) jump the user up or down the page by a small increment; a boxed vertical arrow always leads the viewer back to the top of the page.

The presence of different colored arrows, such as those encountered at the bottom of the page, implies a significant change in informational context. Selecting one of these will lead the user to a completely different section of the site.

One look behind the surface of these carefully crafted pages, and it is easy to see how difficult it is in HTML to accomplish even the most basic of graphic relationships. The simplicity of Audi's pages is achieved only by some very clever and ultimately convoluted partitioning of page elements into complex tables. As the examples on the next few pages show, the web is not an easy place to achieve precision and quality.

The *Audi Report* is a good place to look at the use of tables for layout of the page (discussed in the next section) and of frames to partition the screen. The navigational area in the *Report* (fig. 6) is implemented as a borderless, fixed-width frame. Containing a hierarchical collection of links to the various sections and pages of the *Report*, the links use targeting to control the appearance of the display area on the right.

The design of the tables in the control panel deserves attention as a good example of using nested tables in structuring a mix of bitmapped and HTML-set type. The implementation also introduces a simple technique for establishing a layout grid prior to laying in the content of the page.

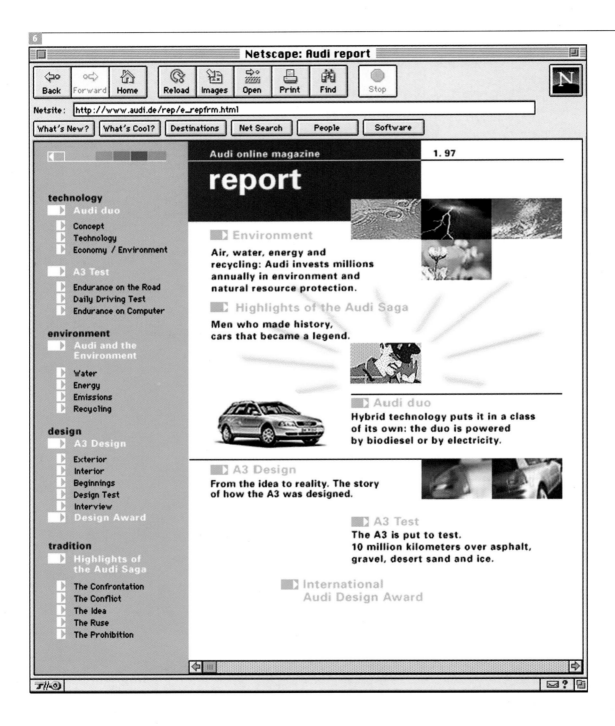

The *Report* Index is built as a two-deep nested table. The outer table establishes the index's horizontal divisions corresponding to the magazine's main sections and individual articles (fig. 7b). Additional tables control the line breaks of the article titles and achieve the vertical alignment of the white arrow buttons (fig. 7c). The overall structure of these tables (extracted from illustration 7b) is shown in figure 7d. Note the dramatic differences in size of the illustrations in figure 7.

As more of the table is revealed, a significant number of pixels are required to render the table borders. Showing table borders eats up significant amounts of precious screen space. Further it is clear that a good typographic arrangement makes the showing of table borders completely unnecessary.

HTML tables cannot generally be defined in advance and independent of their content. A clever work-around to this problem is seen here (fig. 8). By creating a 1-pixel high

row of table cells at the top of the page, a set of vertical divisions—a visible set of columns—is established. In subsequent rows each cell becomes a module of one of these subdivisions. While the grid implied by this top row is hardly flexible, it does provide a clear measure for the remaining elements.

7

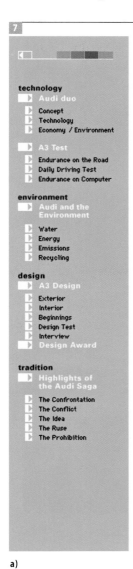

a)

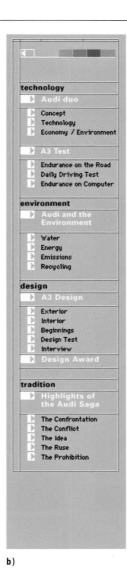

b)

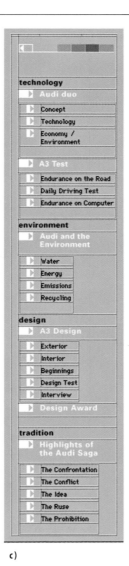

c)

d)

8

By creating a thin empty row at the top of a table all of the necessary subdivisions of the table can be defined in advance. This technique allows for the creation of margins, as in the first cell on the right, and for defining a modular division of the horizontal space. Elements placed in the table on subsequent rows can now be measured as a multiple of these divisions, yielding fairly intuitive values for the colspan settings in the table data tags.

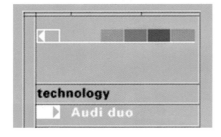

Current implementations of HTML provide little capability for layering. Other than the page's background image, all text and graphics must be assembled on a single surface. The Audi pages have a layered look, but the pages are actually built out of complex mosaics of cropped page areas. The resulting structure is very necessary in the design-hostile world of HTML.

The background image of the *Report*'s display area consists of the title graphic and a large white expanse (fig. 9a).

The remaining elements of the page are built in an ungainly stack of single-row tables, each taking care of a small lateral slice of the page. The first table (9b) locates the publishing date along the background's horizontal rule and uses an invisible GIF to pad space down to the next table. The second table (9c) establishes a left margin in line with the page title and defines a matrix of cells to hold the "Environment" link and the first three small photographs. The cells of the table are pre-

cisely sized to achieve the alignment of these images with the right edge of the title area from the background image. In the next two tables (figs. 9d and 9e) a complex slicing of the page elements gives the impression of sun beams passing behind the adjacent type and grayscale image. Figure 9f shows the remaining tables.

9

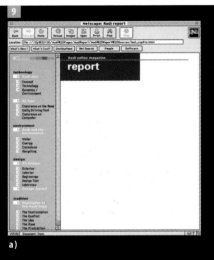
a)

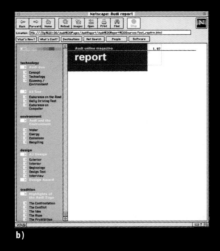
b)

c)

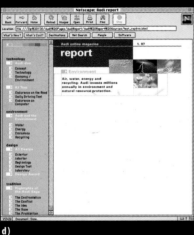
d)

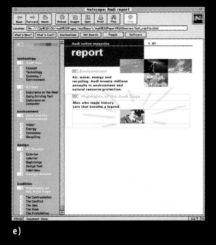
e)

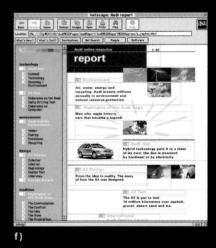
f)

These examples show that layering and precise alignment of elements is achievable in HTML. Unfortunately, registration between the background and foreground layers is not consistent among browsers. In Netscape Navigator, the background image of a page is aligned precisely with the upper left-hand corner of the window, but foreground elements are subject to a mandatory 8-pixel margin along the top and left-hand side of the page. This margin makes it impossible to bleed text or image off the the page.

This inconsistent treatment of margins (Internet Explorer allows margin control in all instances) is very damaging to cross platform consistency. Fortunately this limitation does not exist when using frames which have a margin setting observed on all browsers. Figure 10 demonstrates the problem. The right frame of the *Report* page has been loaded into Netscape by itself. The 8-pixel shift applied to the top layer of the page causes misalignment.

10

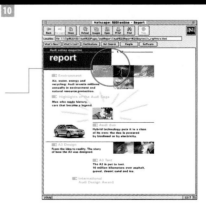

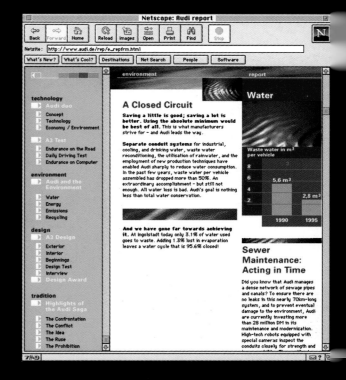

Image Size

In these four pages from an article on Audi's environmental programs (fig. 11), the foreground/background layering approach is continued from the *Report*'s front page. Each page focuses on a different aspect of environmental concern, and a dominant color is chosen to reflect the primal elements of earth, wind, fire and water.

Although the pages are rich in imagery, they are surprisingly small in file size. The block color of the graphs reduces to virtually nothing via run-length encoding and the small photographic images are saved as highly reduced JPEG files. The larger images are further reduced by an intentional use of low-resolution imagery.

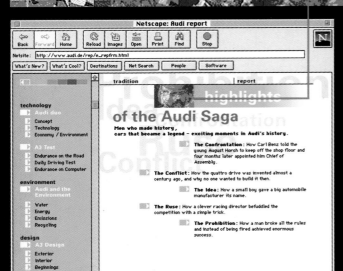

One of the more elaborately structured sections of the *Audi Report* is titled *Highlights of the Audi Saga*. Each page consists of a carefully crafted collage of rectilinear text and image forms. Photographs, text blocks, illustrations and animated GIF files combine to create a dynamic partitioning of the web page. The typography of the pages is set almost entirely in HTML, with the variations in type size and weight controlled by text formatting tags. Page titles and the reversed type are set in anti-aliased Helvetica and brought in as bit-maps. The pages shown here were captured with the browser font set to the recommended 9 pt. Geneva.

Several of the Audi Saga pages contain small black-and-white GIF animations. These grainy "films" have a strong historical connotation, evoking the flickering and stuttering quality of the silent film. Here is a classic example of leveraging the limitations of a medium to one's advantage. The evocations of the past come almost as a result of decisions driven by considerations of the web—reducing the dimensions of the image as much as possible, limiting the palette to a stark range of grays, and reducing the number of frames in the animation to a bare minimum.

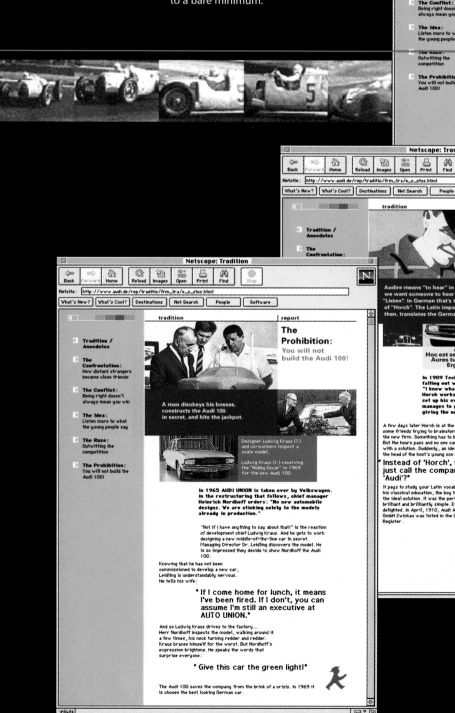

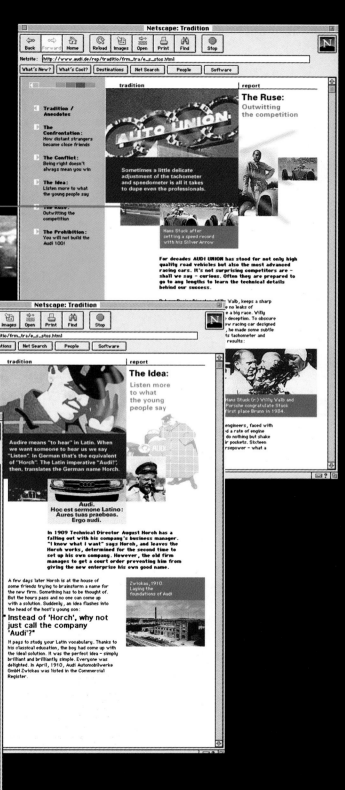

Avalanche Systems

Avalanche Systems Inc., New York City

Avalanche (fig. 1) is one of the true leaders in web based design, having designed compelling on-line solutions for clients in the arts, entertainment, film, financial services, insurance, publishing, real estate and retail. Their award-winning work can be found in virtually every design annual devoted to new media. Among the most notable of their web-based projects are sites for Elektra Records (www.elektra.com), F.A.O. Schwarz (www.faoschwarz.com), Price Waterhouse International (www.pw.com) and Carnegie Hall (www.carnegiehall.org). Avalanche is one of several design firms rapidly establishing New York City as a leading center of interactive multimedia design. The firm offers a broad range of design and technical services including strategic planning, public relations, interface design, corporate identity, networking, computer programming, electronic commerce and multimedia applications.

Using a straightforward typographic approach the site focuses on readability and information access. Visitors to the site learn about the firm's capabilities and design methodology and are given access to a comprehensive on-line archive of the company's portfolio. A simple site architecture, subdued use of user-feedback devices such as rollovers (fig. 2), and workmanlike typography makes navigation of the site's various sections a snap while the modest size of the site results in a quick mastery of the content by even the most casual visitors.

1

2

Visual intrigue is supplied to the splash page by a set of rebus-like symbols whose function is revealed by labels activated with rollovers. Rollovers are a simple way to add a dynamic element to a page and are particularly effective in making labels available on an as-needed basis. The result is a clean and uncluttered page.

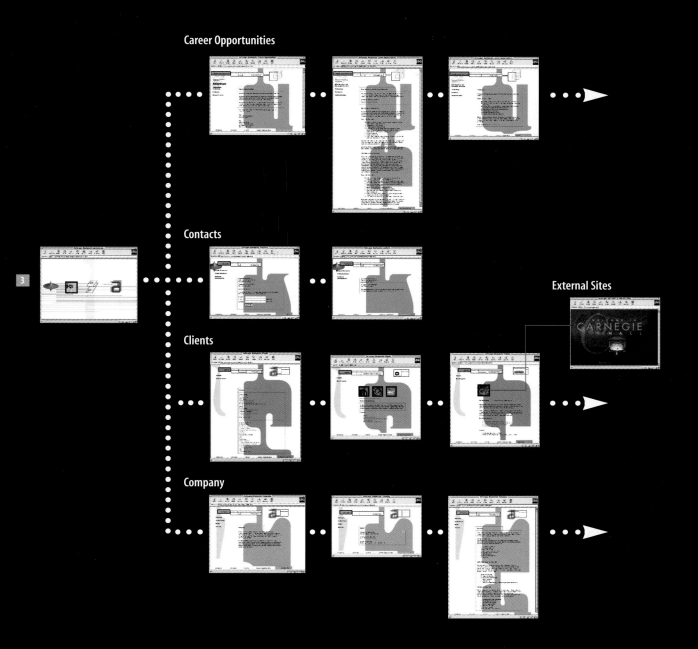

Career Opportunities

Contacts

Clients

External Sites

Company

The Avalanche site is divided into four main content areas (fig. 3). The pages within each section, and throughout the site, are similar in appearance and function. The background motifs, carefully crafted french-curve-like forms, remain fixed within each section while only the textual overlays (and an occasional image) differentiate one page from the next. As a result the site feels as if it contains only four pages each with a set of changing overlays.

The messages contained in the site are divided between everyday information—such as company contacts and job listings—and in-depth presentations of the company's capabilities, portfolio and awards. Hypertext links lead the visitor to on-line examples of work, as well as to reviews and articles about the company published in other parts of the web.

The Avalanche site is designed to ensure a varying, yet precisely controlled inter-play between the foreground and background layers of its pages. Large expressive forms span the page backgrounds providing an intriguing backdrop for the text as the window is scrolled (fig. 4). At 800 by 1365 pixels, the background image is large enough to keep from tiling and the large expanses of flat ensure that despite its large area, the file size will remain quite manageable. For example, the ochre background of the Services section, shown below, occupies only 8K and transmits almost instantly.

Running text is placed within what appears to be transparent text boxes drawn with 1-pixel rules. Simple in appearance,

these boxes require a convoluted manipulation of HTML tables. In order to float these HTML text fields and their ruled boundaries freely above the background image, each component has to be placed in a separate table cell. For the rules this means using table rows and columns which are a mere 1 pixel thick (see figure 4c).

While layering of graphics is now becoming possible on the web, there is still no reliable cross-platform standard. For the near term, table gymnastics like this (and the slicing and blending of frames discussed in figures 5 and 6) will remain a common design practice.

The simplicity and repetitiveness of the site's design language is intentional,

providing several noteworthy advantages to the user. First, the consistency and scale of the large background graphics creates a stable context for reading the largely textual content of the site. Second, the navigational controls are fixed to specific page locations and are therefore quickly mastered. Finally, the performance of the site is given a big boost by the reuse of page elements. With most graphic elements stored in the browser cache, a change of page often requires only the HTML text to be downloaded from the net.

4

The size and shape of a visitor's browser window is one of the many unknown variables in web page design. Educated guesses, however, can be made based on a knowledge of common monitor sizes.

The background images of the Avalanche site address this issue with ingenuity. Each page is designed to function at almost any size or proportion—whether viewed in the display area of a 14″

monitor (4a), a 17″ monitor (4b), or a 21″ monitor (4c). Visual variety is also a function of page scrolling (see fig 6).

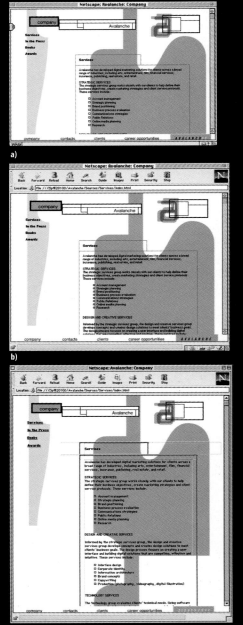

a)

b)

Most of the site's pages are partitioned into three distinct frames. The frame on the left side of the page offers navigational links within the current site section while the bottom frame supports navigation between site sections. The final frame, a scrol-lable page of text (and occasionally a small number of images) delivers content. Note the careful continuation of graphic elements at the frame edges. The result is a blending and visual integration of the frames into a unified composition.

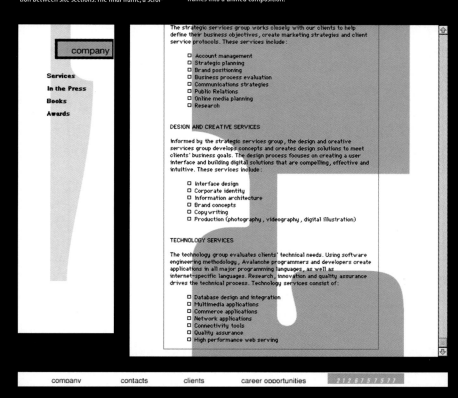

When HTML pages are loaded into the Netscape browser the foreground layer is subject to an eight-pixel margin at the top and left of the page. This margin, however, is not imposed by other browsers such as Internet Explorer. When precise alignment is required between the foreground and background layers this inconsistency can cause misalignment (see below right). Page elements loaded into frames, however, are relieved of this "margin problem". The splash screen of the Avalanche site takes advantage of this fact, using a single frame for the entire page. Set to a height and width of 100%, the frame stretches to fill any window size while guaranteeing consistent alignment (below left).

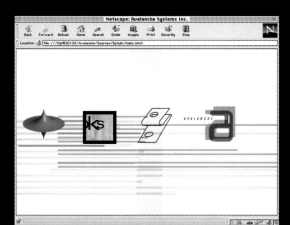
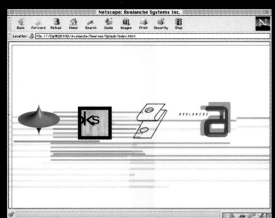

Animation

Animation is one of the most frequently abused elements in web page design. While the inclusion of motion, sound and video is much of what distinguishes a web page from its printed cousin, these effects are too often used for little reason beyond the fact that they are available and relatively easy to make. When a user is reading a page, sound and motion can be extremely distracting, so care must be taken in deciding when these elements should be included, and how active they should be within the visual field. The Avalanche site exhibits sound judgement in this area, first by limiting animation to the splash page (where reading is not the primary task), and by working the animation into the overall conception of the page.

When the splash page first appears, its animated elements are not immediately apparent (fig. 7). Soon, however, some of the linear elements begin to fade in and out in a slow syncopated rhythm. A line shakes subtly to the left and right, while, occasionally, a white highlight moves across and down the elegant curved shape in the page background. These effects are achieved by a carefully controlled and restrained use of animated GIF files (fig. 8). With their backgrounds set to transparent, the animated elements combine gracefully with the rest of the page composition.

7

Animation is used to breathe life into the page composition, not for tacked on entertainment value. Motion adds to the page's mystery by being intentionally understated and sporadic. Shown below left is the splash page as it appears to the user. The four animated GIF elements are indicated by the arrows. On the right these elements are shown as a transparent overlay with the transparent background color set to black for contrast.

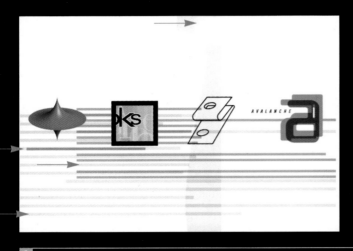

8

The frames of an animated GIF file are stacked within a single file and edited with a simple application such as GIFBuilder. Elements within each frame of the animation change in location (a and d), or in value (b and c), or in composition (d). The duration of each frame and its use of transparency can also be controlled. Note the very long delay given to the first frame relative to the others in each example below. This results in extended periods of inactivity in the animation and contrastingly brief periods of movement.

Frames					
5 frames	Length: 5.13 s	Size: 262×9	Loop: 248 times		
Name	Size	Position	Disp.	Delay	Transp.
Frame 1	262×9	(0; 0)	B	500	1
Frame 2	262×9	(0; 0)	B	1	1
Frame 3	262×9	(0; 0)	B	1	1
Frame 4	262×9	(0; 0)	B	1	1
Frame 5	262×9	(0; 0)	B	10	1

a)

Frames					
13 frames	Length: 5.61 s	Size: 254×8	Loop: 248 times		
Name	Size	Position	Disp.	Delay	Transp.
Frame 1	254×8	(0; 0)	U	300	–
Frame 2	254×8	(0; 0)	U	1	–
Frame 3	254×8	(0; 0)	U	1	–
Frame 4	254×8	(0; 0)	U	1	–
Frame 5	254×8	(0; 0)	U	1	–
Frame 6	254×8	(0; 0)	U	1	–
Frame 7	254×8	(0; 0)	U	250	–
Frame 8	254×8	(0; 0)	U	1	–
Frame 9	254×8	(0; 0)	U	1	–
Frame 10	254×8	(0; 0)	U	1	–
Frame 11	254×8	(0; 0)	U	1	–
Frame 12	254×8	(0; 0)	U	1	–
Frame 13	254×8	(0; 0)	U	1	–

b)

Frames					
11 frames	Length: 4.70 s	Size: 444×11	Loop: 248 times		
Name	Size	Position	Disp.	Delay	Transp.
Frame 1	444×11	(0; 0)	U	450	–
Frame 2	444×11	(0; 0)	U	2	–
Frame 3	444×11	(0; 0)	U	2	–
Frame 4	444×11	(0; 0)	U	2	–
Frame 5	444×11	(0; 0)	U	2	–
Frame 6	444×11	(0; 0)	U	2	–
Frame 7	444×11	(0; 0)	U	2	–
Frame 8	444×11	(0; 0)	U	2	–
Frame 9	444×11	(0; 0)	U	2	–
Frame 10	444×11	(0; 0)	U	2	–
Frame 11	444×11	(0; 0)	U	2	–

c)

Frames					
13 frames	Length: 7.60 s	Size: 190×153	Loop: forever		
Name	Size	Position	Disp.	Delay	Transp.
Frame 1	190×153	(0; 0)	B	700	1
Frame 2	190×153	(0; 0)	B	5	1
Frame 3	190×153	(0; 0)	B	5	1
Frame 4	190×153	(0; 0)	B	5	1
Frame 5	190×153	(0; 0)	B	5	1
Frame 6	190×153	(0; 0)	B	5	1
Frame 7	190×153	(0; 0)	B	5	1
Frame 8	190×153	(0; 0)	B	5	1
Frame 9	190×153	(0; 0)	B	5	1
Frame 10	190×153	(0; 0)	B	5	1
Frame 11	190×153	(0; 0)	B	5	1
Frame 12	190×153	(0; 0)	B	5	1
Frame 13	190×153	(0; 0)	B	5	1

d)

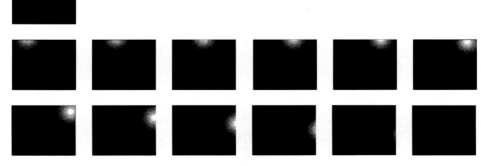

With the advent of new technologies introduced to the web such as Java, Javascript, Active-X, Shockwave and Flash, the degree of interactivity and animated effects available to designers can far surpass the simple click-and-wait realities of basic HTML. Macromedia's Shockwave technology, for example, allows fully functional Director files to be played within web pages (for those users that have installed the Shock-

wave player plug-in). To show off the work that it has done for its many clients, Avalanche creates and distributes promotional materials in a variety of media. An example of this is a disk-based mailer that took users through an interactive tour of its award-winning web site for Elektra records. To gain a wider audience for this presentation, Avalanche makes this tour available directly from its site as a Shockwave file.

Starting with the Warner Music Group portfolio page (fig. 9), a simple mouse click brings up the shockwave file. Once loaded, users interact with its screens in exactly the same manner as those who received the file on disk, clicking on flashing arrows, text and assorted graphic elements to move through the presentation.

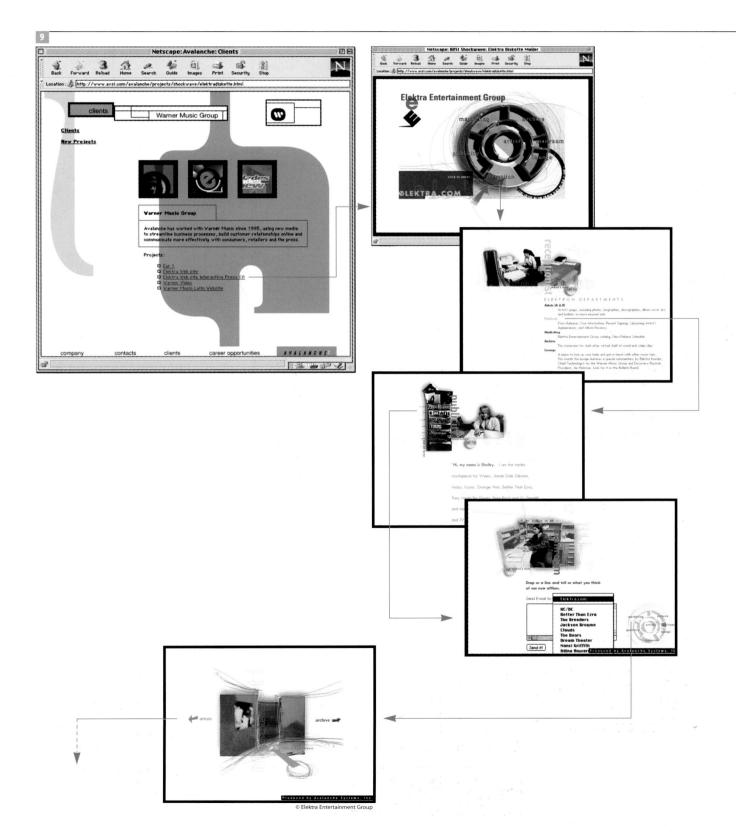

© Elektra Entertainment Group

Carnegie Hall

Avalanche Systems Inc., New York City

Few performance halls are as well loved or steeped in musical history as New York City's Carnegie Hall. So, fittingly, the star of this site is the building itself. Whether it is being discussed directly or just used as a backdrop, the building is a constant presence. Each of the site's section header pages features a large background graphic showing a sinuous architectural detail accompanied by a large swash capital echoing the page's subject matter. These

elements are contrasted by the site's typography which features generously spaced uppercase Futura rendered in luminous orange and white.

The site offers information on virtually every aspect of the Hall's operation including a searchable concert calendar, an on-line box office, information for patrons and donors, schedules of educational and community service programs and even a gift shop.

The site's architecture is kept very simple, so access to the many informational subsections of the site is virtually instantaneous. The design of this site strikes a perfect balance between visual elegance and information access, providing a meaningful experience to both casual visitors and regular patrons.

1

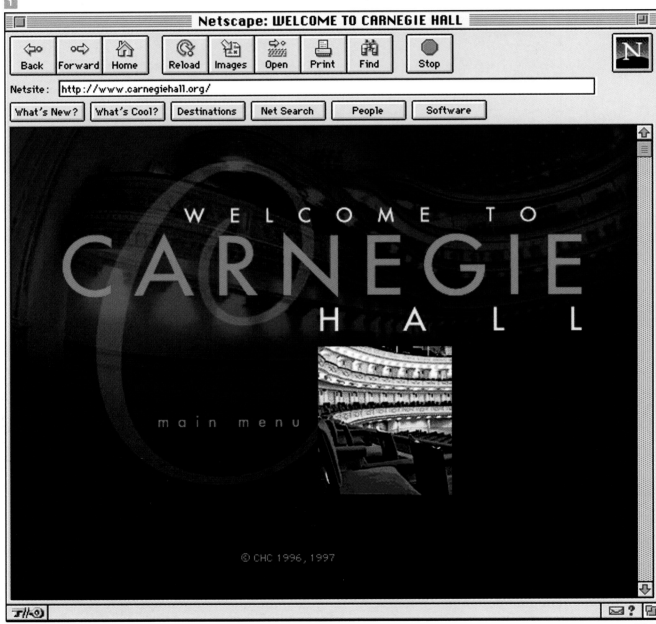

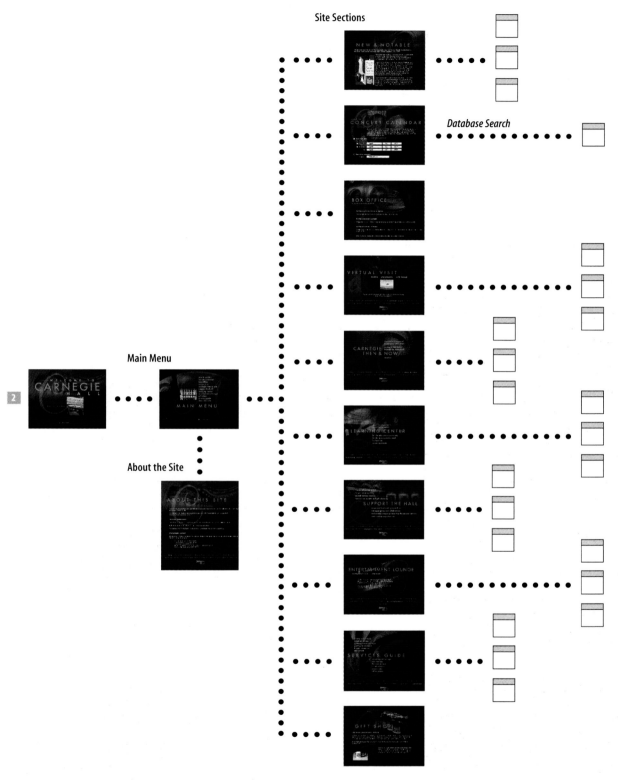

Site Sections

Main Menu

About the Site

Database Search

The overall shape and size of a site hierarchy can depend on a number of factors but should always reflect an appropriate division of information based on the needs of its users. A common mistake in web design is to offer too many navigational options per page. While users often want to get to

the information as quickly as possible, they do not want to get lost in the process. The Carnegie Hall site offers users 11 different paths off the main page. While this number would be too many in most sites, it works here because each site area addresses a unique type of information. There are virtu-

ally no cross-links between the sections, so for the user, this broad, flat hierarchy provides an efficient and perfectly clear navigational space.

Page Structure

For all of their visual richness, the pages of the Carnegie Hall site are built from just a few simple parts. The site is formatted in a seamless mixture of bit-mapped and HTML-set text. Simple tables establish page grids which juxtapose page titles in an asymmetrical relationship with the running text. Clever use of alignment settings within these table cells allows for the relatively easy creation of architectonic relationships of type and image (fig. 3). The striking page backgrounds are saved as large JPEG files. Spanning 750 pixels across and as much as

900 pixels up and down these background images are sure not to tile, even on the largest computer monitors (fig. 4).

Large background JPEGs are one of the simplest ways to give a site the degree of visual complexity that is now customary in the design of print. With the limited support for layering elements on a web page, a straight-forward solution is to merge a number of layered elements (assembled, for example, in Photoshop) into a single bitmapped image. It is important to note, however, the size of the file

when compressed (affecting transmission speed), and the size of the file after it has been decompressed in the user's browser (where it can occupy significant amounts of RAM). In Figure 5 the huge differences between the compressed and uncompressed versions of the background images are shown.

3

The site's Menu page consists of three main visual elements: an image of the building facade, a list of the site's main sections, and the screen title. The building image defines the focus point for the construction of the table. The white text links are bitmapped text stacked into the lower left corner of the cell by an align bottom and left setting. The orange title bitmap is simply centered within the middle cell below.

4

Background images are made to span a size that will exceed any reasonably sized browser window. The photographs of the Hall and the large letterform are placed in the upper left. The height of the image and the amount of solid blue space required is determined by considering the maximum height of a browser window (rarely will users extend a window beyond 800 pixels), or by the amount of page content that will be placed above it.

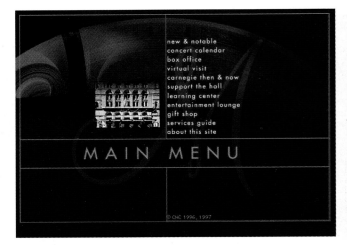

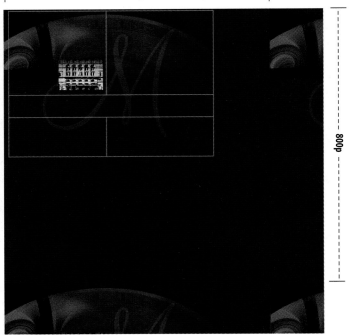

5

JPEG files can result in extraordinary compression of full-color images, but this magic is only in play when the file is stored away in a file. When expanded to full size by a browser they again will occupy a significant amount of space. The memory consumed in this case is in the RAM of the user's machine. Taking too much space can cause system crashes for those with minimal computing setups, so it is important to keep an eye on file size both before and after compression. Compare the differences in the four Carnegie Hall backgrounds shown below.

a) compressed: 28K, expanded: 1.5mB

b) compressed: 22K, expanded: 1.8mB

c) compressed: 30K, expanded: 2.1mB

d) compressed: 29K, expanded: 1.4mB

One of the best measures of success for a web site is the simplicity with which users can locate the particular information they are seeking. A search engine, if designed well can often save users hours of poking around a site in search of a small but significant fact. The Concert Calendar page in this site (fig. 5) offers users the ability to search the various music programs scheduled for the Hall at least a year in advance and in a wide variety of ways. The multidimensional search criteria allow users to sift through the concert schedules for the work of particular composers, for the appearance of favorite performers, by date or by a series of key words.

The design of the page is somewhat encumbered by the necessity of using the prepackaged elements of HTML forms. Because it is virtually impossible to design and implement custom designed text fields and pulldown menus, pages with interactive forms reflect a compromise between visual integration and function.

A well-designed form page is one where the logic and hierarchy of search criteria are apparent at a glance. Formally, the best designed pages treat the form elements as a rigid grid, with field lengths set to a common standard and all alignments carefully in register.

A typical search is to look for the appearance of a favorite composer. In the example shown here, the user has chosen to search by all dates, and for performances of the music of Prokofiev. The first screen returned lists, in a very encapsulated form, the titles and dates of performances that meet the user's request. From here they can search again, or examine one of the search hits in more detail. In this case it is revealed that a particular violin sonata is to be played on November 16th.

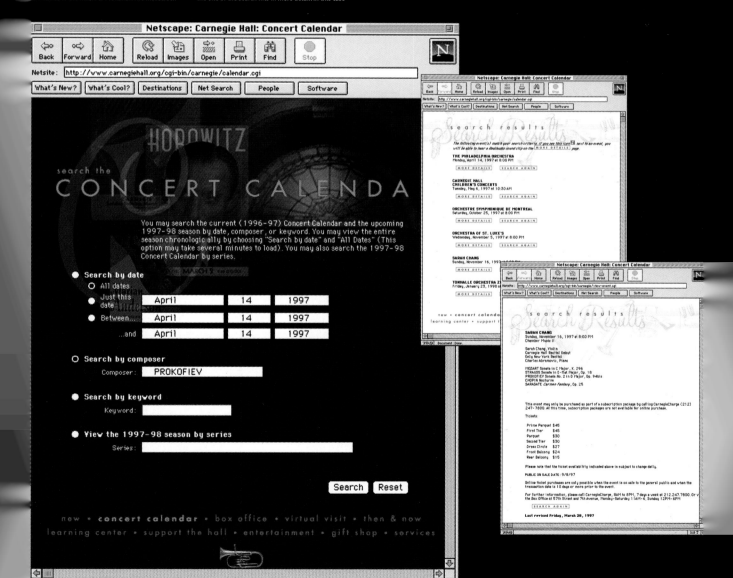

While the Carnegie Hall site offers a wealth of useful information to both attendees and supporters of the building, perhaps its most unique offerings are its three interactive tours. Users from around the world, many who will never have the opportunity to see the Hall in person, can partake in "virtual visits," gaining an almost firsthand feel for the building's wonderful architecture and fabled past. The most dynamic of these tours is the interactive "photo bubble" (fig. 7). Using a technology from IPIX

(www. ipix.com), the interior of the Hall has been captured in a 360 degree fish-eye image. With a player program downloadable at the site, users are transported to the front of the Hall's main stage where they can look around the room at will. Interaction with the viewer is remarkably simple (fig. 8), and the sense of immersion in the space is quite convincing.

User's interested in the history of the hall can move on to the timeline and walk-through areas (figs. 9 and 10). The

time line uses an elegant scrollable graphic as an index into many pages of historical information and images of important artifacts. The walk through allows users to experience a "hypertour" of the building's main spaces by following links through a series of photographs. The tour is made more special by the inclusion of an audio track providing commentary by one of the Hall's most important benefactors, violinist Isaac Stern.

7

VIRTUAL VISIT

timeline photo bubble walk through

Try this month's Carnegie Hall Quiz in the Entertai...
Enter to win free tickets!

new • concert calendar • box office • **virtual visit** • then & now
learning center • support the hall • entertainment • gift shop • services

All images © CHC 1998

8

Users move through the spherical photograph by holding the mouse down near an edge or corner of the display window. Cursor icons provide instantaneous feedback as to the direction of travel, and speed is controlled by the distance of the

cursor from the window edge. Clicking in the middle of the image results in a zoom in or zoom out. Moving closer to the image reveals no additional detail, but adds significantly to the three dimensionality of the space.

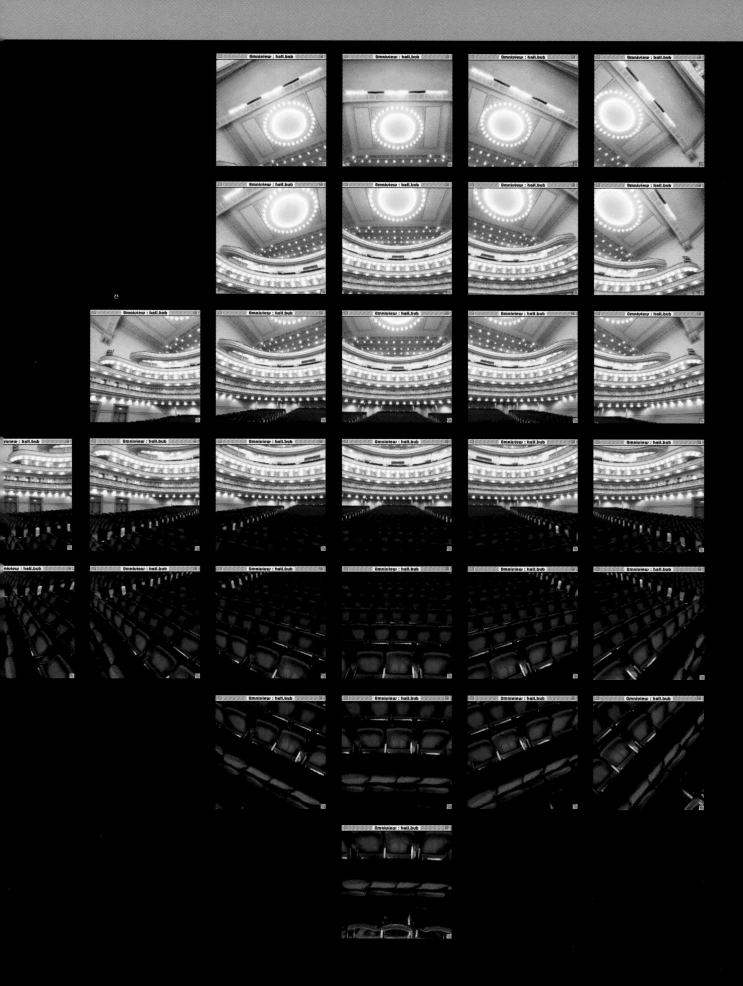

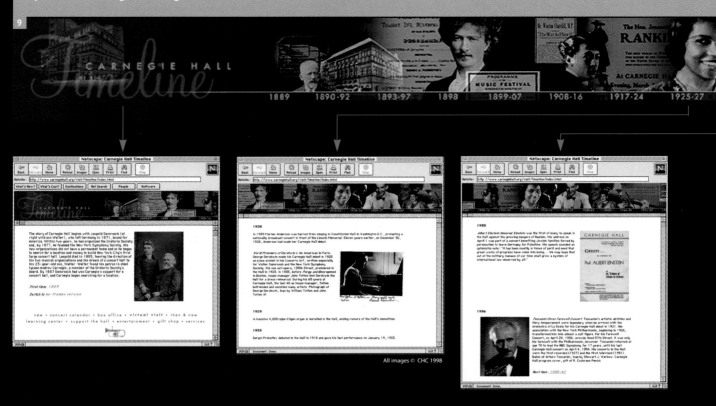

All images © CHC 1998

10

The walk-through area of the site is implemented as a hyperlinked photo tour of the Hall's public and private spaces. Though not as immediate as the photo bubble, the careful design of the tour's links results in a similarly convincing sense of the architectural space. To keep the tour flexible, users can move through the space in any order they choose. The narration, playable through RealAudio, adds a sense of privilege to the user experience. The beautiful photographs are of the highest quality on the screen and result from a use of JPEG compression at the highest quality settings.

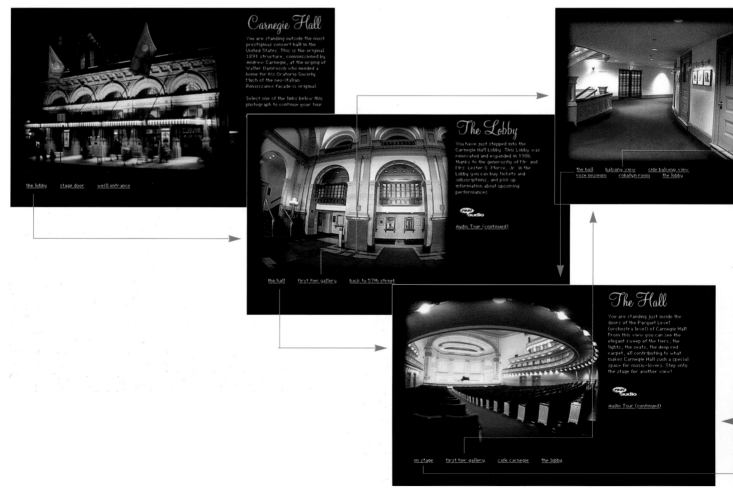

All images © CHC 1998

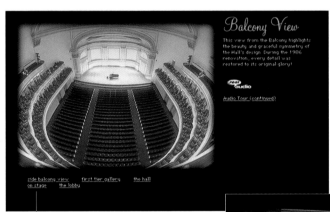

Balcony View

This view from the Balcony highlights the beauty and graceful symmetry of the Hall's design. During the 1986 renovation, every detail was restored to its original glory!

Audio Tour (continued)

side balcony view first tier gallery the hall
on stage the lobby

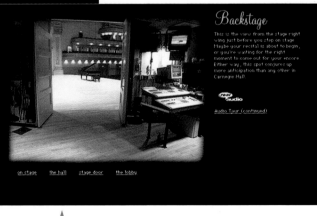

Backstage

This is the view from the stage right wing just before you step on stage. Maybe your recital is about to begin, or you're waiting for the right moment to come out for your encore. Either way, this spot conjures up more anticipation than any other in Carnegie Hall.

Audio Tour (continued)

on stage the hall stage door the lobby

On Stage

You are now standing on stage at Carnegie Hall! This view is just what artists see when they step out from the wings. You can see all the levels of the Hall, from the Parquet up to the First Tier, Second Tier, Dress Circle, and Front and Rear Balconies. Quite a view!

Audio Tour (continued)

the hall from the wings back stage lobby

Discovery Channel On-line

Discovery Communications Inc., Bethesda, Maryland

The Discovery Channel site has been a favorite destination on the web since its debut in 1995. One of the first sites to achieve a distinctive graphic presence, it was an early pioneer in the use of tables to precisely control compositional space. In contrast to the typical gray drabness of most web pages at that time the Discovery Channel's pages presented visitors with bold images, colorful letterforms and articulated white space. Instead of burying navigational links within pages of text, the site brought navigation front and center. The site's initial screens, consisting of small non-scrolling templates of clickable images (figs. 1, 3) provided a navigational superstructure through which users found feature articles on themes from the Discovery Channel's established subject areas.

In spite of its critical success and inclusion in numerous "best-of the web" lists, the site was overhauled in the latter half of 1996. While the site had favorable reviews for its visual design, user studies and informal feedback indicated that the site conception was flawed. The image-heavy screens, though small, proved to be slow in transmission. The navigationally top-heavy structure of the site (see next page) proved less effective than the emerging practice of sidebar control panels made popular by the emergence of HTML frames.

The new design represents a redistribution of image and text, and a new relationship between content and navigation. The focus of the new design is on getting users directly to the information that interests them and building communities of users around the unique subject matters of the Discovery Channel and its sister stations. In abandoning the small tiled screens of the earlier design, the new site presents these themes and their related materials more conventionally, but with much greater efficiency than in the past.

1

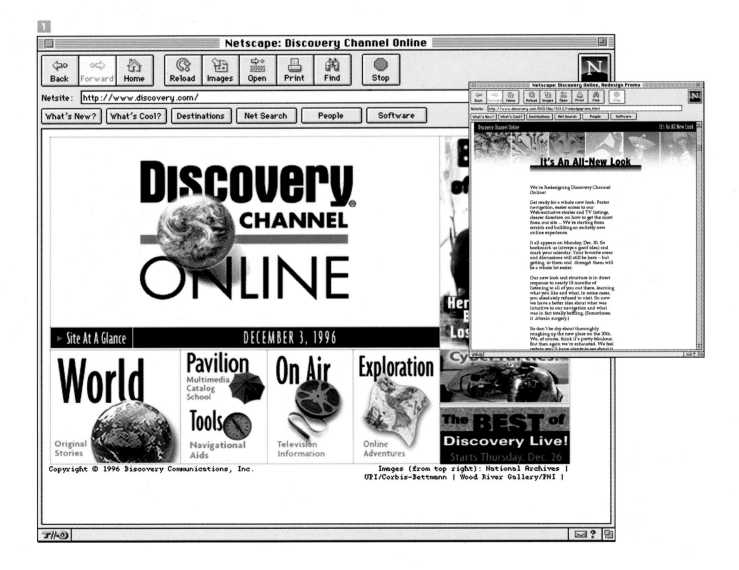

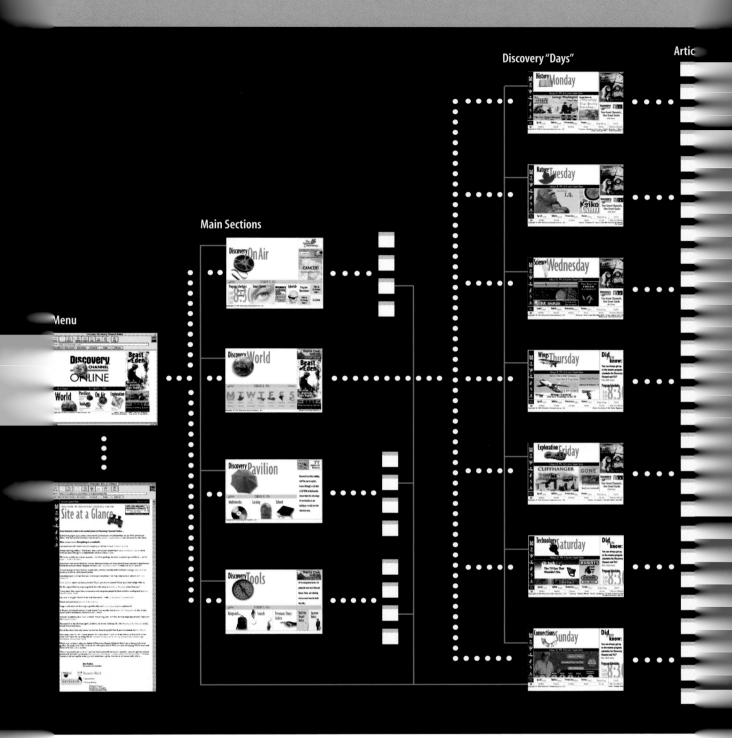

Menu

Main Sections

Discovery "Days"

Artic

ginal Discovery Channel site was
ed as a combination of hierarchical
own in the white dots above) and a
x network (suggested by the blue
ne site felt very tree-like due to the
ne had of drilling down from broad
ies at the top levels to specific arti-
d other information at the bottom.
's network-like nature was due to
sence of the numerous links pre-

sented along the perimeter of most pages.
These allowed users to "go anywhere, from
anywhere," and to shift the context of navi-
gation at any time.

The site had two primary sets of
navigational screens. Immediately below
the main screen were screens devoted to
four main site areas—*On Air* providing tele-
vision listings; *Pavilion* housing the site's
catalogs and special programs; *Tools* con-

taining search engines and archives; and
World, the primary conduit to the site's
daily rotation of feature articles. These daily
features made up the second set of naviga-
tional starting points. Pairing a particular
theme with a given day of the week, these
pages allowed users to visit the site to
keep up on favorite subjects.

The pages of the original Discovery Channel site were unique when they first appeared on the web. Composed almost entirely of bitmapped text and small iconographic images, their design seemed to circumvent the crudeness of HTML typography and page layout. This was achieved by tightly packing visual elements into the smallest space possible—the non-scrolling display area of a 13"

monitor. The site made heavy use of HTML tables, then a newly discovered layout tool, and, in a bold yet pragmatic move, left their borders visible as part of the page design. These borders served to separate and give order to a complex visual structure.

Because the site's tables are so visible—and so wonderfully varied—they have long served as reference points for students of HTML table construction. A

brief study of these structures and their formatting codes reveals quite elegantly the mysteries of table rows and columns and, of course, the perplexing notions of colspans and rowspans. The tables used to structure three typical Discovery Online pages are analyzed on the next page.

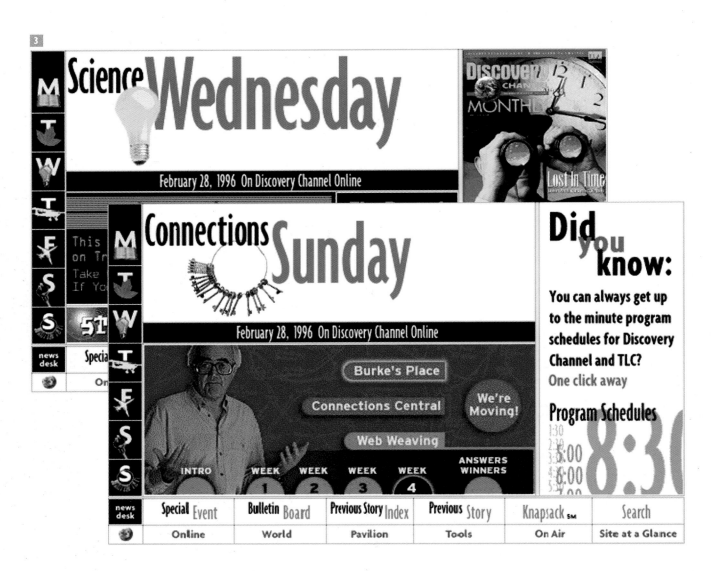

The first step in defining an HTML table is to draw it out. Working from an accurate sketch allows the number of cells and their dimensions to be known in advance. As our first example, consider the relatively simple table used in the *Discovery Pavilion* page (fig. 4).

Tables are built up cell by cell, from left to right and top to bottom. In the *Pavilion* example, the first table row consists of two cells (shown in blue). Moving down and starting again at the left, the next cell to be defined is the orange one, placing it in row 2. Since the blue cell to its right has already been defined, the second row is now complete. Moving down again, the third row starts and ends with the three red cells.

The site's main page (fig. 5) uses a table that is a slight variant of the one described above. The blue, orange and red rows are organized in more or less the same fashion, but with the vertical dimension of the second blue cell shortened to allow additional cells to be inserted underneath. The third row now consists of five cells spanning the entire width of the table. The last of these cells, like the last cell in the blue row, is shortened to allow other cells to be included beneath it. These remaining cells, being the only ones unaccounted for become rows 4 and 5.

When a cell intrudes into the space of another column or row, its 'colspan' and 'rowspan' properties must be specified. The colspan of a cell must be set equal to the maximum number of cells it crosses in any other row of the table. In the three examples on this page the colspan of the upper left blue cell would be 3, 4 and 7—the number of cells that are spanned in the red row. The orange cell in these examples would have a colspans of 3, 4 and 10, with the latter value being derived from its spanning cells in the red and green rows.

The rowspan property works in exactly the same way, only in the vertical dimension. The second blue cell in these examples has, for instance, a rowspan of 3, 2 and 1 respectively.

When a division of space is needed that is unrelated to the divisions of the table (alignment is not desired with other cells), it is easiest to start another table. The bottom row of the Story Index page (fig. 6) is a good example of this situation.

4

Row 1 →
Row 2 →
Row 3 →

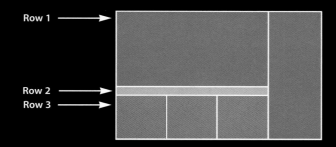

5

Row 1 →
Row 2 →
Row 3 →
Row 4 →
Row 5 →

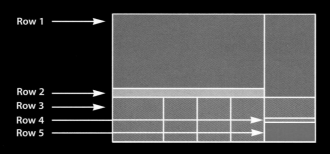
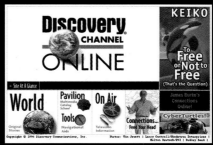

6

Colspan = 7 →
Colspan = 10 →
Rowspan = 2 →
New Table →

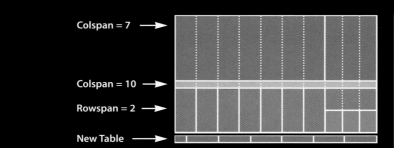

The most obvious change in the new Discovery Channel design is the overall proportion the pages. The first design showed the inappropriateness of the no-scrolling philosophy to a site as large and content rich as this. The new pages vary considerably in length, taking as much space as is necessary to deliver the content. Where the previous design used color—its signature white, green and red—for unifying pages, the new design uses color for differentiation. Strongly colored backgrounds, sidebars and in some cases, hyperlinking text, color-code the various sections of the site.

A significant simplification in the navigational design is the introduction of the top banner graphic, present on most pages. This simple device provides immediate access to the site's main content areas, a function that in the previous design was buried at the third level of the site (the daily pages shown in fig. 2).

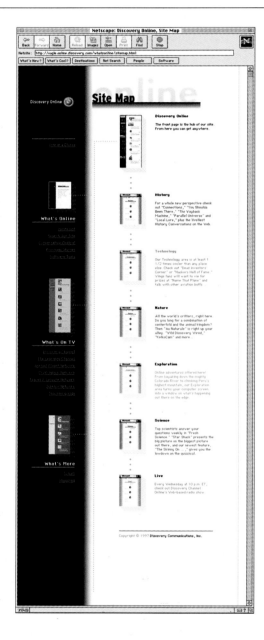

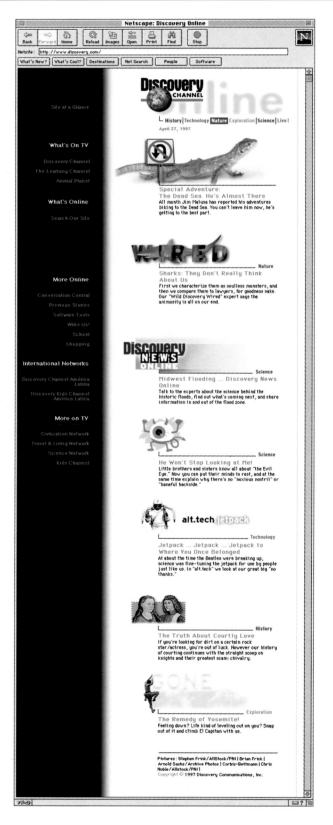

Interest Areas

Service Areas

Feature Article

History

Technology

Nature

Exploration

Science

Live!

The new Discovery site is organized into two distinct functional halves. On one side, and most prominently featured, are the special interest areas—collections of articles and programs built around the core domains of the Discovery experience: History, Technology, Nature and Exploration. On the other side, accessible from links in the black sidebar area of the main page, are the more permanent areas of the site: the commercial and service areas such as television listings, the site's archives, a product catalog, an extensive area devoted to educational support, and several pages devoted the site design itself. At the center is the site's main page, *Discovery Online*. Containing links in all directions, this page sits at the crossroads of the navigational routes between the site's major areas. The centrality of this page is designed to provide a familiar face, a kind of navigational landmark allowing users to reorient themselves as they move in different directions through the site. The final form of the new site is essentially a set of several hierarchical trees, all emanating from the same central root.

The pages of the redesigned site are simple. The rigid and complex mosaics of the earlier design have been replaced by a more flexible scrolling page (fig. 9a). Indeterminate in length, this design is able to expand or contract depending on the number of currently available articles. Freed from the space constraints of the site's previous format, the pages have a more relaxed and uncluttered feel.

The new design is implemented in a simple 5-cell table (fig. 9c). The two cells at the top, housing a running advertisement and a large title-area graphic, appear on every page of the section. The rest of the table divides the page into three columns with two outer margins and a central space for the page content. Rather than subdivide the center column horizontally with additional table structures, the images and text are carefully controlled to sit exactly within its 300-pixel width.

Vertical spacing in the column is achieved with nothing more than simple line breaks. The dashed lines of figure 9c show the implied partitioning of this column. The symmetry of the design is reinforced by the background image, a 24-bit JPEG (fig. 9b), showing ghosted images of a pair of kayakers on one side and mountain climbers on the right. These images, drawn in smooth blends are, unfortunately, not very readable on 8-bit monitors.

b)

a)

c)

Articles in the Discovery site range from straightforward single-page entries to multi-entry, evolving features like the one shown below. While the site encourages audience participation in all of its subject areas—each area of the site supports an electronic bulletin board for example—the site sometimes ups the interactivity quotient by serving as a form of participatory news wire.

The *Journey to the Center of the Earth* event (fig. 10a) tracked the daily exploits of bicyclist/journalist/adventurer Jim Malusa as he followed Moses' trail from Egypt to the Dead Sea. Readers were encouraged to follow regular reports from Jim's laptop computer, and to interact with him via e-mail. Periodic discussion groups, moderated by experts in mid-east history and politics elicited further audience involvement (fig. 10d). In addition to the daily reports, readers could investigate the equipment being used on the trip (fig. 10c), or explore related sites on the web.

As a special feature, some pages contained unique interactive possibilities, such as the Photo Bubble™ representation of the Citadel mosque in Cairo. Viewed through a special viewer, the user could pan, tilt and zoom through a 360° panoramic photo, gaining sense of scale and space impossible from a static array of images (fig. 10b).

c)

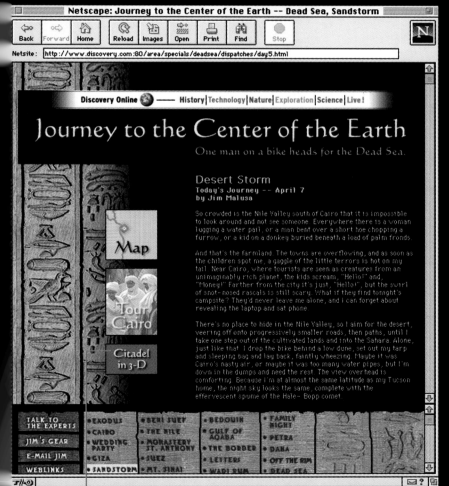

a)

d)

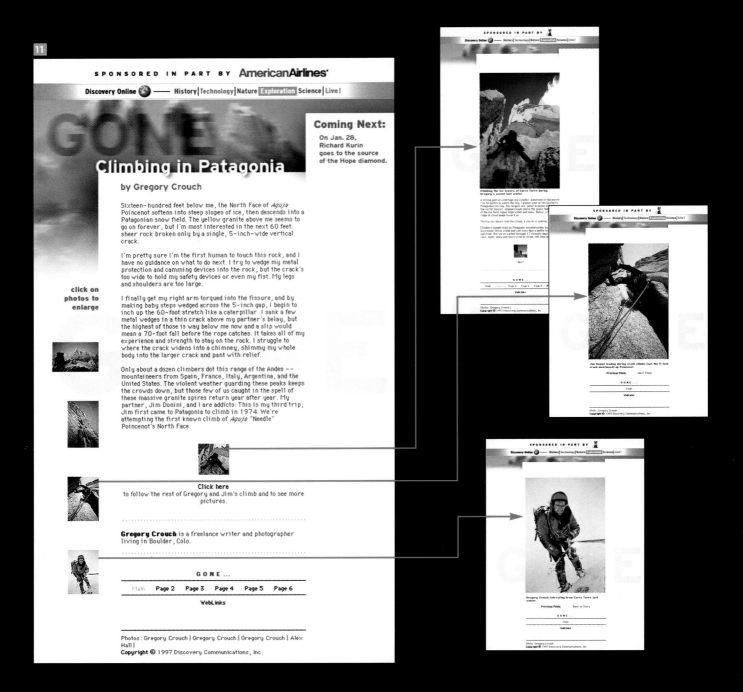

Discovery OnLine operates under a regular programming/publishing schedule. Each topic area of the site features a set of recurring articles, and at any given time, three or four of these are available from the area's main page. As articles of a particular kind accumulate, they are linked together, permitting readers to move through the site's archives for other installments in the series.

In the Exploration area of the site is a travel/adventure series called *Gone* (figs. 11 and 12). The articles in this series provide readers with bi-weekly visits to exotic corners of the globe. The article begins with a main page that includes a brief essay from the author/traveller and a series of thumbnail images. These images serve as hyperlinks to a photographic scrapbook of the trip. The photo pages may be viewed in sequence, or intermittently from the main page. Visually, the *Gone* series is characterized by its distinctive title designs and interlocking column of type. Digitally manipulated photographs, evoking, but not literally illustrating the article's content, are cropped by a rectilinear meander across the top of the page. The layered style of the design is amplified by the application of drop shadows to the descenders of the title's letterforms.

Discovery Online — History | Technology | Nature | **Exploration** | Science | Live !

GONE
to the Sword Man

by David Tracey

Coming Next:
On May 20, Hannah Holmes tours Thailand

click on photos to enlarge

"It's a long story," is the first thing Tsunahiro Yamamura says when asked about his family. Which is the whole point. He's a 24th-generation swordmaker. His son, who would be the 25th, has other plans.

Kamakura is a pleasant coastal city an hour's train ride from Tokyo, known mostly for its Buddhist temples. But 850 years ago, when the first shogun settled here, it was a hotbed of samurai activity. Swordsmiths flocked to the new capital to serve the warrior class. But their weapons were undependable: long, straight, unwieldy and brittle. Thirteenth-century Mongol invaders twice were thwarted by "kamikaze" winds that pushed their ships back toward Korea, but "the government realized that if there was another attack they were going to lose," says Yamamura. "So they started researching how to make a better weapon. That's when a man called Masamune helped come up with a new way to design a sword with blended steel. He was my ancestor."

Dressed in white, the Shinto color of purity, Yamamura thrusts a brick-sized block of metal into a coal fire, then pulls it out, glowing red, to be pounded into shape. The resulting clang is deafening, the sound of his family at work for more than 700 years. "We have to get all the impurities out of the steel," Yamamura explains. "It's hard because there are so many places where you can go wrong. If a tiny air bubble gets into the steel before it's folded, it will end up making a scratch and I'll have to throw the whole thing out. I usually have to make about five swords to get one that I think is worth keeping."

Masamune, born in 1274, combined soft and hard steels into a gracefully curved sword, hard enough for battle but not so brittle that it would snap on impact. His design was copied worldwide. Masamune passed the tradition on to his son, starting what is probably the world's longest recorded lineage in craftsmanship. Because of their ties to the country's rulers, Yamamura's family has a written history of each swordmaker's birth and death dating back more than seven centuries.

Others swordsmiths from Masamune's day also passed the tradition from son to son. But when it came to war, enemies quickly learned that swordmakers were good people to kill first. "Scouts would be sent into enemy territory to get the swordmakers. There were two things the scouts could do," Yamamura says. "One was kill the swordmaker. A lot of swordmaking families died out this way. The other way, which they did with the best ones, was to take them back to work. That's what happened to my family, and that's why we were able to continue this long."

Peace also was progressively hard on the profession: Japan's internal wars mostly ended in the late 1500s, the samurai class was no longer recognized in the 1800s; American military authorities banned swordmaking for four years after World War II. But Yamamura's family kept working.

"We used to have a huge amount of land," Yamamura says, sweeping his arm up toward a distant mountain from the tiny storefront and workshop where he makes his swords. "This is all we have left." Today Yamamura's swords are bought by art collectors, people interested in a family keepsake for a newborn, or patrons who donate them to shrines and temples. The cost of a single sword blade starts at about 2 million yen -- nearly $16,000.

But for quality control swordsmiths are allowed to produce only two swords a month. The government also issues a demanding test to aspiring makers. Some years it lets only one new member into the profession. And like many of the 300 swordmakers in Japan, Yamamura has to do something else to keep the business alive. He makes kitchen knives, a pile at a time, but isn't too interested in talking about the process. "If I could, I'd rather just make swords. But I do what I have to in order to eat."

Swordmaking is hot, it's hard, and it doesn't pay all that well. And Yamamura's 18-year-old son wants to be a singer. "Opera," Yamamura explains. "He says he's going to Italy. What can I say? I can't really recommend swordmaking as a great way to make a living."

Once, Yamamura didn't want anything to do with the family business, either. He studied graphic design at a university. Then in his early 20s he got interested in the art of sword appreciation. "I began to realize how beautiful a sword can be. After that I wondered whether I couldn't make one myself."

His father had died in World War II, so Yamamura learned the art from his uncle. It took five years. "It was tough, but it really does takes that long just to learn."

Yamamura hangs on to the hope that his son will be like him and change his mind. "When I was learning, it was very hard, and I thought a lot about quitting. Why did I continue? Only because I thought that I had to keep our family tradition alive. It was a defensive move, which is not the best reason to choose your life's work. But I knew that if I didn't do it nobody else would."

He's happy with his career choice, and suspects his son might be, too, if he decides to keep the tradition going. "I remember how I didn't like being pressured, so I'm not going to do the same thing to him. He's still more interested in music. I don't think he understands the beauty of swords yet. I tell him music is fine, but once you sing a song, where is it? If you make a sword it will last for 1,000 years."

David Tracey is a freelance writer who lives in Vancouver, British Columbia, and writes often about Asia.

Some Other Places We've Gone:

Patagonia | Mexico | Turkey | Antarctica
Inside Passage | The Big Wood River | Iceland

GONE ...

Main

WebLinks

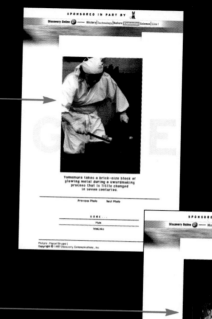

Yamamura takes a brick-size block of glowing metal during a swordmaking process that is little changed in seven centuries.

Yamamura teaches his son the martial art of Iaido "The Way of Drawing the Sword."

Drawing the sword

IDEO Product Development

MetaDesign West, San Francisco

IDEO is a full-service product design consultancy with expertise in industrial design, manufacturing, human factors, interaction design and engineering. To communicate the depth of their work, IDEO commissioned MetaDesign to work with them on developing a web site that would show the diversity of their portfolio and make a statement in its design about IDEO's commitment to innovation.

The site pushes the possibilities of the web in several ways: technically, by its extensive use of Javascript; and conceptually, by questioning the literalness of the web "page" as the appropriate metaphor for formatting on-line information.

In keeping with IDEO's focus on product design, the site has the feel of an elegant machine—a sort of on-line, interactive slide viewer, a magical light table on which dozens of the firm's choicest slides have been laid out for view. Starting with a playful animation based on the versatile IDEO logo (fig. 1), the interface settles into an elegant interactive environment allowing users to familiarize themselves with the extensiveness of the firm's portfolio and to get a feel for its diversity of expertise and culture.

1 The site opens with an elegant animation exercising the possibilities of the versatile IDEO logo. Consisting of four squares placed in a four-by-four grid, the mark is intended to support several arrangements. Shown here are three partial sequences of the animation. After bringing forth several key words starting with the letter "i", the final logo appears as a hyperlink to the rest of the site.

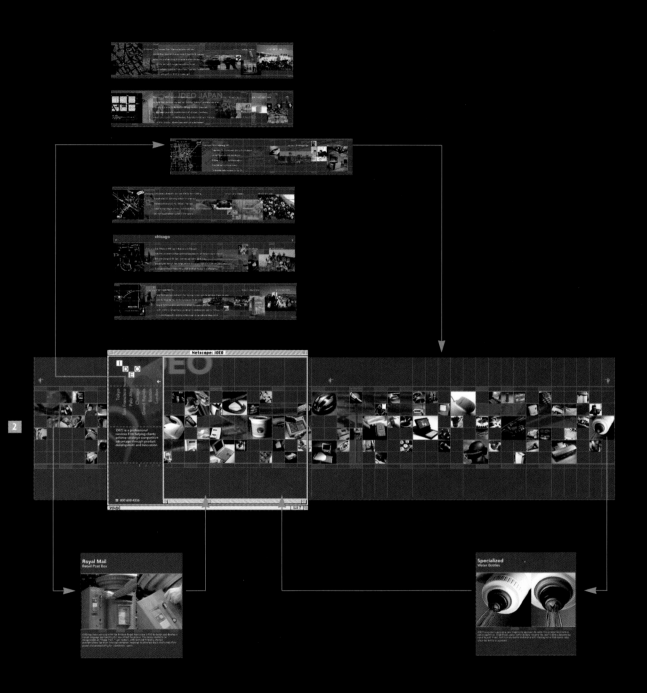

Site Structure

Unlike most web sites, the structure of the IDEO site is not ideally captured by the model of a hierarchical tree. In that structure the user has the clear sense of moving up, down and across some information space. With this model, however, users have the sense of information being brought to them, rather than their having to go and seek it out.

The first panel loaded into the viewing frame, shown in figure 2, above,

displays highlights from the company's portfolio. From each thumbnail image, users can bring up a full-screen overview of the product showing additional photographs. Another set of panels, providing contact information and directions to each of IDEO's seven offices, is accessible from a menu on the left of the screen. Each of these includes a printable detailed map providing street directions for those planning on a visit (not shown above). A brief

statement of the company philosophy and capabilities is also available in a small panel on the left side of the viewing frame.

Like a great many web sites, the IDEO site divides the browser window into two vertical HTML frames. This approach allows the high-level navigational controls of the site to be separated from the primary content. Nicely avoided, however, is the typical decision to treat the frames as visually distinct zones. Throughout the interaction with the site, the palette, typography, structure and rhythm of the two frames are in perfect synchrony, a coherence greatly enhanced by the use of horizontal scrolling. No mat-ter where on the page the user is looking alignment within the grid is guaranteed.

The design takes full advantage of Javascript-encoded rollovers to provide feedback and additional text. For example, when the mouse passes over a thumbnail image in the portfolio page (fig. 3), a yellow box appears around the image confirming its status as a live link. Above and below the image bitmapped text labels identify the relevant expertise that contributed to the product design. Rollovers play a similar role in the horizontal menu of IDEO office locations, and in the interaction with the page numbers of the brief text description of the company's strengths and philosophy (fig. 4).

Navigation of the site's large panels requires nothing more than interacting with the scroll bar at the bottom of the frame, or just for fun, turning on the automatic scroll feature by clicking on the "pointing man" icons at the top of the page (fig. 5).

3

Controls located in the left frame of the page deter-mine the choice of content on the right. Starting with the portfolio page (seen here), users can access information on any one of the IDEO office locations including contact names and specific directions from the nearest airport (see fig. 6, opposite). The white arrow icon serves as a back button. A short verbal description of IDEO is also provided in a series of bitmapped text panels (shown below in fig. 4). Several of the site's many rollover functions are on display here.

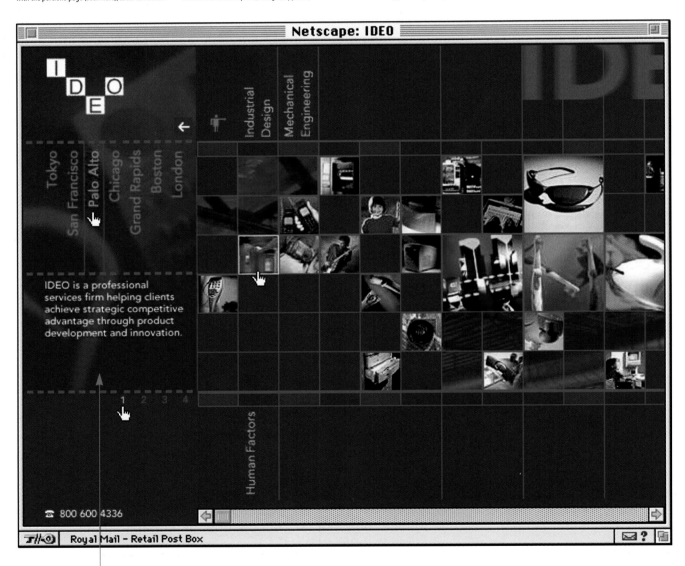

4

IDEO is a professional services firm helping clients achieve strategic competitive advantage through product development and innovation.

Working with clients from a broad range of industries, IDEO has helped create more than 4000 products, and gained a breadth of expertise unmatched by any other firm.

The 300 people on IDEO's team include specialists in the fields of industrial design, human factors, interaction design, environments, mechanical engineering, electrical engineering, software engineering and manufacturing liason

IDEO has served clients in more than twenty countries from its seven office locations in North America, Europe and Japan.

Clicking on one of the "pointing man" icons engages a simple Javascript routine that scrolls the panel automatically in a smooth animation. The code simply adds or subtracts a small increment from the current scroll location while testing for the end of the frame. The autoscrolling can be interrupted by selecting one of the hyperlinked elements on the scrolling page or by interacting with the control panel frame.

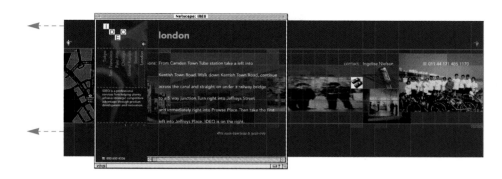

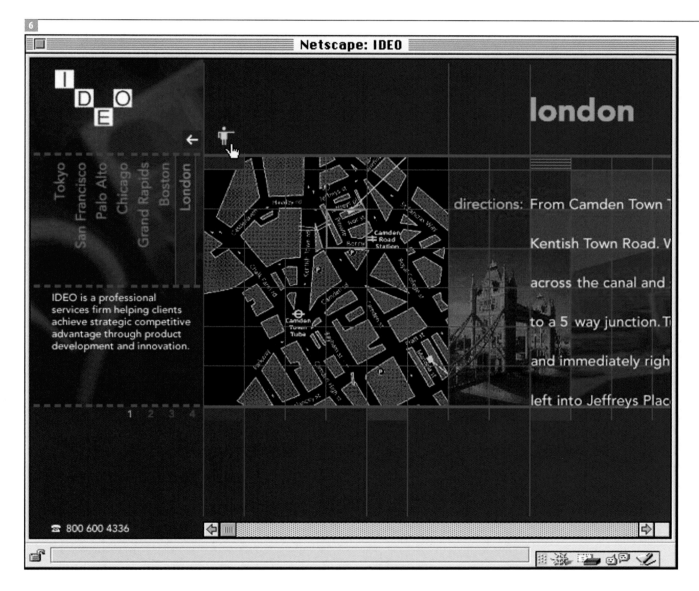

Page Structure

The layout of the site's large graphic displays requires unusually large HTML tables. Divided into lengthy rows of fixed-size units, these tables match the square shapes of the massive JPEG image in the page background (fig. 8). Surprisingly, the tables are not used to position the thumbnail images of IDEO product designs (these are part of the background graphic) but are used to overlay a number of small GIF files above and around them. The purpose of this arrangement is best understood by considering a few examples.

The top row of the image is covered by a table containing 46 identically sized GIF files, some containing simple graphic elements—the "pointing man" icon and the blurred IDEO letters for instance—and others of a simple solid blue. A sample of these is shown at the top of figure 7. The purpose of these overlaying GIF files is twofold. First, because of the high degree of JPEG compression applied to the background image, there are severe defects in its solid-color areas. The GIF overlays mask these problems out, restoring the crispness of the page. Second, since rollovers occur over each product shot, each must have a unique graphic object in place to which the rollover code can be attached.

An example of this function is shown on the far right of figure 7. When a product shot is contacted by the cursor, a transparent blue frame hovering above the image is replaced by a bright yellow one. The appropriate blue panels above and below the image are also replaced with text labels showing which facets of IDEO's expertise contributed to the design solution. A sample of these frame-like GIFs is presented along the top of figure 7 with the previously mentioned images.

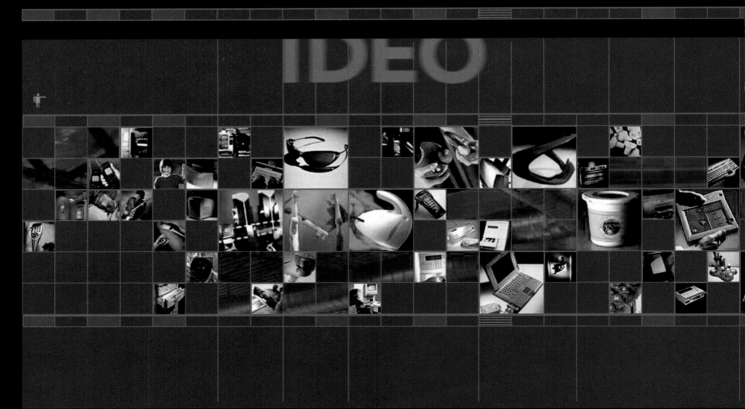

8

A large JPEG image forms the backdrop for a detailed grid implemented with HTML tables. The tables are used to locate small transparent 1-pixel frames around the small product images. Each row of the table is precisely measured to ensure perfect alignment of the background image's many parts. (The misalignment of the table cells in the image below is only a by-product of exposing the table borders for this illustration.

Industrial Design Mechanical Engineering

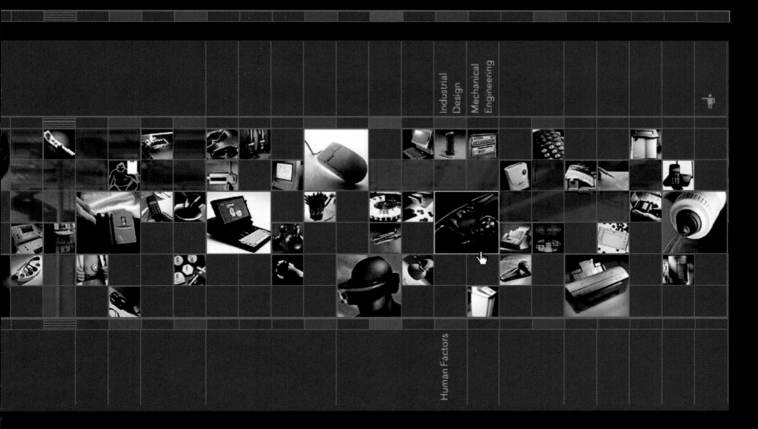

Industrial Design Mechanical Engineering

Human Factors

Human Factors

When the IDEO site is first entered, a check is run to determine which web browser is being used. If the browser supports Javascript, a new browser window is launched, and the remainder of the site is loaded there (fig. 9). If the browser is not Javascript compatible, the original browser window is all the user sees. This window contains a short welcoming message, and the details of the technical requirements for viewing the site.

The decision to move the site in its entirety to a separate browser window is unusual, but results in several important advantages in maintaining the precise layout of the site's interface and information design.

In the usual situation the formatting codes for a web page cannot effect the browser's window size or shape—it is already set by the user when the page arrives. This is not the case, however, for windows created by scripts arriving with the page's HTML code. Using Javascript, a separate window can be launched and loaded with a new HTML file. This window, created on the fly, can be specified to an exact pixel size, and most importantly, with its page resizing controls removed.

The design of this site depends heavily on the precise relationship between its page elements, and, between those elements

and the window frame. A wider window would open up empty spaces around the product pages (like the one below for example), and a significantly larger window would likely result in tiling of the background image (fig. 10).

While these problems are encountered by every site designer, the approach taken here shows a novel way to work around them. There are some costs—for example, exclusion of users without the appropriate browsers and a little extra memory to maintain two windows—but the result is a graphic precision that is unique.

9

Using a separate window to format the site content allows increased control over the proportions of page elements and it ensures their permanence over the course of the interaction. External windows can be fixed in size, creating a predictable environment in which to define HTML frames, while page backgrounds can be defined without concern for how they will tile in different sized windows.

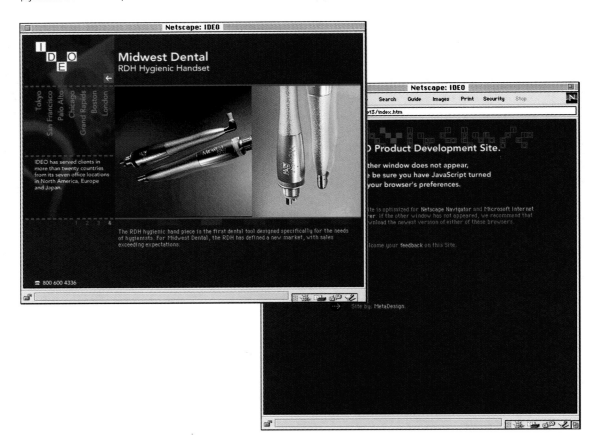

10

The IDEO site is shown here as it would appear in an arbitrarily sized browser window. The background images of the two frames tile along the bottom.

The large scrolling graphic panels of this site place heavy demand on the normal trade-offs that must be made between image size, image quality and transmission. To achieve the site concept, JPEG compression has to be taken to the extreme, and even then, the pages push the boundaries of acceptable transmission size.

Consider the site's worst-case, the portfolio page. At 1795 by 464 pixels, the background graphic of the scrolling panel—even when subjected to the most severe JPEG compression—is a whopping 77K (fig.11) . On top of this, the many small graphic elements overlaying this image,

and the rollover behaviors associated with them, require a significant amount of HTML code to describe. Where most of the pages shown in this book require HTML page descriptions ranging from 3K to about 30K, this page's code occupies 56K. Factoring in the size of the small GIF files (described in figure 7), the total file size of the panel area is about 136K. Totals for the remaining elements of the site interface come up to about 36K. This implies, for some dial-in visitors, an initial loading time of at least 3 minutes, and with the control panel elements in the cache, a 2 minute wait for each subsequent panel. For users with

faster connections (the target audience for the site) the wait is less significant, but noticeable.

What of image quality? While the visual quality of a design portfolio is extremely important, in this context the goal is to show IDEO's vast experience and the diversity of its clients. The impression given by the numerous images of the portfolio panel do this perfectly.

11

JPEG compression produces images which are remarkably readable, even after severe image reduction. The imperfections and obvious lack of clarity observable in this enlarged illustration virtually disappear when the image is viewed at normal size on a computer monitor. The masking off of the grid squares by the GIF overlays (see figure 7) also contributes greatly to the image's appearance.

12

Shown here for comparison are two versions of the same image used in the site. Figure 12a is an enlargement of the thumbnail image used in the grid above (fourth image from the left in row 3). The larger image (12 b) is taken from the full-page description of the product (like that shown in figure 9). JPEG compression is extreme (12 c), but at this larger size the image reads remarkably well.

a)

b)

c)

Informatics Studio

Informatics Studio, Pittsburgh, Pennsylvania

The Informatics Studio site (fig. 1) introduces the work and services of this design firm to the international audience of the web. Founded in 1992, Informatics Studio specializes in corporate communications in a wide range of media and informational contexts. This site is intended to serve a dual purpose.

First, through a continual focus on the studio's portfolio, the visitor's attention is directed to the high caliber of work performed for an array of clients. Second, the site demonstrates by example the firm's emerging strength in putting together clear and elegant interactive visual communica-

tion on the web. The formal elements used within the web site—the color scheme, typography and playful iconography—are drawn from the studio's existing print identity. The result is a strong unified presence in all facets of client relations.

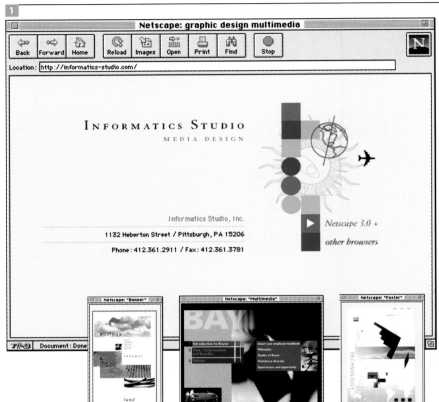

The Informatics Studio site is designed with one clear mission in mind: to put the studio' portfolio on display. Shown here is the site's initial screen which provides a quick confirmation of the site's content and a request for the user to indicate which browser is being used. Shown also are a few of the many on-line illustrations of the Studio's work in both print and interactive media.

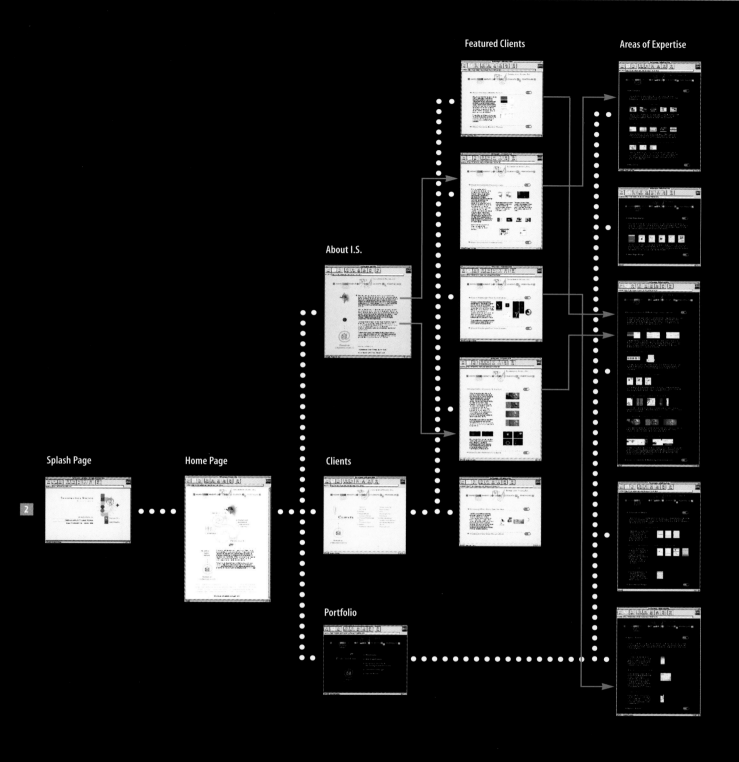

Featured Clients

Areas of Expertise

About I.S.

Splash Page

Home Page

Clients

Portfolio

The architecture of the Informatics site is built with the aim of portraying the studio's work and design approach from a number of perspectives (fig. 2). After the initial screen (shown opposite) a home screen directs visitors to the site's three main content areas. The first, *About I.S.*, describes the business from a primarily verbal perspec-

tive with embedded text links allowing direct jumps to client profiles and related work. The next section, *Clients*, profiles several key client relationships and presents brief case studies of projects done with them. Finally, a *Portfolio* section presents work based on diverse application areas and media. To help visitors establish con-

nections between work done for different clients, the site offers direct links from the client case studies to similar projects in the Portfolio. These hot links are kept few in number and, with their destinations clearly indicated, result in little or no disorientation when the user jumps across the site structure.

The main wayfinding tool in the Informatics site is the playfully designed navigation bar located at the top of each page (fig. 3). Using type elements, iconographic symbols and a small dose of animation to indicate its links, the banner also shows which part of the site is currently in view. A white arrow inside the colored square next to the section name, coupled with the activation of an animation in the same area, emphasize the point. In the example shown

below—taken from the site's home page—the animated element is a diagram of planetary paths and a radiating sun.

Another important navigational element in the site is found in the two on-line "tours" of the *Client* and *Portfolio* sections. While many of the pages in these sections can be reached through random access links, they can also be viewed sequentially. A circular arrow button labeled *Tour* leads the visitor to the next page (fig 4).

By giving users such a diverse set of links to its pages, the Informatics site makes it extremely easy to look around. The clarity of the site's writing and design ensures that the random access nature of these links never disorients the user.

3

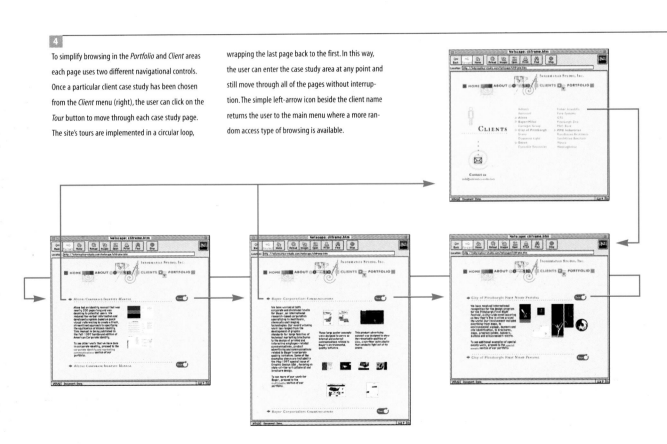

4

To simplify browsing in the *Portfolio* and *Client* areas each page uses two different navigational controls. Once a particular client case study has been chosen from the *Client* menu (right), the user can click on the *Tour* button to move through each case study page. The site's tours are implemented in a circular loop,

wrapping the last page back to the first. In this way, the user can enter the case study area at any point and still move through all of the pages without interruption. The simple left-arrow icon beside the client name returns the user to the main menu where a more random access type of browsing is available.

Not all visitors to a site have the ability—or the inclination—to view all the graphics on its pages. Some users prefer, mainly for speed, to browse the web in a text-only mode. Site designers must consider carefully if they want to lose out completely on these potentially important readers. A common practice therefore is to include the site's most important content in both a text and pictorial form.

The Informatics site has been carefully designed to include an engaging and complete message on every page (fig. 5). These texts include a carefully selected selection of links to the site's other main pages. While the written component of this site only tells a small part of the story, all visitors to this site will come away with a good sense of the personality and core capabilities of the company. The *About I.S.* page below is a good example of this approach. A brief description of the firm's corporate clients and the studio's professional strengths provides a place for direct text links to the pages that show examples of particular projects. The page also supports direct communication with the studio by providing a prominent *Contact us* icon leading to an e-mail editor pre-loaded with the firm's address.

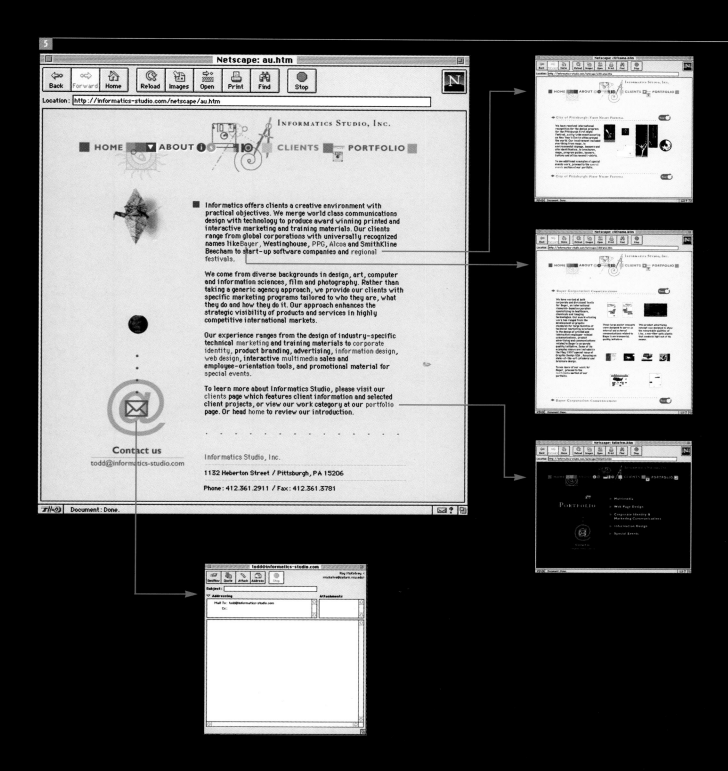

The page designs of the Informatics site exemplify clean and economic HTML layout. The majority of the pages are divided into two frames, with the top devoted to the main navigation bar and the bottom displaying the site's primary content. Tables are used to organize text and images into carefully crafted asymmetrical structures. These, and the clickable map in the top frame, are centered within the browser window. This arrangement minimizes the effects of window resizing by the user. Enlarging or reducing the browser window affects only the outside margins of the page while the internal relationships of the page elements remain constant. Figures 6 and 7 show two variations of this approach to structuring the page.

The precision of the tables in these two examples is worth noting. Achieving the exact alignments and spacing exhibited here requires careful planning of each table element. Unlike page layout programs, where the size and proportion of page elements can be changed at any time, building an HTML table requires a commitment to the exact size of graphic elements before they can be pieced together. For example, the title graphic in the top row of the table in figure 6 (containing the navigation arrows and the client name) matches exactly the combined widths of the seven table cells placed underneath. In the table in figure 7 the bottom element, four lines of bitmapped type, is precisely typeset with point size and letter spacing carefully chosen to fit the words exactly to the pixel width of other table elements.

6

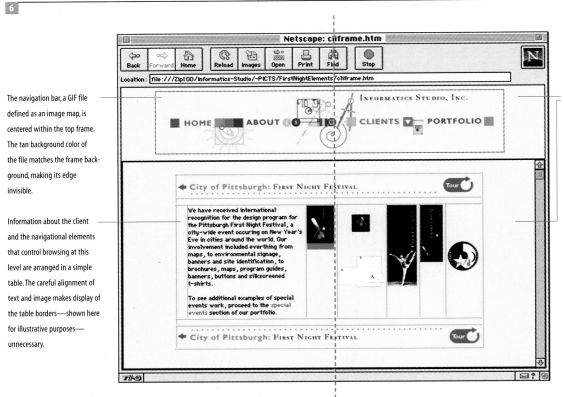

The navigation bar, a GIF file defined as an image map, is centered within the top frame. The tan background color of the file matches the frame background, making its edge invisible.

Information about the client and the navigational elements that control browsing at this level are arranged in a simple table. The careful alignment of text and image makes display of the table borders—shown here for illustrative purposes—unnecessary.

The Client and Portfolio pages are split into two separate frames. The top frame, containing a single fixed-size GIF file, is fixed in size with scrolling turned off. The bottom frame, the content of which varies from page to page, can be resized by enlarging the window. Scrolling of this frame is available as needed. The black rectangle surrounding the bottom frame is an artifact of the browsing program. Unfortunately this stark graphic element cannot be controlled by the site designer.

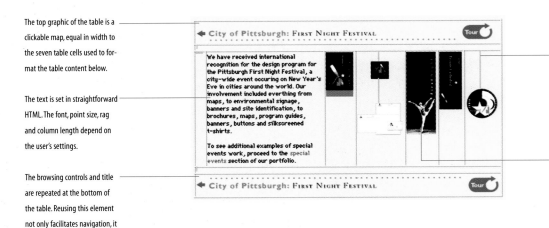

The top graphic of the table is a clickable map, equal in width to the seven table cells used to format the table content below.

The text is set in straightforward HTML. The font, point size, rag and column length depend on the user's settings.

The browsing controls and title are repeated at the bottom of the table. Reusing this element not only facilitates navigation, it also has the benefit of requiring no additional down loading time from the network. The element is simply copied from the browser's image cache.

Transparent single-pixel GIFs (shown here in orange) push the graphics into their proper location within the table. Single-pixel GIFs are also used to occupy the empty cells which space out the visible elements.

Thumbnail illustrations are placed in separate table cells. Setting the alignment property of these elements to *top* and *center* assures their visual alignment on the page.

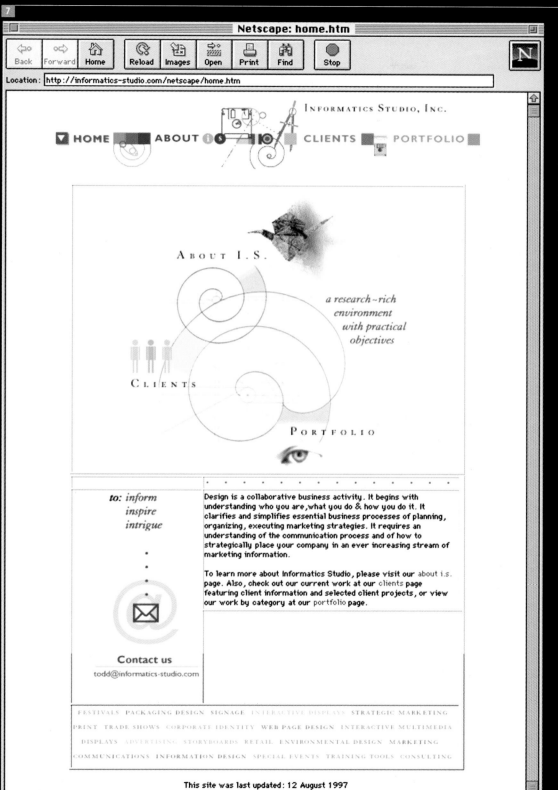

The site's home page is a slight variation on the client page. With its entire message included on a single page, the need for frames goes away. Instead the navigation bar is simply placed at the top of the page with the table added underneath. Selection of a hyperlink (either from the navigation bar, the large graphic or the text) leads the visitor to a completely different page in one of the site's other main sections.

In order for visitors to the site to look at the work in the Informatics portfolio on-line, they must be able to view it at a scale that allows enough detail to show on the coarse resolution of the computer monitor. Rather than burden the user with large pages of images and long download times, the site offers pages of thumbnails which can optionally be expanded by the user. Instead of presenting the larger images in a separate page or frame, the linked files are loaded into a separate window.

The technology for creating new windows is relatively recent on the web, and is not uniformly supported by all web browsers. To ensure that most visitors will be able to see the expanded portfolio, page one of the site forces users to provide information about the browser they are using (fig. 8). Based on this choice, the links to portfolio pieces are either loaded into a window created with Javascript or take the safer but clumsier route of launching a new browser window for the task.

A benefit of using external windows for repetitive display of catalogued elements such as these is that the external window can serve as a temporary display area while the more general task of browsing clients can proceed without interruption. As long as the window is left up, each portfolio element selected replaces the previous one. This dual display approach is far more efficient and satisfying for the user than jumping back and forth between image magnifications and client pages within the same browser.

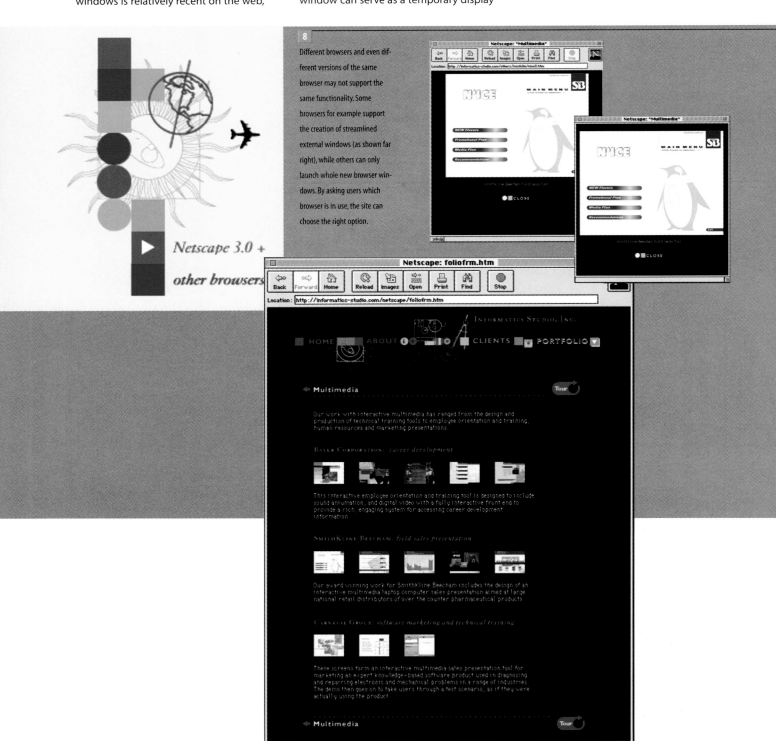

8

Different browsers and even different versions of the same browser may not support the same functionality. Some browsers for example support the creation of streamlined external windows (as shown far right), while others can only launch whole new browser windows. By asking users which browser is in use, the site can choose the right option.

Animation can be two-edged sword in web page design. Animated sequences can be both entertaining and informative, but often the eye-fetching nature of motion graphics becomes a distraction. The use of animation in the Informatics site is a good example of how simple kinetics can be used to add flavor to a web page without getting in the way of the central message. The key to this effectiveness is threefold: the small scale of the animations, their integration into the fabric of the overall page (in terms of both color and form) and the simplicity of their motion.

Consider the three sequences shown below. The *Portfolio* section's menu page (fig. 9) contains two small animations. The first is the floppy disk in the navigation bar which moves subtly in and out of a one-pixel wide slot. Below this, a blinking eye moves slowly up and down. Small and floating in the black space of the page, the animation adds visual interest without interfering with the reading of the menu or the other elements on the page.

An almost identical use of animation is found on the *Client* menu page (fig.10). Here, the navigation bar animation is a small spinning spiral while the menu is accented with an animation of three human forms becoming one (symbolizing the kind of intimate client relationship aimed for by the studio). The *About I.S.* page (fig. 11), includes a small origami bird in flight. This bird, an in-studio mascot of the firm provides a nice personal touch.

9

The eye animation in the Portfolio page uses images captured on the site designer's terminal with an inexpensive QuickCam camera. The images were then reversed in PhotoShop and assembled into an animated GIF file in GifBuilder.

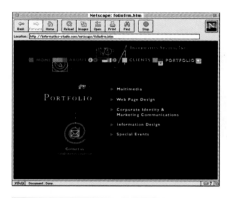

10

The frames of this animation were constructed in a drawing program, converted to 8-bit color bitmaps, and then assembled in GifBuilder. The use of drawing programs allows motion to occur in precise increments.

11

To produce this simple animation the QuickCam was pointed at an origami bird sitting in the studio. Using a stop-frame approach, the bird was posed in four different phases of wing motion.

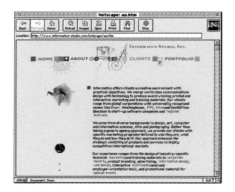

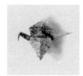

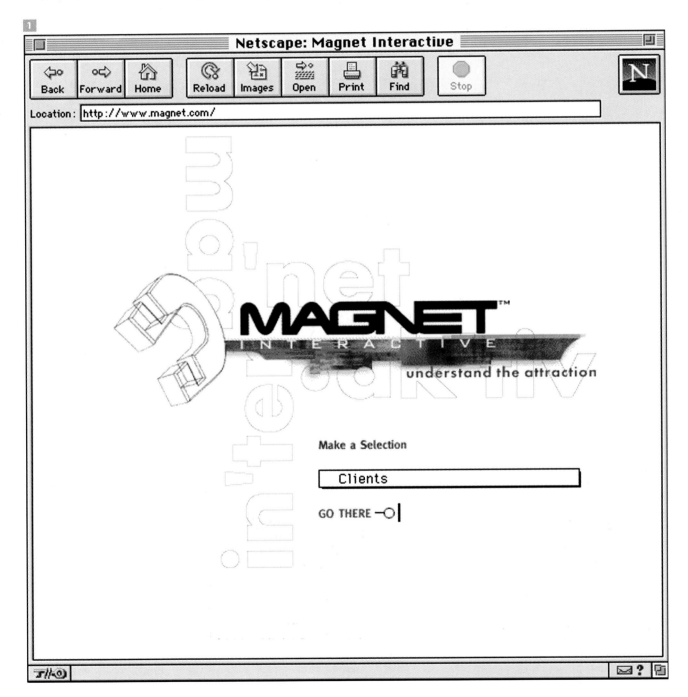

Magnet Interactive

Magnet Interactive Communications, Washington, D.C.

Magnet Interactive Studios specialize in the design of interactive communications, including web sites, CD-ROMs and games. Their own web site, shown here, is essentially a capabilities brochure and corporate portfolio. The site features two hyper-linked presentations, one focusing on corporate philosophy, and the other on the Magnet approach to interaction design and development. Relatively small in scale, the site can be comfortably explored in one sitting. As a result, Magnet's message is to the point and an effective example of keeping a web site true to its purpose.

The rhythm of the site is not unlike a slide presentation, with modestly sized screens devoted to one clear message. Despite its visual complexity, the site is easy to use and not at all difficult to digest. The typographic approach is playful and image-oriented, with bit-mapped text carrying virtually all the site's message. The result is a page design with a rich, layered feel, perfectly appropriate for the "in the can" nature of the site's message.

Home Page

Presentations

Portfolio

External sites

Special Feature

Architecturally, the Magnet site is quite simple (fig. 2). The site's home page, reached directly from the splash page, offers access to one of two interactive presentations. The first, entitled *Interactive Communications,* presents the company's design methodology and links to the on-line portfolio. The second area, called *Company Services,* describes the company's core capabilities. On occasion additional features are added to the site. For example, for the holidays, an interactive Christmas card service was offered to visitors, where they could select from a number of animated cards and send them to anyone else on the web.

To facilitate navigation through the site, a simple search tool is provided on every page, either as a central element, as in the splash page, or in a separate frame on the bottom (fig. 3). This mechanism allows visitors to jump at any time to the part of the site that interests them. To direct users to the on-line portfolio, a main selling point of the site, the search list defaults to *Clients*. A sampling of these search paths is shown above in blue.

A prominent feature of the Magnet site is the elaborate black frame surrounding each page (fig. 4). At the top, the wireframe magnet and typographic mark keep the Magnet name on permanent display, while photographic variants on the magnet image reinforce the verbal message below. At the bottom a black borderless frame, set to a fixed height, houses the *Go There* search form, while the sides result from the unavoidable 3-pixel "black box" used in HTML frames to show the current focus of interaction. The frame is further reinforced by the background image of the top frame (outlined in blue in fig. 5). Consisting of a 16 by 800 pixel GIF file, the image tiles across the page, extending the frame to fill any size browser window. To see this, compare the right screen banner in figure 6 with those below.

Because the Magnet pages are comprised entirely of bitmaps, they could be transmitted as a single image file. The slow transmission rates, however, would be extremely clumsy. To make such extensive bitmapping viable, the screen image is sliced into four horizontal strips separating those parts of the image which are unique from those which will be used again (fig. 7). By placing the page banners and titles in separate files, they can be cached on the user's machine and reused with no additional load on the server. The end result is a surprisingly efficient approach to using extensive bitmapped text and complex image layers.

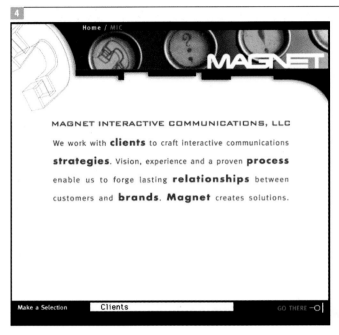

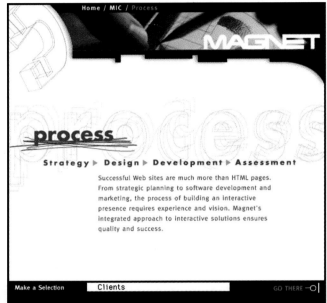

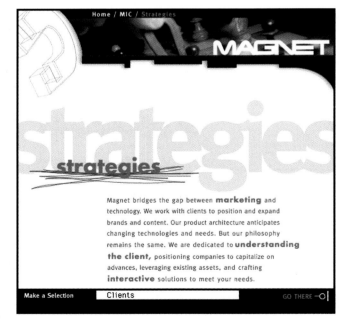

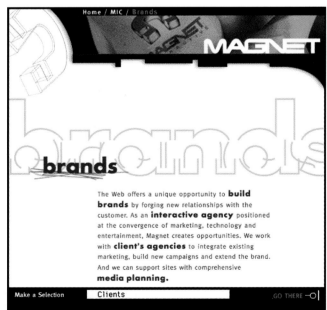

5

The background of the Magnet pages is created by allowing a tall, thin two-toned GIF file to tile across the page. As a result, the black-and-white partitioning of the screen occurs at any window size.

6

By cutting the page into horizontal regions parts of the page can be used over and over without requiring retransmission from the web. This is a smart strategy for bitmapped banners and titles.

Home / MIC / Strategies

MAGNET

strategies

Magnet bridges the gap between **marketing** and technology. We work with clients to position and expand brands and content. Our product architecture anticipates changing technologies and needs. But our philosophy remains the same. We are dedicated to **understanding the client,** positioning companies to capitalize on advances, leveraging existing assets, and crafting **interactive** solutions to meet your needs.

At the heart of the Magnet Interactive site is the on-line portfolio. Covering the full range of Magnet's activity, the area devoted to web-based design also provides direct links to the external sites. This immediacy of the work allows potential clients to interact directly with the designs and evaluate them in their working context.

From the portfolio listing (fig. 7), visitors are led to an intermediate page describing the project brief and pointing out the features of the site's design and implementation. Connections to the actual sites are first loaded into the top frame of the *Clients* page, allowing the bottom navigational frame to remain available while the external site is inspected (figs. 8, 9 and 10). Unfortunately, external sites that load new framesets into the browser window override this division of the screen in which case returning to the Magnet site demands use of the browser's back button.

7

Home / MIC / Clients

MAGNET

clients

Web Sites

ADP

American Greetings

BET

Diamond Information Center

FedEx Learning Lab

Galaxy Latin America

Kellogg's

Matchbox

Mercedes-Benz

National Geographic

Nissan Motor Corp. USA

Paine Webber

PC Flowers

Radisson

SRA International

CD-ROMs

Dow Jones & Co.

Harvard

Army National Guard

NYNEX

Make a Selection Clients GO THERE ─O|

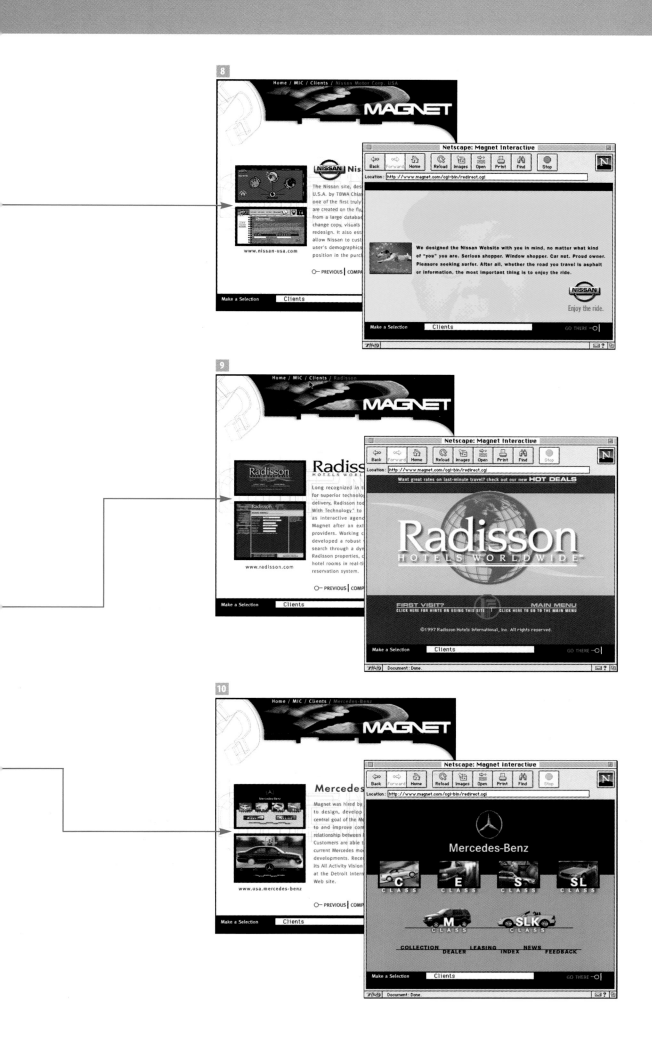

MetaDesign is an information design firm with offices in San Francisco, Berlin and London. It has a reputation for its intelligent and systematic approach to solving visual communication problems in a diverse range of media. Projects range from the development of custom typefaces to the design and implementation of large-scale signage systems.

Despite the firm's size and geographic distribution, the methodology and visual presence of the company and its work is remarkably consistent and identifiable. These attributes are fully evident in the design of their web site, which offers a wealth of information about MetaDesign's philosophy, clients and portfolio in an engaging and well-engineered presentation. The site features a careful mix of bitmapped type elements—set in the firm's hugely popular typeface, Meta—and HTML-set body text using fixed-width Courier. The pages are laid out in both modular and idiosyncratic grids, defined by a particularly thoughtful use of HTML tables. The site is notable for its carefully crafted navigational scheme using both inner-page and inter-page links to manage information flow.

1

2

The site's splash page offers a simple introduction to the MetaDesign approach in the form of an animated sequence of design "truths". These thought-provoking phrases are incorporated in an animated GIF file with each blurring into the background color field before being replaced. The images are tightly cropped to a rectangle just large enough to hold the longest of these phrases and fuse seemlessly into the page by virtue of their red backgrounds.

Home Page

MetaCulture

Clients

Projects

Type

MetaWho?

Corporate Identity

New Media

Editorial Design

Trade & Industry

Arts & Education

Transport & Logistics

3

The architecture of the MetaDesign site is driven by the site's use of long scrolling pages to deliver content. Each of the major sections begins with a high-level presentation of the firm's activities or accomplishments in a particular area. Readers wishing for more detail can pursue hyperlinks from these pages to other pages within that section, or to pages elsewhere in the site.

The division of high-level and detailed treatment of information is reflected in a color-coding of the page backgrounds. Red pages are found in the upper levels of the site and are devoted to broad themes and navigation. Gray pages are used for specific case studies, reprints from the press, profiles of the company's principals and job opportunities. Each presenta-

tion of material in the site is kept within a single page. As a result a significant amount of scrolling is often needed. The benefit of this strategy, however, is in keeping the amount of navigation required to a minimum, and the flow of information well within the hands of the reader.

A close look at the page structure of the MetaDesign site reveals an interesting approach to establishing a layout grid. Tables are defined to be quite malleable, normally stretching out to fit the data as it is placed within its cells. This "shrink-wrap" behavior is the opposite of the traditional notion of setting the layout grid first.

Taking advantage of the fact that the shape of a table is ultimately determined by its most populated rows and columns, the designers of the MetaDesign site start each table with an empty row of cells, each containing a 1-pixel high transparent GIF graphic. The width of these cells establishes the columns for the table, and all remaining graphics and text is scaled to some multiple of them (fig. 4 and 6). The cellspacing property of the table is used to manipulate the negative space between cells, creating gutters, revealing the grid as an intentional part of the image (see fig. 6), or by disappearing altogether with a setting of zero (fig. 5).

Having established a grid, the preparation of bitmapped elements that will occupy its cells becomes more manageable. The size of each element is now determined by a consideration of grid dimensions and the need to keep graphics to a minimum size (fig. 4). The splicing of images needed to imply image layering is also much more straightforward (fig. 7).

4

The typographic elements of the splash page are positioned with respect to a grid established by the first row of an HTML table. Containing 1-pixel high transparent GIF spacers, the row establishes the modules by which all subsequent colspan settings will be made. The grid defines both positive and negative spaces depending on whether the cells are filled or left empty. Vertical spacing is determined by the height of the bitmaps placed within the table, or by 1-pixel GIF spacers (shown in orange) stretched to the desired height. Note that the table holds only those elements necessary to space out the table and which are clearly distinguishable from the page background. In particular, note how the bitmapped type elements are cropped short of the full cell width. This technique shows a concern for reducing file size to an absolute minimum. A cellspacing setting of 4 pixels provides additional separation between the elements and in some cases comprises the whole of the negative space.

| --- 56 p --- | -------- 113 p -------- | --------- 120 p --------- | ----------- 120 p ----------- |

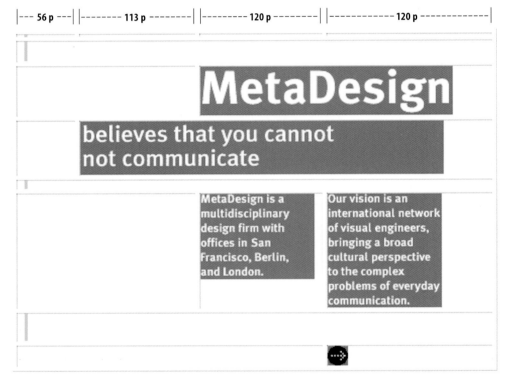

MetaDesign

believes that you cannot not communicate

MetaDesign is a multidisciplinary design firm with offices in San Francisco, Berlin, and London.

Our vision is an international network of visual engineers, bringing a broad cultural perspective to the complex problems of everyday communication.

The navigation bar and title area is contained in a table which is separate from the main table/grid below. This is done for two reasons. First the elements within the banner are set flush against each other (no cellspacing is added). Second, the icons within the navigation bar—each a separate graphic element to support a Javascript rollover—are of various widths, each unrelated to the module of the grid below. When modularity breaks down in this way, it is usually easiest to start a new table rather than to further segment the main grid of the page.

The main section of the *Projects* page uses a table to establish a regular grid with cells 113 pixels wide and a cellspacing of 4. As in the example in figure 4, the table's first row contains empty cells whose function is to establish the overall grid spacing. In this page, the cellspacing—combined with a table border setting of 0—results in a partial exposing of the grid lines within the page. The bottom of the page, providing text links for those browsing with images turned off, is set in yet another table (not exposed in the illustration) with cells set to multiples of 113.

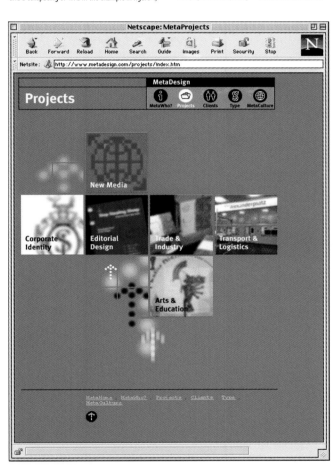

Unlike image manipulation, programs like Photoshop typically support the creation of unlimited layers in an image. To bring these images into the web, these layers have to be flattened to no more than two. When a flattened image is placed within a table, it often has to be sliced into sections to preserve the illusion of overlap. The image layer containing the dotted arrows used in the *Projects* page above is shown here in its complete form.

The primary means of navigating through the MetaDesign site is by use of the navigation bar/title graphic (fig. 8). This provides feedback to users on where they are currently are in the site and gives them access to the top of the main section areas. The current location is reinforced by a significant degree of redundant coding: the current section name is placed in the upper right-hand corner, while the subsection is featured more prominently below. The icon for the section is also highlighted in white. Bringing the mouse over the icon triggers rollovers on the remaining icons indicating their availability.

Hyperlinks within the body of the page are kept to a minimum. Each page within the site is constructed with clear visual hierarchy, separating different topics within the page with a combination of rules and outdented titles. Typically each of these sections contains a single link to some other part of the site, or occasionally to another page on the web (fig. 9).

Given the significant length of many of the site's pages, an important feature of the navigation scheme involves the design of inter-page links (figs. 10 and 11). In order to access the navigation bar at the top of the page, users must be able to jump quickly to the top of the page. Similarly, users arriving at a page often will want to jump down to a particular topic. The simple system of text links and return symbols accomplishes this with little fuss.

8

The navigation bar provides multiple clues to the current location in the site hierarchy as well as an indication of links to the site's other main sections.

9

The site's pages are typically divided into several horizontal sections. In the case of the Projects pages each section is devoted to a particular client or project. Links to other pages are few, usually being limited to one per subsection. In this example, the part of the site devoted to Editorial Design work provides access to short briefs about the project, and, occasionally to links that lead outside of the site.

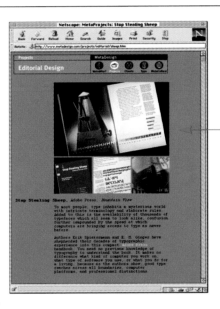

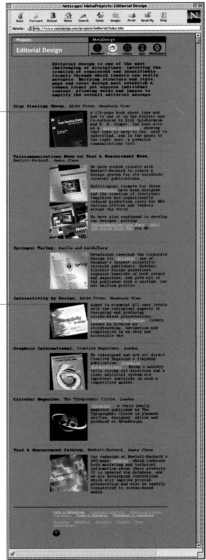

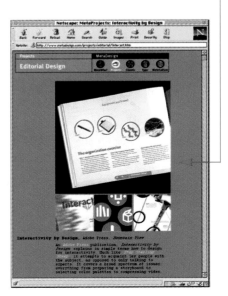

10

Many of the tallest pages of the site include navigational support for jumping around within the page. The MetaCulture page, for example, provides links from an introductory paragraph to particular sections far below. Distinct arrow symbols lead the user immediately back to the top. Access to subordinate pages is consistently located in the outdented titles starting each section of the page.

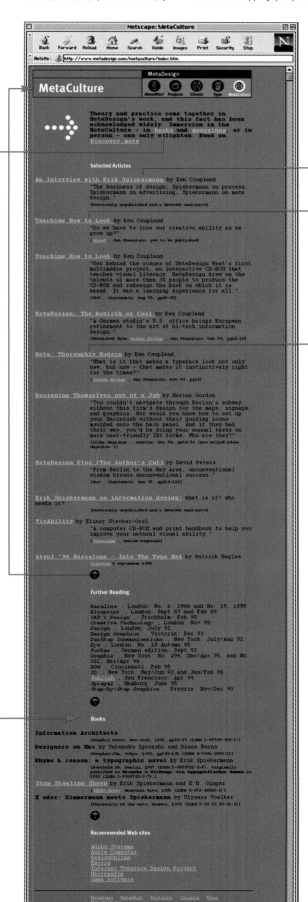

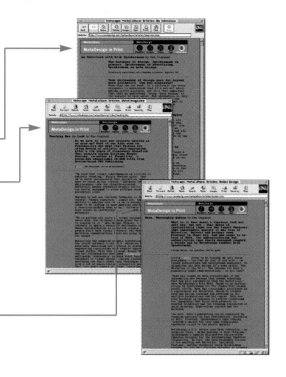

11

With normal sized monitors the site's lengthy pages are cropped significantly within the browser window. When a link to a particular page section is followed (for example the link from the top paragraph in figure 10), it leads to an arrow marker and a section header set in white text in a bitmapped format. By registering the targets of the hyperlinks within the browser window at this location, the way back to the top of the page is consistently available and easy to locate.

Good typography involves more than just attention to the fine details of letterforms, spacing and paragraph shape—it is also a matter of clearly articulating information structure. While there is much attention being given to improving the details of web-based typography, it will be a while before the requisite controls on font selection, letter spacing, line spacing and hyphenation are in place and supported uniformly. Until then, typographic sophistication on the web is best displayed by paying attention to issues at the macro scale.

The pages of the MetaDesign site are remarkably simple in their use of HTML typesetting tags. Using none of the latest typographic controls such as style sheets and layers, the pages are implemented instead with basic HTML tags that have a consistent effect on a wide array of web browsers and computing platforms. Use of the *typewriter text* tag, <tt>, leaves font selection to the browser's default fixed-width face—usually Courier—and word spacing, leading and the placement of line breaks are left to the browser default. Typographic contrast is achieved by the use of two font sizes (defined with the rather imprecise tag), two weights (normal and bold), and the introduction of bitmapped type elements in section titles and in the page header.

The overall shape of the text blocks and the spaces between them are a result of using multiple tables to separate the page's main sections, and a thoughtful use of the cellspacing property to control the space between individual items. Set to a width of 4 pixels, the table's cellspacing serves as a *de facto* paragraph space, and is sometimes doubled by the introduction of empty table rows between elements.

Each table starts with a row of single-pixel GIFs establishing a four-column grid. The main body-text is placed within the last three columns of this grid, while section titles begin in column one. The final shape of these text blocks makes the structure of the page immediately apparent.

12

Shown here are two tables used to structure the MetaCulture page (see figure 10). A simple 4-column grid sets up two column widths, a 4-column width for titles, and a 3-column width for the narrative content.

Grid established with row of 1-pixel high transparent GIFs

Fixed-width font stems from use of typewriter text tag (<tt>); font size set to 4 using the bold () tag

Bitmapped GIF graphic scaled to grid module of 113 pixels.

Theory and practice come together in MetaDesign's work, and this fact has been acknowledged widely. Immersion in the MetaCulture - in books and magazines, or in person - can only enlighten. Read on. Discover more.

Fixed-width font as above with style set back to normal weight; colspan of 3 spreads text across three table cells.

Section headers set in bitmapped Meta typeface

Paragraph spacing created by use of cellspacing setting of 4 pixels; double-spacing achieved by introduction of additional empty table row.

Titles placed in table cells spanning entire grid (colspan = 4); hyperlinked text set in muted orange.

Selected Articles

An Interview with Erik Spiekermann by Ken Coupland

"The business of design: Spiekermann on process, Spiekermann on advertising, Spiekermann on meta design. "

[Previously unpublished and a MetaWeb exclusive]

Teaching How to Look by Ken Coupland

"Do we have to lose our creative ability as we grow up?"

[*Wired*, San Francisco: yet to be published]

Typographic defects such as a lack of hanging quotes and unadjusted rags accepted as is.

Subordinate text set with size = 1; italic style used for bibliographic link.

Full-color, real-time animation is now an easy addition to a site, but the size of most animated files, the need for special plug-ins or particular browsers makes the use of this technology more appropriate for non-essential information.

A particularly appropriate use of animation is to entertain. As an experiment in letting its designers exercise the new possibilities of Shockwave and Java applets, MetaDesign issued its Advent calendar. Each day one of the firm's three offices would add a new animation to the mix, incrementally filling out a clickable grid showing key frames from each piece. The pieces range from the technologically simple to the complex, and express attitudes towards the holiday ranging from the nostalgic to the macabre (note the "swinging" Santa in entry 13). Some of the entries consist of simple self-running holiday vignettes (a sheep pushing a present), while others offer a simple interactive puzzle (connect the dots to make a Christmas tree).

Experimentation and playfulness is an important part of the web ethos, and special events such as this give a morale boost to site designers and site visitors alike. Freely given amusements of this caliber and inspiration are what keep people coming back to the web and to other sites as well done as this one.

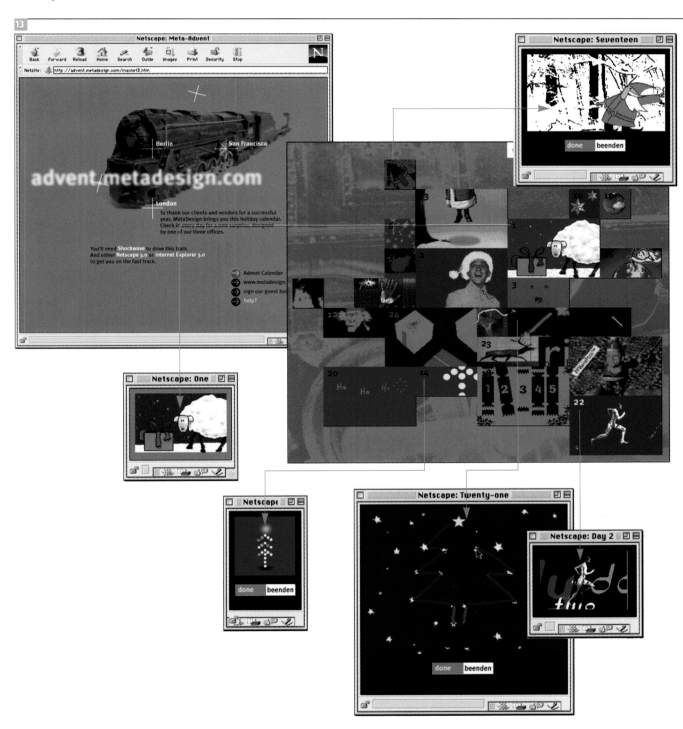

Nissan-USA

Magnet Interactive Communications, Washington, D.C.

The Nissan-USA site extends the company's highly successful *Enjoy the Ride* campaign into the medium of the web, providing a rich source of information—both fun and practical—about Nissan and its products. Using a large database to hold page elements, programs on the server compose pages "on the fly", inserting page elements just prior to their delivery. According to Magnet Interactive this separation of content and page structure allows Nissan "to change copy, visuals and other elements with minimal redesign. It also establishes a foundation that will allow Nissan to customize the site based on the user's demographics, personal preferences and position in the purchase process."

The bulk of the site is divided into three main areas. *Our Cars* provides information about the current Nissan fleet, dealer locations and financing options. *Car Crazy* caters to the autophile, featuring information on Nissan car clubs, the company's engineering research and a gallery of concept-car images. The third area, *Joy Ride*, provides lighter fare, including information on current promotions, storyboards and other imagery from the company's popular television ads, articles on company history and tradition, and several small interactive games and puzzles. Shown below are the site's initial splash screen and the frames of an enclosed animation.

Car Crazy

Personal Journal

Home Page

Our Cars

News Flash

Joy Ride

Site Structure

The pages of the Nissan site are organized into two distinct functional categories (fig. 3). At the top levels of the site the pages are purely navigational. Starting with the home page, and then at each of the site's three second-tier pages, users do nothing more than select drill-down paths from a limited set of icons. After passing through these two top levels, the site's actual content begins. For example, imag-

ine a user looking for information on a particular Nissan sedan. At the home page, this user would select *Our Cars* (see fig. 4 for a closer view). Arriving here, the user would next select the *1997 Models* icon, taking him into the area dealing with particular car models. Note how clearly the visual design of the home page prepares the user for understanding the simple tree arrangement of the site. The three main areas of

the site are indicated with large, amusing photographic icons. At a central node, connecting these icons is another icon representing the site's unique personal journal. The journal is a customized bookmarking tool maintained for each visitor. With the journal, users can save quick links to their favorite pages, no matter where they are in the site hierarchy. The "quick links" provided by the journal are indicated above in blue.

Once past the site's splash screen and home page, the user begins drilling down on one of the site's three main informational areas. Each page, from the third level down, is capped with a navigational banner consisting of four clickable regions. The Nissan logo in the upper left provides a consistent link to the site's home page. The thumbnail image in the upper-right corner, modified every time the page is loaded, provides a sort of "serendipitous link" to diversionary content such as the site's e-mail postcard area, or to an amusing article (for example the story on *Albert the World's Largest Bull* shown opposite). The central panel, present on every page, provides immediate access to the site's three main pages as well as a back button and link to the user's *Personal Journal*. The journal is a customized bookmarking tool maintained by the Nissan site. Users open a journal by providing a log-in name and password. Once opened, any page in the site can be marked and used on a return visit for a "quick link" to a favorite page. The navigational banner also provides visual feedback on the user's location by highlighting the links that precede the current page in the hierarchy.

In the example below several pages of the *Whiz Bang* section are shown. These are reached from a menu on the left side of the Whiz Bang page. The banner at its top reveals that this page is contained in the *Car Crazy* area of the site. The *Personal Journal* page, situated outside of the site's content areas (see the site diagram in figure 3 for an illustration), shows its independence by the absence of this highlighting.

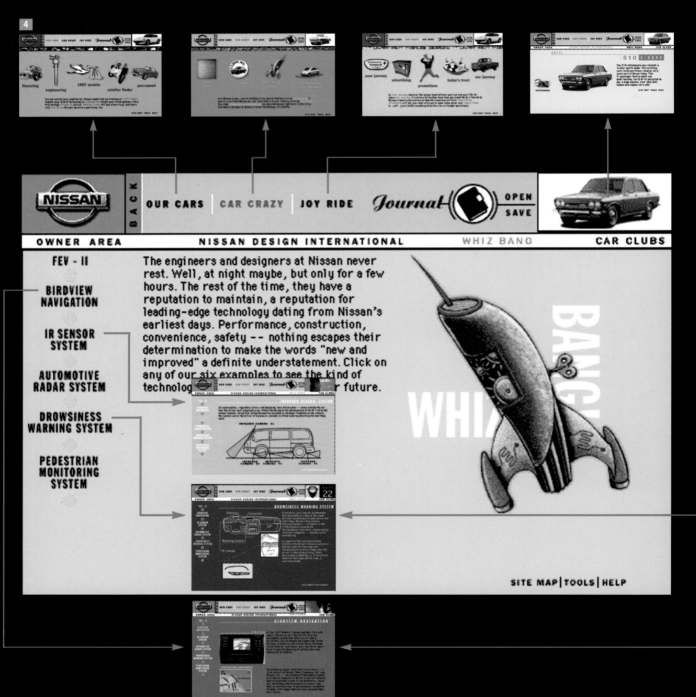

Albert the World's Largest Bull

EXIT 14

BACK | **OUR CARS** | **CAR CRAZY** | **JOY RIDE** | *Journal*

MY
Journal

**roy
mckelvey**

Update
PROFILE

Delete
ITEMS

Promotions

Overview

Car Clubs

Birdview

Drowsiness

SITE MAP | TOOLS | HELP

One of the more frustrating aspects of designing for the web is the inability to control the size and proportion of the browser window. The common graphic device of bleeding elements off the edges of the page is an iffy proposition at best when the page's size and shape cannot be determined in advance. For bleeds to work as planned, users must be encouraged to help out by resizing their windows. The Nissan site's pages are designed to be unusually small and are at their best when the window size is reduced. Rather than instructing users to resize the window with an explicit text, the site's initial pages are designed to make the point visually.

The splash screen (fig 6a) is deliberately placed on a background of drab gray. The intended size of the web page is clearly communicated and, with luck, the user will move the window borders in. The site's home page (fig. 5) reinforces the message with its black frame of links to the car pages. The home page also establishes the idea that not all content will be limited to the smaller screen size. By placing boilerplate information about the site and its technical requirements in a small point size below (fig. 6b), a secondary information zone is established and the slight variations in page height that will later be encountered are foreshadowed (fig. 6c).

The design of the site's main informational pages (described on the previous page and shown in fig. 8) is based on a set of five HTML frames. The headers area's frames serve as targets for downloading a variety of clickable images, some randomly selected, others chosen in relation to the current navigational context (fig. 7). Plans for the site include improving the tailoring of these images to particular users based on data gathered during their interactions with the site.

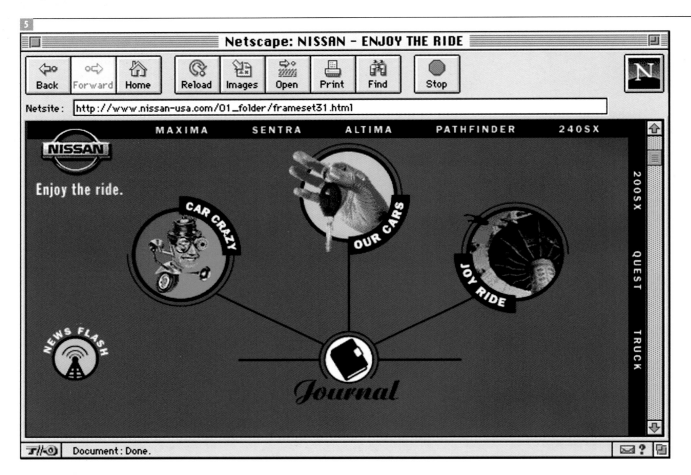

a)

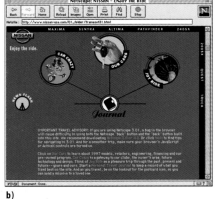

b)

c)

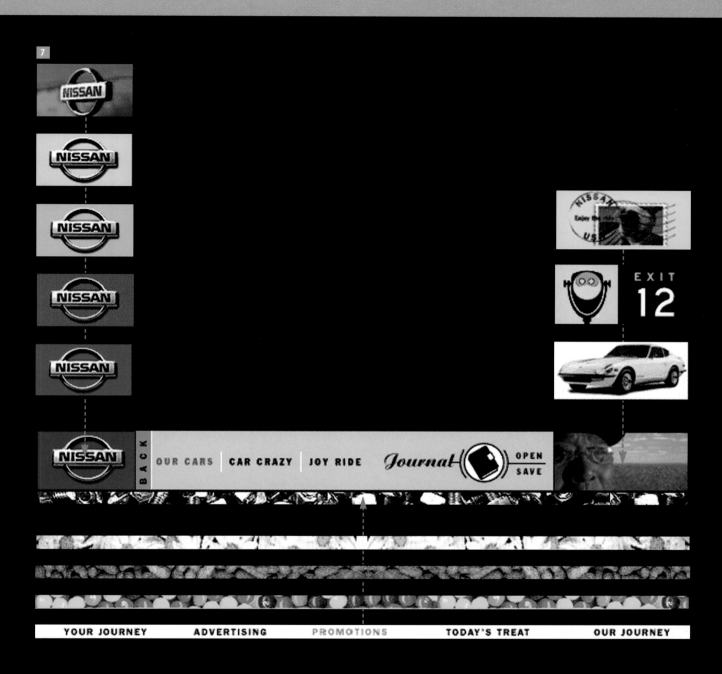

7

8

Color can be a powerful signal to indicate the relationships of several pages in a site. However, color can also be used in a more playful manner. In the Nissan site, color is used in this more serendipitous fashion, reinforcing the random treatment of images in the navigation area.

Despite the carefree nature of its application, the colors used in this site have been very carefully selected. To avoid the ugly graininess and texture of dithered col-ors on 8-bit monitors, all background col-ors come from the browser-safe palette (fig. 10d). In one of the site's postcard pages of classic cars (fig. 9) a palette of analogous greens and browns is distributed across the display and navigational areas (fig.10d). The bold type and rule at the top of the display area and the photograph of the sedan are brought into the page as back-ground-transparent GIF files (figs. 10a, 10b). The greenish halo surrounding these ele-ments (most evident in the enlargement in fig. 10c) shows that the images were anti-aliased to an identical green color before being exported out of Photoshop. Once reunited with their natural background color, the smoothness of the edges is restored.

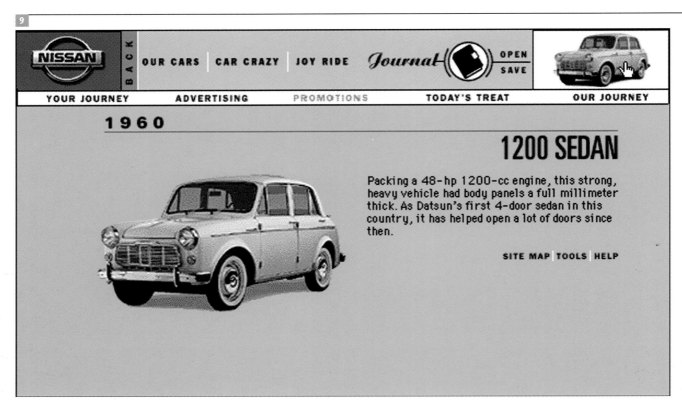

9

NISSAN BACK OUR CARS | CAR CRAZY | JOY RIDE Journal OPEN SAVE

YOUR JOURNEY ADVERTISING PROMOTIONS TODAY'S TREAT OUR JOURNEY

1960

1200 SEDAN

Packing a 48-hp 1200-cc engine, this strong, heavy vehicle had body panels a full millimeter thick. As Datsun's first 4-door sedan in this country, it has helped open a lot of doors since then.

SITE MAP | TOOLS | HELP

10

1960

1200 SEDAN

a)

b)

c)

	R	G	B
	204	204	153
	204	204	0
	153	153	51
	51	102	102
	153	102	0

d)

This page, providing an entrance to a 4-page article on Nissan's support of the Thelonious Monk Institute of Jazz, uses shifting lines of brightly colored type over an evocative JPEG image of a saxophonist (fig. 11). Like the example on the previous page, the typography here is a mix of bitmapped and HTML-set type.

The page's title, cheerleader icon, orange menu items and the green type elements have been anti-aliased in advance and exported with the background set to transparent (fig. 12a). The orange paragraph is set in simple bold HTML. Note the effect that transparency plays in the two page examples shown here. In the Datsun 1200 page the background image is a solid green and the bitmaps placed on it are completely separate on the page. An alternative approach would have been to save thee images as rectangles with opaque backgrounds that match the page background color. Once placed, they would fuse into the background in the same manner as the transparent files in the example.

The case is different, however, in the page below. Since the type passes over an image, it must be saved without background colour. The colors used in the Monk pages, with RGB values carefully limited to multiples of 51, are again carefully selected to avoid dithering (fig. 12b).

11

12

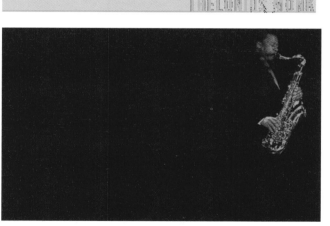

a)

	R	G	B
	204	204	153
	204	204	0
	153	153	51
	51	0	102
	204	255	0
	255	255	0

b)

Project New Zealand

Renee Lamm Esordi & Michael Esordi, San Diego, California

Project New Zealand (fig. 1) is an example of a new genre of journalism unique to the web—the virtual tour. Functioning as a real-time travelogue, this web site invited readers from around the globe to follow and participate in a coast-to-coast bicycle tour of New Zealand. Visitors to the site were treated to daily uploads of photographs and personal journal entries made by the two cyclist/designers who undertook the trip. The design of the site's pages features large translucent background images, sparse typography and ample white space—a perfect visual corollary of the open space and extreme distances experienced by the riders. Map fragments and forms abstracted from bicycles appear frequently, connecting the visual design with the theme of the site. Technically, the design pushes the limits of web color and image size, but its creators acknowledge their purpose was to attempt a graphically rich experiment in real-time graphic communication. The liveliness and personal nature of the e-mail exchange between the riders and remarkably diverse audience—many of them displaced New Zealanders—attests to the possibilities of the web to foster new relationships between readers, writers and designers.

1

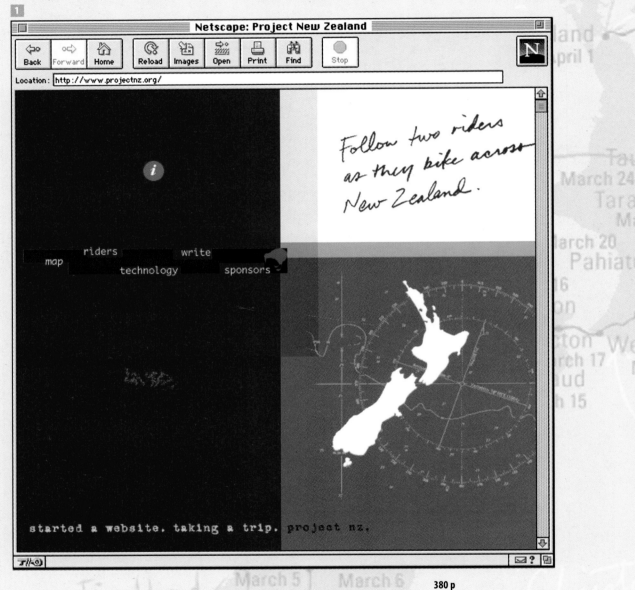

380 p

590 p

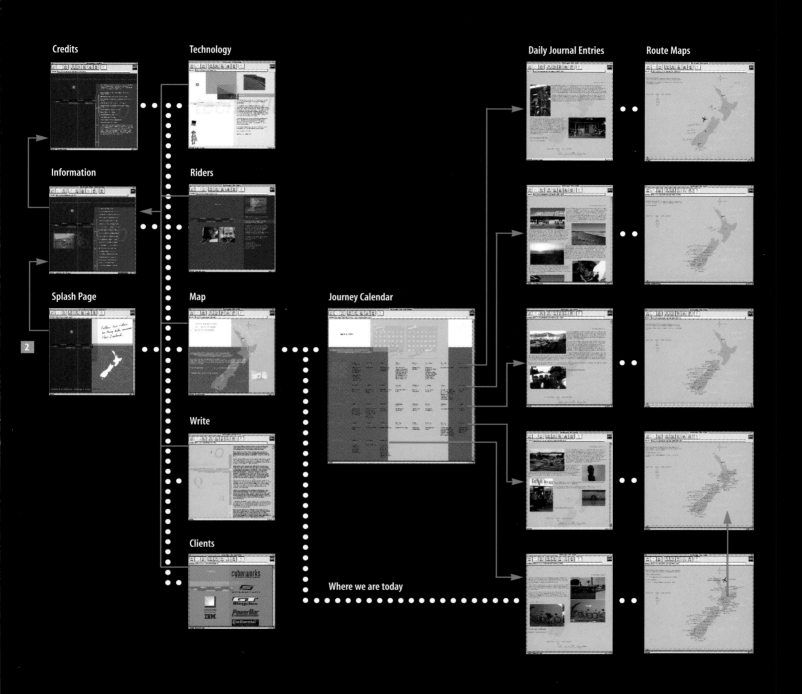

Credits

Technology

Information

Riders

Splash Page

Map

Journey Calendar

Write

Clients

Where we are today

Daily Journal Entries

Route Maps

2

The Project NZ site is divided into two main content areas (fig. 2). The first, found on the site's upper-level pages, concerns information about the project itself. This includes pages that profile the riders and their equipment, acknowledge the project's many sponsors, and present the highlights from the ongoing e-mail correspondence with the web audience. The second area, making up the bulk of the site, focuses on the reporting of the daily experi-

ences of the riders. Included here are a photo-illustrated journal and a graphic depiction of the tour's progress on an evolving map page. These daily reports could be accessed in a number of ways. A "where we are today" link takes readers to the most recently posted material. This information, plus all of the compiled entries from previous days, is also available from a large calendar page. The diagram above gives a schematic overview of the site

organization. The dotted lines indicate the main avenues of navigation, accessed through navigation bars. The blue lines indicate links which represent "leaps" across the site structure. As indicated, this style of navigation is the main approach used in the calendar page where users are encouraged to check out entries for any number of days. The ability to connect to previous day's entries is also available from selecting a particular location on the map.

Visitors to the Project New Zealand site arrive with distinctly different navigational needs. First-time visitors, unfamiliar with the site's purpose, need to be oriented to the project and the way in which it is being reported. Perhaps of equal importance is that users become interested personally in the project's participants—the two riders and the crew at home assembling the web site more or less in real time. The second type of visitor, the kind that the site's authors really hoped for, were those who would follow the progress of the riders and hopefully feel compelled to write in to the site's e-mail centers. These regular visitors required a way to quickly find the day's latest information, and sometimes to catch up on several days of progress.

Navigation through the upper level pages of the site is accomplished by using a simple navigation bar integrated into each page design (fig. 4). The site's *information* page, containing a brief essay on the trip and its goals is made accessible on almost every page (fig. 6). This link makes it possible for visitors arriving to the site from a side door (for example from a search engine) to determine the context of what they are seeing. Navigation through the daily journal and map pages is handled through a network of links connecting these pages to a large calendar (figs. 3 and 5).

3

The site's massive calendar page was updated daily by the design team in San Diego. The page offers access to material from each day of the trip, and through its brief text descriptions gives a good overview of the riders' experiences. The size of the map, about 1300 by 1100 pixels, requires a fair amount of scrolling to see—a 15" monitor for example covers about only 1/4 of the page—but the macro view of the whole journey that it makes possible is well worth the trouble.

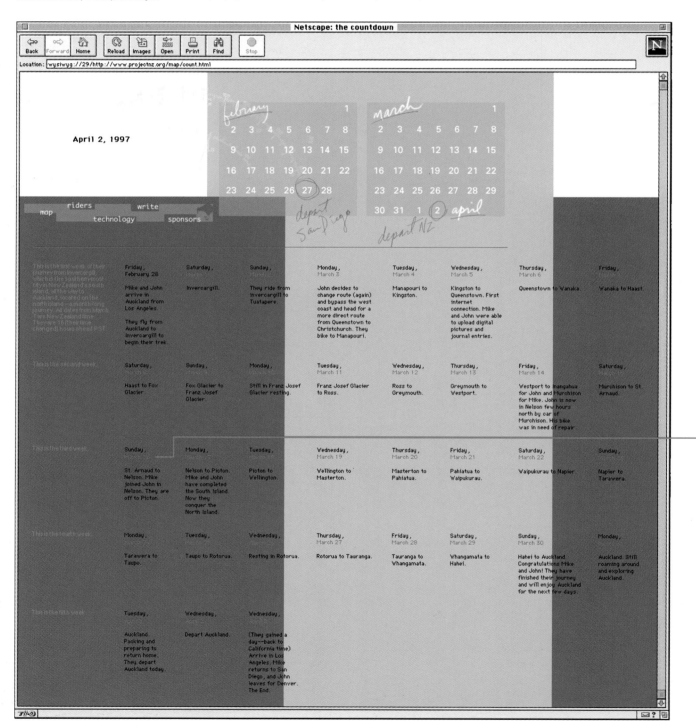

4

The site's navigation bars, implemented as clickable maps, provide access to the site's five main sections. The blurring of the type is a result of anti-aliasing. The decision to anti-alias type involves choosing between the illusion of higher resolution and legibility. Many side-effects occur as a result of anti-aliasing: text type, 18 points or less, will usually exhibit distinct blurring, and in many cases there will also be a distinct increase in the apparent stroke weight due to the addition of transitional pixels at the edges of the letterforms.

5

This elegant map shows the daily progress of the riders. The map provides links from each location to a journal page describing what was seen on that day.

The red type elements, provide an alternative method for moving back and forth.

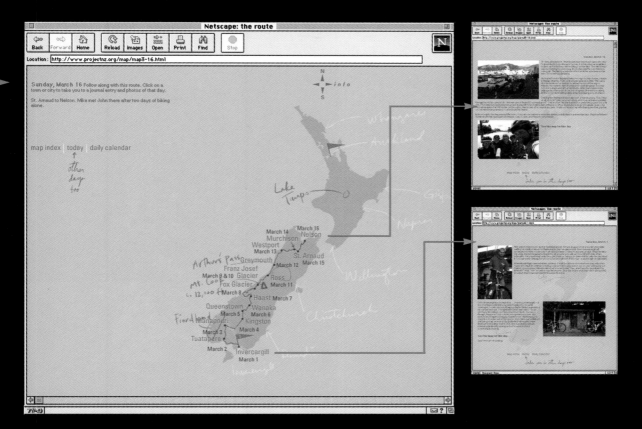

6

A common fallacy in interface design centers around the notion of consistency. While it is crucial that interactive elements such as buttons or menu-items display an absolute consistency of behavior, the question of consistent look, or even location, is not so straightforward. The design and organization of a set of consistent visual signs involves juggling a number of variables. These include color, shape, size, degree of abstraction and the interplay between visual and verbal content. The design of the "info" icons in the Project NZ site exhibit a wonderful variety, but because of a consistent treatment on the page (each is placed in isolation at the page top) there is little confusion as their function. The result is a set of controls which are consistent and a visual delight for the user.

The pages of the Project NZ site have the appearance of being made up of sets of interlocking, translucent planes (fig. 7a). Layers of type and image float freely on the page resulting in a complex structure that seems beyond the capabilities of simple HTML. The design of the pages is actually remarkably simple. Most of the image complexity is contained in the large background images that underlie each page (fig. 7b). Created in Photoshop, these over-sized images create large expanses of color on which to float the page content. Foreground elements, navigational graphics and text blocks are carefully positioned within the image by a combination of single pixel GIF spacers and simple HTML tables (fig. 7e). These tables are carefully defined using both fixed cell sizes and window percentages, resulting in a page that smoothly adjusts to any window size (figs. 7c, 7d). Bitmapped graphics such as the "info" icon, hand-written script and typewriter text are anti-aliased to the background colors on which they will be placed and saved with transparent backgrounds (figs. 7e and 8). This approach allows the graphics to be positioned over any part of the background image without concern for precise registration. Note that these elements look equally good in any of the three window sizes shown on this page (figs 7a, 7c and 7d).

7

The site's Splash page typifies the organization of many of the pages found throughout the site. A large GIF file—800 by 800 pixels—underlies a small set of elements placed in the page foreground. The oversized background image is necessary to keep it from tiling when viewed on large computer displays. The blue rectangles in figure 6b show the background image as framed by both a 15" and 19" display.

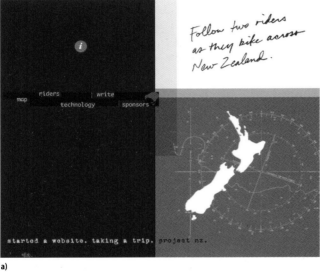

a)

b)

c)

d)

8

Graphic elements, including bitmapped type, are anti-aliased to the background image with the background colors then knocked out by use of the transparency setting available in the GIF format. The resulting image can be placed successfully on any part of the background with a similar color range.

Note that the table in figure 7e is scalable only in the vertical dimension. Graphic elements such as the typewritten message at the bottom of the page can move only up and down, and therefore within a region of relatively fixed color.

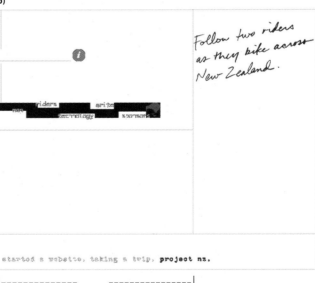

e)

The visual richness of the Project New Zealand pages carries over into each section of the site. Like the splash page shown opposite, these pages represent a well thought out separation of visual content into the foreground and background layers of the page. Note the consistency of the visual organization. The background image divides the page into two asymmetrical halves, while the navigation bar provides a consistent horizontal element around which the page content can be structured.

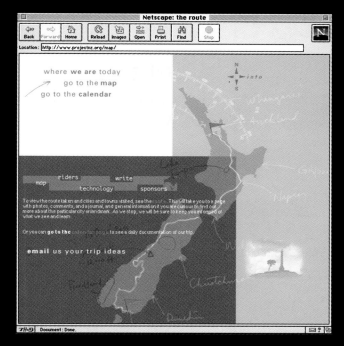

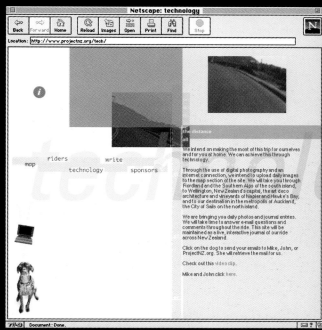

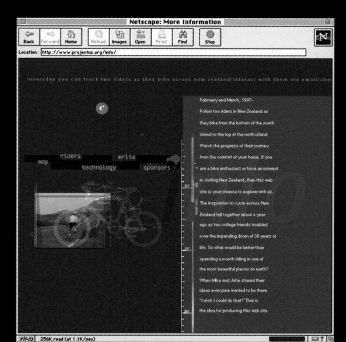

Slate

Microsoft Corporation, Redmond, Washington

Slate debuted to unprecedented media attention in June of 1996 and represents one of the web's most ambitious efforts in creating a traditional magazine in digital form. Slate's unashamed simulation of a printed political publication has subjected it to much criticism, mostly aimed at the publication's failure to "get" the more libertarian and participatory aspects of the web. Slate, like a printed magazine, is written by professionals and designed with an emphasis on reading rather than interaction for its own sake. Playing no small part in the debate over Slate is its affiliation with the Microsoft Corporation, and the fact that it is edited and managed by Michael Kinsley, an accomplished veteran of print and broadcast media who came to the project with no apparent experience on the web. Whether Microsoft should be publishing a political magazine or if it is somehow inappropriate for accomplished writers and editors to shift their emphasis to the web (a move made daily by people from every other walk of life), it remains that Slate has one of the cleanest and most intelligible site designs on the web.

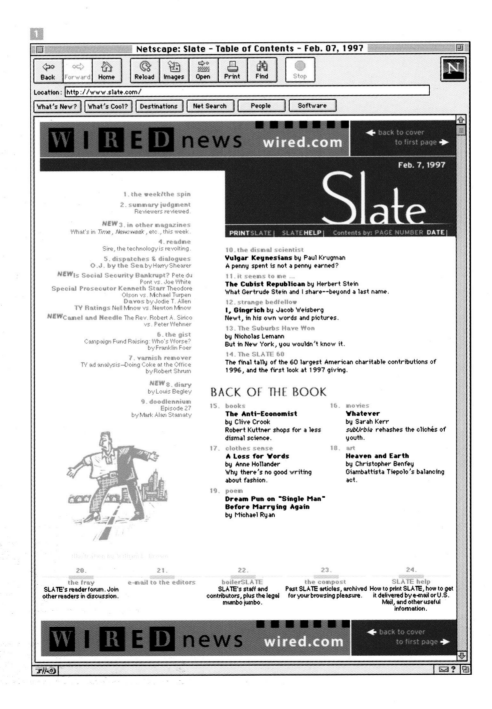

Cover and Contents

The Front of the Book : social and political commentary

The Back of the Book : culture, the arts, reader feedback, archives and help

As a deliberate on-line recreation of the political magazine, Slate's site organization mirrors the linear, page-by-page structure of a printed periodical. Pages are sequentially numbered and navigation is analogous to the physical interactions required of a real magazine. "Next-page" and "previous-page" arrows (fig. 3) allow simple page turning. The table of contents (fig. 1) provides direct access to particular articles, and the page number "number-line" at the bottom of every page (fig. 5) approximates the idea of "flipping through" the magazine. Here the reader can move to a page, say, "near the front", to the table of contents, or perhaps to the start of the cultural section of the magazine (indicated by the vertical rule between the 14 and15).

Unlike a printed magazine, Slate's articles are confined to a single page. Navigation within these sometimes lengthy pages is facilitated by the use of "compass" icons which provide hyperlinks to the top and bottom of the page as well as to adjacent pages (fig. 4).

Slate is divided into two large sections—the front section dealing with political and social commentary, and "The Back of the Book" featuring commentary on the arts and culture (see fig. 2). While the formal design language differs slightly in the pages found in these two sections, there is little to distinguish them in the site architecture, both being part of the same linear sequence of pages.

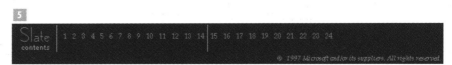

Each page in Slate begins with a banner that identifies the section in view, and serves as a locus for advertisements and the page-by-page navigation controls. The design of these banners maintains a careful balance between design consistency and playful variation in the treatment of section titles (fig. 7). The geometry of the title areas is not bound by a pre-defined grid, but varies with the height and line length of the titles set at various point sizes (the *f(title)* dimensions of fig. 6).

Slate articles are laid out in and around a "floating" 334 pixel column of text

aligned initially with one of the dominant verticals of the section title area. As the reader scrolls down the page this text column shifts occasionally to the left or right (fig. 9). These breaks in the text serve several important functions for the reader. Reading a two-hundred line pillar of text on a computer monitor can be quite tedious and even unsettling. Although attending to the scroll bars provides a brief respite from reading, it is not a substitute for the familiar pause of turning a page. By shifting the column, Slate's page design provides pauses in reading, relieving ten-

sion in the reader and allowing some sense of progress through the article (fig 8).

In a scrolling text, it is difficult to maintain one's place as the text moves up the window (e.g. the bottom screen of fig. 8). The column shifts, as well as the frequently occurring sidebar illustrations, serve as important referents of the reader's current focus. These simple devices make Slate surprisingly inviting, even in the most lengthy of its articles.

6

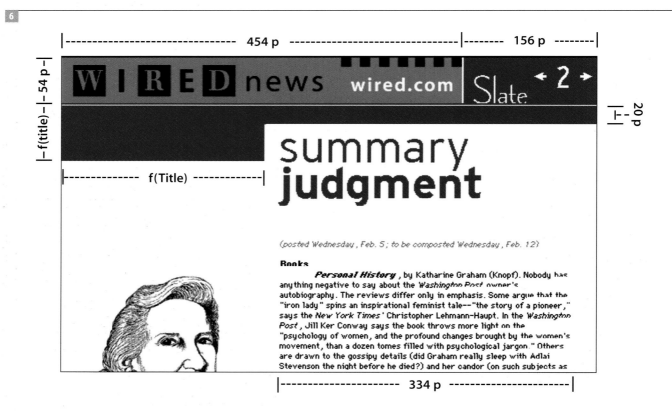

7

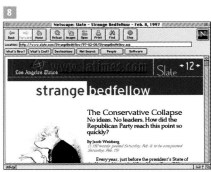

Netscape: Slate - Strange Bedfellow - Feb. 8, 1997

Back | Forward | Home | Reload | Images | Open | Print | Find | Stop

Location: http://www.slate.com/StrangeBedfellow/97-02-08/StrangeBedfellow.asp

What's New? | What's Cool? | Destinations | Net Search | People | Software

Los Angeles Times — www.latimes.com — Slate ←12→

strange bedfellow

The Conservative Collapse
No ideas. No leaders. How did the Republican Party reach this point so quickly?

By Jacob Weisberg
(1,150 words; posted Saturday, Feb. 8; to be composted Saturday, Feb. 15)

Every year, just before the president's State of the Union address, the White House Press Office invites political reporters in for a spin session. In keeping with the current mood in Washington, the message this time--conveyed by National Security Adviser Sandy Berger, Budget Director Franklin Raines, and Domestic Policy Adviser Bruce Reed--was about bipartisanship and cooperation. But after about an hour of anodyne sentiments, Rahm Emanuel, a Clinton political adviser more pugnacious than the others, couldn't take it any more. "About a year ago there was a debate about whether there would *be* a Department of Education," he said, jumping up from his chair. "We have covered a lot of ground here. When everyone makes the point that the president is somewhat conceding the agenda, the fact is ... [the Republicans] have conceded the president's priorities. In fact, it is his initiatives that are the center of agreement."

It is amazing how much has changed in 12 months. The chief theme in analyses of the president's State of the Union address a year ago was that Clinton was trying to catch a ride on the unstoppable conservative freight train. But history appears to have changed directions again. From the comfortable perch of a 62 percent approval rating, the highest of his presidency, Clinton spent most of his speech Tuesday night proposing a variety of new government programs. These were not merely small-bore, Dick Morris-era programs. Many were substantial and costly efforts in the areas of education and health-care reform. And now, it's the Republicans who are scrambling to get on board.

Emanuel and other gloating Clintonites contend that the president brought about this transformation by reclaiming the "vital center." Clinton did indeed move deftly and systematically to deny Republicans all their familiar means of portraying Democrats as being incorrigibly leftist and outside the mainstream. By pushing a harsh anti-crime bill, proposing his own version of a balanced budget, and signing a welfare reform package very different from his own original notion, Clinton deprived Republicans of what they expected to be their three best issues. After the president got done repositioning, Bob Dole had very little left to run on.

But Clinton's co-option is not the whole story. Conservatism has collapsed. It has been a cliché since the early 1980s that the GOP is the party of ideas. But today, as Clinton generates--with seeming ease--popular and plausible proposals, like expanding college opportunity and extending health insurance to uncovered children, Republicans are openly admitting that their party has no clue what it is in favor of. "It is clear that the faithful are paralyzed by ennui and the party is floundering," writes William J. Bennett in the most recent issue of the *Weekly Standard*. "What is missing is a focused, appealing, and philosophically coherent national agenda." One would expect Bennett, after making such a statement, to propose such an agenda. But the former drug czar's notion of what the GOP platform should say resembles nothing so much as Clinton's farrago of demitasse ideas from a year ago. Bennett suggests focusing on such "targets of opportunity" as missile defense and opposition to racial set-asides and partial-birth abortion. These are poll-driven wedge issues, which are likely to have little effect on the lives of most people, and which surely don't constitute a philosophical program.

It was only two years ago that Republicans had enough consistent doctrine for Thomas Aquinas. What happened? Essentially, conservatives had an unpleasant encounter with reality. They took a few steps in the

Illustration

Slate's illustration style is firmly rooted in the tradition of the political cartoon—a perfect complement to the print-based overtones of the publication. The wry humor and liveliness of Slate's illustration provide a welcome relief to what what would otherwise be, at least for a web page, an imposing dose of text.

The uncomplicated line art and wood-cut styles in Slate are not only highly appropriate to the editorial style, but also pay dividends in terms of overall page size and, consequently, the speed at which Slate's pages are transmitted.

To reduce the file size of digital images, the most effective approaches involve 1) reducing the number of colors in the image palette, and 2) maximizing the areas of continuous solid color. The images shown on these pages are remarkable for their economy—they carry significant content, occupy large expanses of Slate's pages and surprisingly all come in at less than 15K of space. Consider, for example, the pen and ink drawing in figure 10. This illustration, accompanying an article about economic theory, takes up a full 3 by 9 inches of screen space but only 9K of

the page. What makes this reduction possible is the limited set of four grays allowed for anti-aliasing the image and the large solid expanses of pure black and white. The 3-color "wood cut" in figure 14, though occupying about half the area of figure 10, requires a little more disk space. To maintain the quality of the textures within the image, an expanded palette is necessary for smoothing. The more complex anti-aliasing results in a slightly less impressive compression of the file.

11
Illustrator: Michael Sloan
Dimensions: 230 x 221 pixels
File size: 4K
Palette:

10
Illustrator: Robert Neubecker
Dimensions: 230 x 640 pixels
File size: 9K
Palette:

12
Illustrator: Robert Neubecker
Dimensions: 230 x 505 pixels
File size: 10K
Palette:

13

Illustrator: Michael Sloan
Dimensions: 230 x 640 pixels
File size: 9K
Palette:

14

Illustrator: William L. Brown
Dimensions: 230 x 320 pixels
File size: 10K
Palette:

15

Illustrator: Mark Alan Stamaty
Dimensions: 260 x 185 pixels (x3)
File size: 34K
Palette:

16

Illustrator: Robert Neubecker
Dimensions: 260 x 772 pixels
File size: 14K
Palette:

Web pages of the size found in Slate are, of course, not designed to be seen at this scale, but sometimes a macro-view is well worth the look. From this distance, you can see the wonderful variety of image and text combinations that the user will experience as he moves down the page. Also evident is the role the illustrations play in carrying the eye down the page, while at the same time providing an additional layer of interpretation to the content.

‹ 18 ›

Slate

the city

Helter Shelter

Just try to help the homeless help themselves.

BY JAMES TRAUB
(1,265 words; posted Wednesday, April 30; to be compacted Wednesday, May 7)

In 1983, a group called the Coalition for the Homeless began handing out sandwiches and fruit every night to the horde of homeless people who gathered around Grand Central Station. It was a pretty dismaying experience, straight out of *Les Misérables*: the tattered crowd, the forest of groping hands, the healthy-looking young guys who conned their way to seconds or thirds while the quiet or confused went home empty-handed. But at least the coalition was doing *something*. It was the coalition, too, that had won a court order mandating a "right to shelter," a signal victory in those Darwinian, early Reagan years. Throughout the '80s the coalition—and its founder, Robert Hayes, a former corporate lawyer—was the principal voice for the homeless, both in New York and nationally. Hayes insisted the problem of the homeless could be summed up in three words: "Housing, housing, housing."

The coalition succeeded by turning homelessness into a simple, powerful moral equation, but the equation wasn't actually so simple. In 1992, a commission chaired by Andrew Cuomo, now the federal housing secretary, released a study showing that up to 50 percent of single homeless men suffered from severe mental illness, and 65 percent used drugs or alcohol. The numbers for families were smaller but still substantial. Homeless advocates had always known substance abuse was a problem, but they had rarely aired their knowledge in public for fear that it would shift public debate and blur the image of the homeless as victims of an unjust housing policy. They attacked the Cuomo study, though they couldn't discredit its findings. In 1993 Hayes, who had returned to private legal practice and had begun to question his old single-minded formulation, proposed to Mayor-elect Rudy Giuliani that the court order be revised so that the city would guarantee the homeless the "continuum of care" that Cuomo had proposed, and the homeless in turn would be obliged to accept counselling, work training, and the like. Despite Giuliani's interest the idea went nowhere since, Hayes says, it "created a grave sense of panic, at least in the coalition, because it was seen as undermining the ultimate entitlement to shelter." The coalition seemed to be painting itself into an ideological corner.

This past March, that corner became smaller still. George McDonald, another longtime homeless activist, filed suit against the coalition on the grounds that officials of the organization had engaged in "harassment and physical interference" of his rival program, called Ready, Willing & Able. The allegation would have seemed bizarre if it hadn't been familiar: Two years earlier, coalition officials had accused another nonprofit of using "goon squads" of homeless men to roust other homeless people from ATM vestibules—charges later found to be groundless.

Ready, Willing & Able, which runs private homeless shelters, requires participants to submit to frequent drug tests, abide by a range of rules inside the shelter, and make modest payments toward their own room and board. In exchange, they get jobs renovating apartments or cleaning streets for $5.50 an hour, plus, when they "graduate," a bonus that normally amounts to $1,000 to help them find permanent housing. McDonald is a former sportswear executive with a businessman's regard for the therapeutic power of the marketplace. The premise of his program was that since society will never pay for the kind of long-term drug treatment Cuomo and others have envisioned, and since such treatment so often fails, the most effective form of treatment is, as he puts it, "the positive reinforcement of a culture that's established around work, around earning money." McDonald says that half to two-thirds of single men on the street can benefit from his program. This sounds pretty optimistic, and Larry Rhodes, a formerly homeless man who does "intake" at the shelter McDonald runs in Harlem, says the program has succeeded partly because it screens out drug addicts and hard cases. In other words, McDonald may not have so much solved the Cuomo problem as avoided it.

Still, Ready, Willing & Able provides not only work but what appears to be a relatively calm and secure environment, and it would hardly be surprising if this drastic change from the world of the streets, or even of the typical shelter, motivated men to turn around their lives. McDonald says two-thirds of those who graduate from his program hold down permanent jobs and apartments—an almost unheard-of success rate among single homeless men. Most of the nine or 10 men I interviewed at the shelter spoke of their experience in overtly moralistic terms: They talked about taking responsibility for themselves, for the money they earned, and even for the children whom they had fathered and then neglected. The program, with its combination of rules and incentives, had prodded them to do something they would not have done for themselves.

McDonald's problems began when he tried to impose his program on men in the Harlem shelter who were accustomed to getting their three squares with no questions asked. McDonald acquired control of the Harlem facility, widely considered one of the most dangerous and disorganized in the city, when the city turned over the shelter system to nonprofit providers. When McDonald took over, many of the men rebelled against the program's strictures, especially the random drug testing. Some left for shelters elsewhere. The coalition serves as the court-appointed monitor for the shelter system, and what McDonald alleges, and others at the shelter corroborate, is that the official who represented the coalition at the shelter worked actively with the dissidents who remained to disrupt the program. In a meeting of all the tenants in late January, the coalition's monitor allegedly called McDonald a "Nazi" who was enriching himself by exploiting poor blacks, and berated the black shelter manager as McDonald's lackey. Coalition director Mary Brosnahan supposedly stood nearby and said nothing. The dissidents, lead by the former head of the coalition's "client advisory board," urged the other homeless men to stop working and allegedly issued threats of physical violence.

McDonald claims the coalition is "ideologically opposed" to his program. Brosnahan has lent some credence to this charge by describing McDonald's work program as "indentured servitude." She declined to talk about this case, but her lawyer, Steven Banks, says the defendants deny making the statements McDonald attributes to them. It is true, Banks says, that the coalition was so disturbed about the program that it contemplated suing him. The reason, he says, is the $65 a week McDonald was withholding for room and board, in violation of rules that govern the shelter system. But since residents were free to go to a conventional shelter, it's hard to see what right was violated. And since the money was being deducted from salaries they otherwise wouldn't have had, it seems perverse to focus on the issue of rights in the first place.

The fundamental issue is whether it's permissible to impose obligations on the homeless in exchange for various goods, to regard them as something other than victims to whom certain rights attach. This is, of course, the same question we are now asking about welfare recipients. We have moved very swiftly from seeing welfare as an unconditional right to viewing it as no right at all. Perhaps we could have found our way to a middle point if welfare's champions had seen their way beyond the language of rights to a different, and

‹ 16 ›

Slate

movies

The Designated Mourner
Directed by David Hare
First Look Pictures

My Panel Discussion With Andre

The return of Wallace Shawn.

BY SARAH KERR
(1,217 words; posted Friday, May 2; to be compacted Friday, May 9)

Wallace Shawn

Who is Wallace Shawn, exactly? He's been around for years, yet it's still hard to know. In arty circles, he's famous as the highbrow exhibitionist who wrote and starred in *My Dinner With Andre*, but there's more to Shawn than grandiose nerd angst. Millions of small children around the country could pick him out in a lineup. They'd know him as the dotty character actor from mass-appeal films like *The Princess Bride* and *Clueless*—a guy who, unlike the earnest playwright Shawn, appears to have stopped taking anything in life seriously, least of all himself. On the contrary, he hams up his resemblance to a clown and wheezes for laughs (and, presumably, a paycheck).

Shawn doesn't appear in this film based on his latest play, but his schizoid spirit haunts it all the same. *The Designated Mourner* is one of those sobering allegories set in the not-so-distant future in a country not unlike our own. The actors deliver lots of brooding speeches, and the plot is a downer. On the other hand, the star is Mike Nichols, in his first-ever film appearance and with a sneering comic timing that has somehow improved in the 30-odd years since he stopped performing with Elaine May.

Nichols plays Jack, a shrewd, middle-aged pragmatist. Years ago, in college, Jack impulsively married smart but prissy Judy (Miranda Richardson), unaware that by doing so, he was entering a stifling ivory tower. At the time, Judy's father, Howard (David de Keyser), was one of the country's leading intellectuals. He was a great man but also a jerk; he surrounded himself with suck-ups and expected his daughter to wait on him hand and foot. For a while Jack admired Howard's strong convictions and his ability, apparently rare in this bleak hypothetical future, to understand the poetry of John Donne. But one day Jack admitted to himself that he didn't give a damn about art or poetry, that Howard got on his nerves, and that anyway he'd fallen out of love with Judy. Relieved, he left her and her clique behind.

Director David Hare has preserved the no-frills setup of the stage production he oversaw in London. (It makes sense that the London production was more successful than the American one, and that the director and two of these three actors in the film are English. Since when in America have we really obsessed over the fate of intellectuals?) The play unfolds in monologues, with Jack making a witty case for his desertion of Judy, then Judy speaking, then Howard, then back to Jack, and so on; the three of them sit at a long table and talk into the camera, occasionally pouring themselves glasses of water as panelists at a conference do. The drama comes from the way Shawn craftily shifts your sympathy back and forth among characters. Just when Jack has you convinced that Judy is a pretentious albatross (Richardson's very British clucking-tongue routine helps here), Judy's stock rises as she stoically describes how the intolerant new government had begun to crack down on her and her father. Then, slowly, it becomes clear that the government is going to do worse than harass the intellectuals. And you realize—or you're supposed to realize—that however arrogant and annoying you find Judy and Howard, some bottom-line human decency will be violated if they are harmed.

The writing is ostentatiously literary, and I expect that although a hard-core band of fans will praise *The Designated Mourner* for condemning the vulgarian times we live in, a larger group will think it's just more intolerable hooey from that highbrow exhibitionist it's actually better than hooey, but it's also a hopelessly conflicted piece of work. The whole conception of "the intellectual life" feels dated: The film is set in the future, but earlier, Judy starts off as a virgin, then becomes a servant to be traded back and forth by the men. Later, when Jack casts off the brainy lifestyle, he becomes a porn addict. In the Shawnian scheme of things, being or not being an intellectual would appear to be an issue only for men, as if the only thing that kept them from humping everything like craven dogs was a fondness for sonnets. Then there's the problem of what's killing the intellectuals off. They are themselves partly to blame, because they're such insular snobs. But the big villain is a power-mad government whose only agenda seems to be hunting down and killing smart people. Shawn has been vocal about his belief that theater should be more political, but this government of philistine meanies seems more like a cheap device designed to give his play some tension. All he's really telling us is: Beware of people with bad taste.

Jack (Mike Nichols) and Judy (Miranda Richardson)

The implementation of Slate's pages is clean, straightforward and appropriate. There is nothing in the site that comes off as technology for its own sake, yet the pages always exude a strong sense of quality web page engineering. Slate doesn't go out of its way to push technological limits and this restraint contributes greatly to the aura of seriousness about content that is essential to the magazine's mission. The layout of Slate's pages employs a straightforward use of nested tables (fig. 21). Articles are housed in a single table divided into horizontal rows which span the entire width of the virtual page. These rows each contain an additional table dividing the horizontal space into separate areas for a text column, side-bar illustrations and the shifting areas of white-space on the left and right side of the page.

To keep the size of pages to a minimum, articles are typeset almost completely with HTML formatting tags. Bitmap text is limited to the drop caps that mark the location of paragraph shifts. To establish hierarchy and contrast within article titles, a careful selection of HTML font size and a parsimonious use of color is all that is needed.

The conservative approach to typography and illustration found in Slate pays significant dividends in overall page size and speed of transmission. Slate pages rarely exceed 40K, including the ever-present advertisement at the top of every page. The reliance on simplicity of text and image produces a site which on a per-byte basis delivers considerable information.

21

Nested tables can be difficult to implement and confusing to maintain. In moderation however, multiple tables permit a "divide and conquer" approach to laying out pages that can significantly reduce complexity. Slate pages are first divided into horizontal sections by a simple table consisting of single table data entries for each row. Once established, each row of this table is further subdivided by incorporating another table used to locate the text column and the spaces on the left and right margin. The border frames have been turned on below to show this structure.

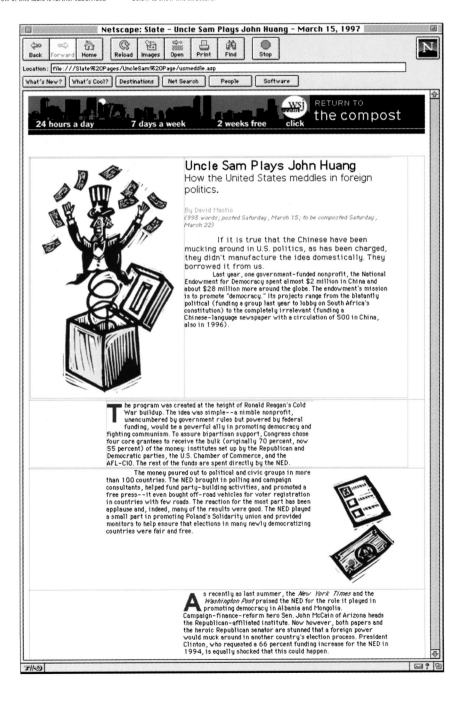

The drop caps used throughout Slate are relatively straightforward in HTML. The letterform is created as a tightly cropped GIF file (with either a white or transparent background) and is inserted at the start of the text in the HTML file (fig. 22a). The image tag contains an *Align=left* setting which instructs the remaining text within the paragraph to pour around the image. This technique works regardless of the point size or typeface selected in the reader's browser (fig. 22b).

Slate's paragraph indents (fig. 22c) are implemented with the (non-breaking space) character, the closest thing to an N-space available in HTML. The indent shown at the right is set as six consecutive non-breaking-spaces (" , , ,…"). This approach allows the indents to be proportional to the default point size rather than set to an absolute distance by an invisible GIF file or the "spacer" tag.

22

As recently as last summer, the *New York Times* and the *Washington Post* praised the NED for the role it played in promoting democracy in Albania and Mongolia. Campaign-finance-reform hero Sen. John McCain of Arizona heads the Republican-affiliated institute. Now however, both papers and the heroic Republican senator are stunned that a foreign power would muck around in another country's election process. President

a)

As recently as last summer, the *New York Times* and the *Washington Post* praised the NED for the role it played in promoting democracy in Albania and Mongolia. Campaign-finance-reform hero Sen. John McCain of Arizona heads the Republican-affiliated institute.

b)

It's hard to be against the angels of democracy and human rights, but imagine how Americans would feel if the Chinese Communist Party openly gave a million bucks to the Republicans for a voter-registration drive (not to mention the fact that U.S. law makes most political contributions by foreigners illegal here). But we do similar things in other countries all the time, and call it

c)

23

Netscape: Slate - Uncle Sam Plays John Huang – March 15, 1997

Location: file:///Slate%20Pages/UncleSam%20Page/usmeddle.asp

What's New? | What's Cool? | Destinations | Net Search | People | Software

The Wall Street Journal Interactive Edition is continually updated

RETURN TO the compost

Uncle Sam Plays John Huang
How the United States meddles in foreign politics.

By David Mastio
(993 words; posted Saturday, March 15, to be composted Saturday, March 22)

If it is true that the Chinese have been

Like many other web sites, Slate uses a banner at the top of each page to establish the overall width of the page design and to provide a place for navigational controls. To make the "capping" effect of the banner more versatile, the Slate banner stretches out to occupy windows of any proportion (fig. 23). This "stretchability" is achieved through a clever use of nested tables. The content of the banner—the ad and the navigational area—is placed in a fixed table conforming to the proportions of the page grid (see fig. 6). The background of the banner, three horizontal stripes of black and white, is implemented as a separate table whose cells are colored with a BGCOLOR setting in the table data tags. The width of this table is set to 100%. The first table is set within the first row of the outer table so that when a window is resized by the user, the outer super-table grows to the new width while the interior table remains flush left and in place.

On-Line Resources

There's no better source for up-to-date information than the web itself. Because the web is in a permanent state of change, keeping up is a constant challenge. These URLs represent a good resource for understanding how the web works today, and how it will be working in the future. Readers are advised to pay special attention to the pages mentioned in the first category, *Keeping Up with the Web*. These sites are updated constantly and cover the evolution—and the future—of the web with great enthusiasm and accuracy.

Keeping Up with the Web
http://www.builder.com
http://www.cnet.com/Content/Builder/Authoring
http://www.hotwired.com/webmonkey
http://www.microsoft.com/workshop
http://www.projectcool.com/developer
http://www.webreference.com

Web Design Tutorials & Advice
http://www.cnet.com/Content/Builder/Graphics
http://www.cnet.com/Content/Builder/Graphics/Design
http://www.hotwired.com/webmonkey/design
http://www.microsoft.com/workshop/design
http://info.med.yale.edu/caim/manual
http://www.netscape.com/comprod/products/navigator/
 version_3.0/layout/index.html

Web Color
http://www.lynda.com/hex.html
http://www.microsoft.com/workshop/design/color/
 . default.asp
http://www.webreference.com/dev/graphics/
 compress.html

Graphic Formats & Image Reduction
http://www.cnet.com/Content/Builder/Graphics
http://www.cnet.com/Content/Features/Techno/Gif89
http://www.hotwired.com/webmonkey/graphics_fonts
http://www.webreference.com/dev/graphics
http://www.webreference.com/jpeg
http://www.w3.org/TR/PR-png-960701.html

Web Typography
http://www.hotwired.com/webmonkey/graphics_fonts
http://www.microsoft.com/truetype
http://info.med.yale.edu/caim/manual/pages/
 typography.html

HTML Standards
http://www.w3.org
http://www.w3.org/hypertext/WWW/MarkUp/
 html-spec/html-spec_toc.html
http://www.w3.org/hypertext/WWW/MarkUp/Wilbur
http://www.w3.org/TR/REC-html40

Netscape HTML Extensions
http://www.netscape.com/assist/net_sites/
 html_extensions.html
http://www.netscape.com/assist/net_sites/
 html_extensions_3.html

InternetExplorer HTML Extensions
http://www.microsoft.com/workshop/author/newfeat/
 ie30html-f.htm
http://www.microsoft.com/ie/ie40

HTML Tutorials
http://www.cnet.com/Content/Builder/Authoring/Basics
http://www.davesite.com/webstation/html
http://www.hotwired.com/webmonkey/html
http://www.hotwired.com/webmonkey/teachingtool
http://www.ncsa.uiuc.edu/General/Internet/WWW/HTML
 Primer.html
http://www.projectcool.com/developer/html.html

Tables
http://www.hotwired.com/webmonkey/html
http://www.netscape.com/assist/net_sites/tables.html
http://www.projectcool.com/developer/alchemy/
 03-tables.html

Frames
http://www.hotwired.com/webmonkey/html
http://www.netscape.com/assist/net_sites/frames.html
http://www.projectcool.com/developer/alchemy/04-
frames.html
http://www.webreference.com/dev/frames

Cascading Style Sheets

http://www.cnet.com/Content/Builder/Authoring/CSS/
 index.html
http://www.hotwired.com/webmonkey/stylesheets
http://www.microsoft.com/workshop/author/css/
 css-ie4-f.htm
http://www.microsoft.com/workshop/design/layout/
 css.asp
http://www.microsoft.com/typography/css/gallery/
 entrance.htm
http://www.w3.org/TR/WD-css1.html
http://www.w3.org/TR/WD-CSS2
http://www.w3.org/TR/WD-positioning

Java

http://www.cnet.com/Content/Builder/Programming
http://www.gamelan.com
http://www.hotwired.com/webmonkey/java
http://www.microsoft.com/java
http://www.sun.com/java

Javascript

http://www.cnet.com/Content/Builder/Programming
http://www.hotwired.com/webmonkey/javascript
http://developer.netscape.com/library/documentation/co
mmunicator/jsguide4/index.htm
http://www.projectcool.com/developer/javascript/
 index.html
http://www.webreference.com/js

Dynamic HTML

http://www.hotwired.com/webmonkey/dynamic_html
http://www.microsoft.com/workshop/author/dhtml
http://www.webreference.com/dhtml

GIF Animation

http://www.webreference.com/dev/gifanim
http://iawww.epfl.ch/Staff/Yves.Piguet/clip2gif-home/
 GifBuilder.html

Interactivity & Animation

http://www.macromedia.com/shockzone
http://www.macromedia.com/software/flash
http://www.webreference.com/dev/flash

Plug-ins

http://home.netscape.com/comprod/products/navigator/
 version_2.0/plugins/index.html
http://browserwatch.internet.com/plug-in.html

Web Usage Statistics

http://browserwatch.internet.com/stats.html
http://www.cc.gatech.edu/gvu/user_surveys

Web Search

http://www.altavista.com
http://www.hotbot.com
http://www.lycos.com
http://www.metacrawler.com
http://www.yahoo.com

Web Site Reviews

http://www.highfive.com
http://www.microsoft.com/powered/bestofbest.htm
http://www.pointcom.com
http://www.projectcool.com/sightings

Design Organizations

http://www.ac4d.org
http://www.aiga.org
http://www.acm.org/sigchi

Index

Contributors

Avalanche Systems Inc.
304 Hudson Street, 7th Floor
New York, New York 10013
http://www.avsi.com

Adobe Systems Inc.
345 Park Avenue
San Jose, California 94043
http://www.adobe.com

Carnegie Hall
881 7th Avenue
New York, New York 10019
http://www.carnegiehall.org

CNET: The Computer Network
150 Chestnut Street
San Francisco, California 94111
http://www.cnet.com

Digital Stock Corporation
750 Second Street
Encinitas, California 92024
http://www.digitalstock.com

Discovery Communications Inc.
7700 Wisconsin Avenue
Bethesda, Maryland 20814
http://www.discovery.com

Dynamic Diagrams
12 Bassett Street
Providence, Rhode Island 02903
http://www.dynamicdiagrams.com

Michael and Renee Lamm Esordi
4409 Long Beach Avenue
San Diego, California 92107

Fitch
10350 Olentangy River Road
Worthington, Ohio 43085
http://www.fitch.com

IDEO Product Development
151 University Avenue
Palo Alto, California 94301
http://www.ideo.com

Informatics-Studio, Inc.
1132 Heberton Street
Pittsburgh, Pennsylvania 15206
http://www.informatics-studio.com

IPIX (Interactive Pictures Corporation)
1009 Commerce Park Drive
Oak Ridge Tennessee 37830
http://www.ipix.com

Magnet Interactive Communications
3255 Grace Street N.W.
Washington, District of Columbia 20007
http://www.magnet.com

MetaDesign, Berlin
Bergmannstrasse 102
D-10961 Berlin
http://www.metadesign.com

MetaDesign, San Francisco
350 Pacific Avenue, 3rd Floor
San Francisco, California 94111
http://www.metadesign.com

MSNBC on the Internet
One Microsoft Way
Redwood, Washington 98052-6399
http://www.msnbc.com

Netscape Communications
501 East Middlefield Road
Mountain View, California 94043
http://www.netscape.com

Slate
One Microsoft Way
Redmond, Washington 98052
http://www.slate.com

Studio Archetype
600 Townsend Street, Penthouse
San Francisco, California 94103
http://www.studioarchetype.com

Wired Digital
660 3rd Street, 4th Floor
San Francisco, California 94107
http://www.hotwired.com

Ziff-Davis
One Park Avenue
New York, New York 10016
http://www.ZDnet.com

Picture Credits

Chapter 1. Site Architecture

Figs. 1-3. Roy McKelvey.

Fig. 4. Used by permission of Adobe Systems, copyright ©1997.

Fig. 5. Used by permission of Audi AG, copyright © 1997-98.

Fig. 6. Used by permission of Discovery Communications Inc., copyright ©1997.

Fig. 7. Reproduced from www.ibm.com, copyright © 1997-98 by International Business Machines Corporation.

Fig. 8 (top). Used by permission of Adobe Systems, copyright ©1997.

Fig. 8 (bottom). Used by permission of Netscape Communications Corp., copyright ©1996. Netscape Communications Corporation has not authorized, sponsored, or endorsed, or approved this publication and is not responsible for its content. Netscape and the Netscape Communications Corporate Logos are trademarks and trade names of Netscape Communications Corporation. All other product names and/or logos are trademarks of their respective owners.

Fig. 9. Screen shots used by permission of the Digital Stock Corporation, copyright © 1998. All rights reserved.

Fig. 10. Used by permission of Discovery Communications Inc., copyright ©1997.

Fig. 11. Roy McKelvey.

Fig. 12. Used by permission of Studio Archetype. Copyright © 1996-97. StudioArchetype Inc. All Rights Reserved.

Fig. 13. Used by permission of Adobe Systems, copyright ©1997.

Fig. 14. Used by permission of Studio Archetype. Copyright © 1996-97.

Fig. 15. Used by permission of Wired Digital, Inc., copyright © 1994-97 Wired Digital, Inc. All Rights Reserved.

Fig. 16. Used by permission of Fitch Inc., copyright 1997-98. All Rights Reserved.

Fig. 17. Reprinted with permission from CNET (www.cnet.com). Copyright © 1995-7.

Fig. 18. Screen shots of MSNBC used by permission from MSNBC. Copyright © 1997-98. MSNBC is not a sponsor of and does not endorse Virginia Commonwealth University or "Hypergraphics." Photograph on MSNBC page by Ken Light, copyright © 1997, used with permission.

Fig. 19. Screen shots used with permission from ZD Net. Reprinted from ZD Net August 8, 1997. Copyright © 1997 Ziff-Davis Inc.

Fig. 20. Used by permission of Virgin Records of America, copyright © 1997-8.

Fig. 21. Used by permission of Wired Digital, Inc., copyright © 1994-97 Wired Digital, Inc. All Rights Reserved.

Chapter 1. Page Architecture

Figs. 1-9. Roy McKelvey.

Fig. 10. Used by permission of Discovery Communications Inc., copyright ©1997.

Figs. 11-18. Roy McKelvey.

Fig. 19. Used by permission of Discovery Communications Inc., copyright ©1997.

Figs. 20-21. Roy McKelvey.

Fig. 22. Used by permission of Carnegie Hall Corporation and Avalanche Systems Inc., copyright ©1997-98.

Figs. 23-26. Roy McKelvey.

Fig. 27. Used by permission of Audi AG, copyright © 1997-98.

Figs. 28-30. Roy McKelvey.

Fig. 31. Used by permission of Wired Digital, Inc., copyright © 1994-97 Wired Digital, Inc. All Rights Reserved.

Chapter 3. Web Color & Image Formats

Figs. 1-2. Roy McKelvey.

Fig. 3. Images taken from CD-ROM, "Everyday Objects, v1".©CMCD 1994. All Rights Reserved.

Figs. 4-9. Roy McKelvey.

Fig. 10. Screen shot used with permission by MetaDesign, copyright © 1997-98.

Fig. 11. Used with permission of the Nissan Motor Corporation U.S.A., copyright © 1997.

Fig. 12. Courtesy of Robert Gonzalez, designer and implementer.

Figs. 13-14. Roy McKelvey.

Fig. 15. Photograph and image manipulations used courtesy of Warren Fix.

Fig. 16. Roy McKelvey.

Fig. 17. Used with permission of the Nissan Motor Corporation U.S.A., copyright © 1997.

Figs 18-19. Photograph used by permission of Warren Fix.

Fig. 20. Roy Mckelvey.

Chapter 4. Analyzing a Web Page

Figs 1-4. Used with permission of Informatics-Studio Inc., Copyright © 1998. All Rights Reserved.

Fig. 5 (left) Pop-up menu used with permission of Netscape Communications Corp., Copyright © 1996.

Fig. 5 (right) Pop menu used with permission of the Microsoft Corporation. Copyright © 1997-98.

Fig 6. Bird image used courtesy Informatics-Studio Inc., copyright © 1998.

Fig. 7. Bird animation frames used courtesy Informatics-Studio Inc., copyright © 1998.

Fig. 8. Copyright 1996 Netscape Communications Corp. Used with permission. All Rights Reserved.

Figs. 9-11. Roy McKelvey.

Fig. 12-13. Used with permission of Informatics Studio Inc., Copyright © 1998. All Rights Reserved.

Chapter 5. Looking at Web Sites